CONCRETE CONCEPT

Frances Lincoln Limited
74–77 White Lion Street
London N1 9PF
www.franceslincoln.com

Concrete Concept
Copyright © Frances Lincoln Limited 2016
Text copyright © Christopher Beanland 2016
Photographs copyright, see page 192
Design: Glenn Howard
Commissioning editor: Zena Alkayat

First Frances Lincoln edition 2016

A catalogue record for this book is available from
the British Library.

ISBN 978-0-7112-3764-3

Printed and bound in China

1 2 3 4 5 6 7 8 9

FRANCES
LINCOLN

CONCRETE CONCEPT

Brutalist buildings around the world
Christopher Beanland

CONTENTS

INTRODUCTION

Why brutalism? Some questions keep recurring like the same sad songs on the radio: why do you like these ugly buildings? Where the bloody hell did they come from? The answer to the first one is easy as pie; the second – well, how long have you got…

Dreams of brutalism

Why do you like these ugly buildings? The swirling, lucid dreams (that seem to come more frequently after evenings down the pub) that haunt me. Dreams of brutalism. Dreams about blonde-haired girls lolling on roundabouts, outside tower blocks, beneath flyovers. An itch you can't scratch. I know the culprit: Birmingham, in the middle of England. When you're in a romantic relationship that counts, you want to understand your partner's past. Birmingham was my temporary other half – potty-mouthed, smoking at sun-up, hilarious, mysterious, ridiculous. It was a funny kind of love; desire filtered through wonder and disgust. I had to know 'Brum'. From 2002 to 2007, I carved out some kind of life in 1970s-built concrete canyons and freezing offices and bars that stank of cigarettes, optimism and repressed lust. The dented desire for better futures lurked on landings and haunted subways. Post-war Birmingham rebuilt itself in austere raw concrete, like Kuwait and Hanover and Manila. Brutalist buildings were everywhere – imposing, crumbling, taunting. One stood out: John Madin's 1974 Birmingham Central Library. From which strange seeds did grand ideas like these sprout?

Weird but normal

After five years living anywhere we accept our environment; humans have a great aptitude for adapting. Buildings are like theatres: the backdrops for lives; lives are 10% drama, 90% workaday. The lives of me and my colleagues and a million strangers played out among these future ruins. No one noticed what was around them any more. Things were weird but normal: normal life, with its happy and sad bits, played out in weird surroundings. Couples bickered, chicken sandwiches were eaten too quickly and chalky dyspepsia pills followed; college crushes, office crushes, *any* crushes were discussed over tepid beers in brutalist piazzas, brutalist boozers. This idea of these spaces being odd – yes – but not always being dystopian informed a novel I wrote in 2015 – it was a love letter to Birmingham and its brutalist buildings. I wasn't the first to have been affected, afflicted. This was inspirational architecture, it wasn't always failed architecture, didn't always cause societal collapse, wasn't universally hated. Hate? Hate comes from outsiders who are too scared or appalled to dwell in industrial cities. Brutalism's aesthetic philosophy can

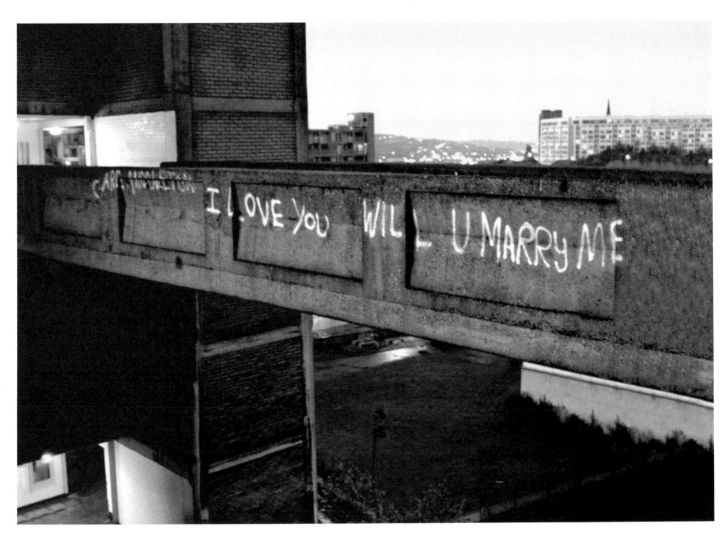

sometimes be, conversely, about love – for urbanity, for the masses. Rodney Gordon's Eros House in south London is named after the Greek god of love. On Sheffield's Park Hill Estate, a bridge bears a clumsily appended spray-painted proposal: 'Clare Middleton I Love You Will U Marry Me'.

Where the bloody hell did brutalism come from?

Why did this style emerge? The cultural complexities needed for anything to happen can spin on a dime. History is reliant on a million chances; on breeding, war, natural disaster, the theories and drawings of a few that filter miraculously down to the many. Victor Pasmore's 'Blue Peter' compositions from the mid-1950s (that is, bits of glued plastic and ink), hanging today at London's Tate Modern, paint a picture of brutalism to come. The artists at This Is Tomorrow, the seminal Whitechapel Gallery exhibition of 1956, signalled something. The Nazi bunkers of Guernsey and Austria informed the aggressive forthcoming shapes. So did the grain silos at Buffalo and Montreal, and Dorman Long's

coke oven at Middlesbrough. Le Corbusier threw the baby out with the bathwater, trashing the international style in favour of rough concrete when he built the Unite d'Habitation (the 'Maison du Fada' – 'Mad House') in 1952 – though that was down to expediency as much as philosophy and the "massacre of concrete", as he put it, that had resulted from so many contractors on site in Marseille.

Some brutalist architects were artists – Pasmore, Marcel Breuer, Lina Bo Bardi, Rodney Gordon. Many more were copycats, functionaries on meat-and-potatoes missions to put up cheap bits of vernacular work which might have been hack jobs but still stand out like gloriously grisly sore thumbs on streets across the globe. The best people pushed the style to the extremes, gave the forces of reaction the middle finger, waved magic wands, and built overblown megastructures Ivry-sur-Seine in Paris, or Herlev Hospital in Denmark, or Cumbernauld in Scotland. They designed distinctive set pieces like the Lycée Sainte-Marie

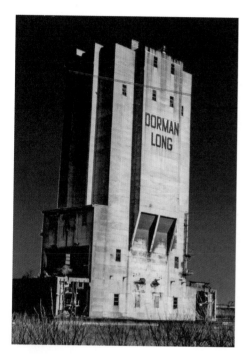

Dorman Long coke oven,
Middlesbrough, England

at La Verpillière or the Kirche Johannes XXIII in Cologne. Concrete was cheap, but it could be stretched into crazy shapes.

The history of brutalism? You know that by now. It's been repeated ad infinitum in boring architecture books and on design websites. Brutalism lasted from roughly the mid-1950s to the mid-'70s. That word – brutalism. It slithers from many streams: nybrutalism in Swedish, Reyner Banham's 'new brutalism' (a tag added, especially, to Alison and Peter Smithson), the French for raw concrete – 'beton brut'. 'Brutalism' is a decisive word, the architecture is too. No pussy-footing. This lot built like they meant it. They had confidence; society put its trust in them – well, the flabby chaps in charge did, the public didn't get a say. The 20th century was about the 'new' – new art history, new ideas, new society. But ideology shaded into social democratic consensus, and brutalism expressed the new compact.

Concrete logic

In appearance, brutalism is about severity, abstraction, ambition; angles that promote nausea, shapes that promote dizziness, spaces that occasionally evoke terror. As Jonathan Meades points out: we don't expect our literature, film or painting to be 'nice', so why do we expect our architecture to? And yet… the cool watergardens of London's Barbican or the Alexandra Road Estate's terraces or George Finch's Lambeth Towers (which looks rather like a giant ice cream sundae) can be calming, even elevating oases amid the undoubted urban insanity. These buildings, these spaces, these chunks of engineering all look like they do because they were meant to stand up to the city, to answer back to it, to challenge it: not to hammer the human. They are fistfights with metropolitan grit, signposts to a technological future that never quite came, or at least came with computers masquerading as phones rather than aeroplanes masquerading as cars. Brutalism could also do 'surreal' before postmodernism sauntered in wearing heels and a smirk, then vomited red and green in the corner. Hidden animal faces are

recurring visual jokes in brutalism. Even weirder is the way Charles Rennie Mackintosh's house has been recreated on Glasgow University's thrilling concrete campus – its DNA has been mashed with the adjacent Hunterian Museum, like The Fly. Glasgow reimagined itself in the post-war years in surreal, flamboyant style just like Newcastle and New Haven and Belgrade.

Strong institutions build strong buildings; architecture is a pointlessly priapic power game. Brutalism's patrons were: city councils, government departments, corporations, universities, even God. When the institution fades, so does the building. God needs better PR these days, and the spooky, abandoned St Peter's Seminary in Scotland – now a haven for bums on Buckfast Tonic Wine blowouts – shows it. Public relations, with its bullshitting and jollies, has never had it so good; public housing has had the funds sucked out of its corpse, like at Carlo Celli's Rozzol Melara housing estate in Trieste. Brutalism was the visual language of a post-war welfare state on which the sun is setting – of schools, higher education, libraries, hospitals, housing estates, playgrounds, city halls. Yet it landed on both sides of the Iron Curtain. Remember though – it also had guest-starring roles as shopping centres, banks, company headquarters (yes), research labs, TV transmitters, embassies, telephone exchanges, courts, police stations, prisons, hotels, youth hostels, railway stations, bus stops, airport terminals, border crossing posts, the bridges and tunnels and service stations of the motorway age, theatres, art galleries, lighthouses, private houses.

Brutalist buildings pay little heed to history, seldom tip their caps to local tradition. They were a break with the past, a lust for the future; a lust now lost. If only this was a book about the future. But it isn't, it's a book about a vision of the future from the past. Brutalism emerged at the beginning of the jet age, as architects freely flew around the world pinching ideas from one another, carousing with fast women and driving fast cars, like in Mad Men. The style was globalised: a new city hall in Sheffield, a new city hall in Sorocaba.

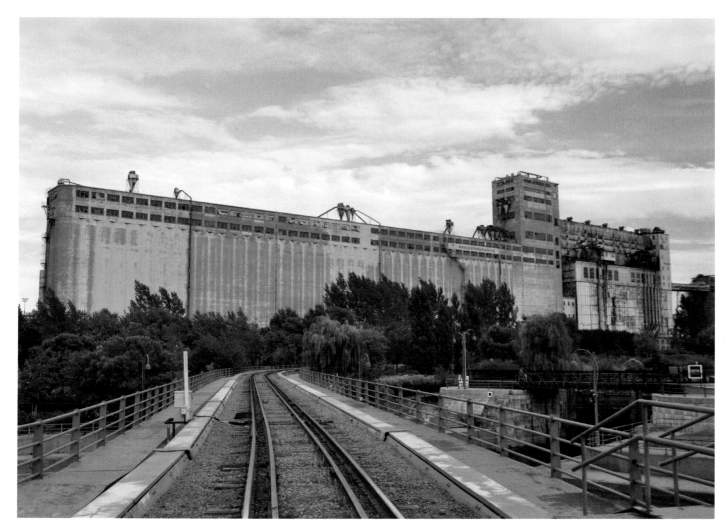

Brutalism was more widespread than you'd ever imagine. It could also be deployed on a huge scale. This was the age of the planner, of the expert in the suit who knew what was best for us. The supersized plan was unfurled by Arthur Erickson on university campuses in Canada (Lethbridge in Alberta and Simon Fraser in British Columbia) and by Kenzo Tange, who planned Skopje's remodelling. But brutalism could be anonymous too. Radical buildings didn't always arouse fervour, often they blended seamlessly into the new background – John Madin's sadly lost Yorkshire Post Building in Leeds or Paul Rudolph's stately Yale Art & Architecture Building. They slotted perfectly into an urbanised late 20th-century landscape of cars and concrete. At least we know the architects of these two: with many vernacular bits of brutalism it's a definite case of 'author unknown'.

Brutalism might sometimes have just blended in. At other times it lodged in the throat, it got you in the gut, it spawned art every bit as challenging as itself. Art that begets art: now there's a thing.

Antonioni celebrated industrial chic and depicted fresh, white brutalism like the Brunswick Centre in London in his film The Passenger; Kubrick and Truffaut saw threat instead. Yet the real mid-century hepcats were into pop, play. Pop architecture, pop culture, pop music. Lightweight stuff. Later, urban landscapes from Bristol to Berlin, scarred by economic slowdown and littered with heavyweight edifices, inspired films like Radio On and the music of Joy Division and David Bowie, the novels of BS Johnson and Catherine O'Flynn. It wasn't always so serious – people forget that. The clichés of Kraftwerk, crack, dole and despair aren't the whole story. Watch Telly Savalas Looks at Birmingham – camp as Christmas. Today we have twee brutalism: toy brutalist building blocks, posters showing stylised drawings of Brunel University, Orange County Government Centre on a cushion. Would you believe you can even buy hardback books discussing your favourite ugly concrete ducklings?

Silo No 5, Montreal, Canada

Park Hill Estate, Sheffield, England.
Jack Lynn and Ivor Smith

Official narratives and nostalgia

From the late 1970s onwards it was all-out assault on modernism. The official narrative ran that modern architecture was a failure in practice, that brutalist buildings especially were ugly, inhuman, unfit for purpose; their architects were megalomaniacs, lunatics. Newspapers, TV and academics rallied to trash the modernist project. Brutalism had few friends in high places in the 1980s and '90s. Money was in the ascendency. The plan: redevelop brutalist plazas and estates, build offices or flats, make money. Does concrete cause anxiety? Urban life does, material possessions (or the scramble for them) do, antisocial behaviour does, driving does, pollution does, long hours and commuting do, ill health does, being geographically and socially excluded does, not having access to transport and other essential services does. But concrete? My first taste of brutalism was Denys Lasdun: a school trip to the University of East Anglia when I was a nipper. My second: an A Level psychology conference at his Institute of Education.

The psychologists had chosen brutalism as a venue to discuss the mind – this seemed proof that concrete could be forgiving as well as foreboding. JG Ballard's writing asked psychological questions – pertinent questions; questions of whether we can trust ourselves to reimagine the world. We are but sacks of organs and water, our heads flecked with odd notions. We make mistakes. Better to aim high than to demur, though? Perhaps these buildings were too utopian, too avant garde.

It takes time for the works of imaginative painters, writers, comedians, directors, architects to be understood and appreciated. Life is – or should be – lived with fiery passion, an intensity that befits its brevity and ultimate road to nowhere. A building is designed for centuries. These were sometimes rubble in half a human lifetime. The idiots were winning – Rod Gordon's bravura Tricorn Centre in Portsmouth and his Trident car park at Gateshead (star of the movie Get Carter) were demolished by British bureaucrats. Ditto Bertrand Goldberg's Prentice Women's Hospital in Chicago.

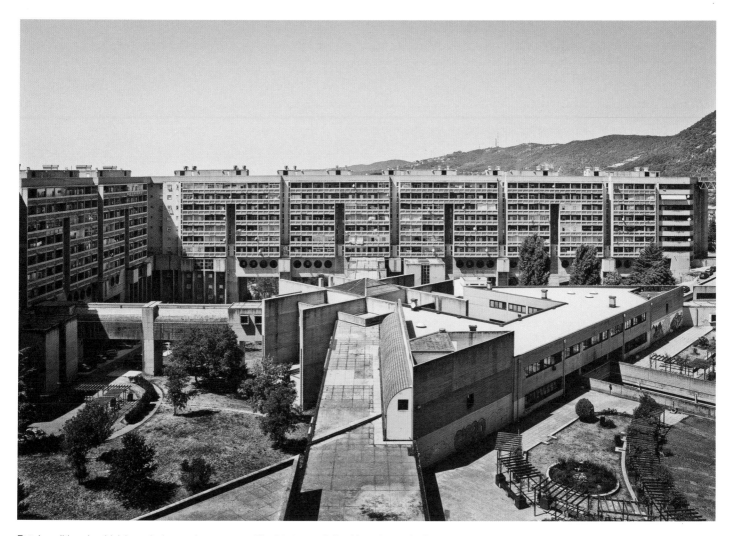

Rozzol Melara, Trieste, Italy. Carlo
and Luciano Celli, and Dario Tognon

But demolition shouldn't be today's way. Any city that, in the 2010s, continues stupidly felling 1960s and '70s brutalist monuments needs its head examining (I'm looking at you, Birmingham). These buildings are (slowly) being rediscovered: written about, printed on plates, converted into hotels, featured on film not solely as malevolent. Brutalism inspires a cultish devotion among a growing band of aficionados. Neo-brutalist buildings are going up: see Elemental's UC Innovation Centre in Santiago, Chile.

Ultimately though it's a nostalgic exercise, and nostalgia is the preserve of a culture with something missing. The 21st-century reappraisal of brutalism is partly an attempt to re-invoke pre-1979 values of social democracy – even though the 'democracy' wasn't necessarily all it was cracked up to be and the 'social' could be antisocial if you were outside the mainstream (ie not male, not white). Today's society fizzes with variety. But its architecture is often compromise. Compromise is useful. But no one writes books about it.

The 2010s are defined by an icy cocktail of hedonism and cynicism; lives underwritten by social networking and shopping, sex and narcissism – high capitalism triumphant. Architecture today is 'the built environment' – eco-architecture, tourist architecture, money-making architecture, iconic rebrand architecture, pop-up architecture. Modern art is the new religion – a mainstream pursuit; galleries and museums are today's cathedrals. Architecture is art – or at least it should be. But it was the architecture of the mid-20th century that was really creative, that really bared its teeth. Yet for all the extraordinary swagger, brutalism settled into the city and became the stage set for millions of ordinary lives. Those brutalist buildings were meant to impress. They didn't always oppress. Why brutalism? Why not.

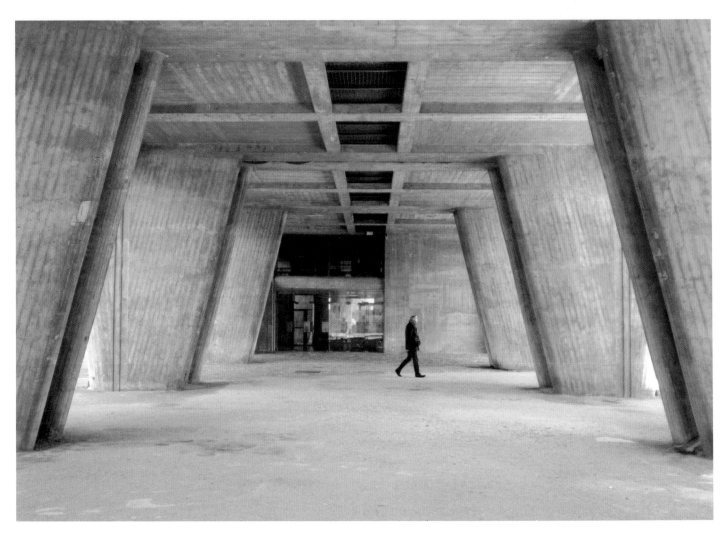

AN A-Z OF BRUTALIST ARCHITECTURE

BY JONATHAN MEADES

Asplund

The term nybrutalism, or new brutalism, was the jocular coinage of architect Hans Asplund. He applied it to a small house in Uppsala, in his native Sweden, designed in 1949 by his contemporaries Bengt Edman and Lennart Holm and built of bricks. Were it not for that material, the house might stand as the very example of the light, ascetic, prim, nordic modernism that afflicted Britain for some years after the war. The Festival of Britain in 1951 was actually The Festival of Plagiarising Scandinavian Architecture. Asplund's neologism caught on in Stockholm and was picked up by British architectural pilgrims to that city, among them Oliver Cox, Graeme Shankland and Michael Ventris, the decoder of Linear B (an ancient script seen as one of the great linguistic riddles). Although the epithet signified nothing, or maybe because it signified nothing, it was taken up as a slogan of defiance or something by arty young British architects, none artier than Alison and Peter Smithson and their representative on Earth, Reyner

Banham, an architectural critic whose prose may cause all but the entirely insentient to wince. The Smithsons' Hunstanton School in Norfolk, finished in 1954, derives from Mies van der Rohe and has little in common with subsequent buildings that were deemed brutalist.

Béton brut

Banham expanded Asplund's coinage, turning it into a bilingual pun on the French béton brut – literally raw concrete. Exposed concrete, left rough and unfinished, would become the defining trait of brutalism. So Banham, with his weakness for feeble wordplay, linked brutality with concrete, even though there had been concrete structures since the Romans, most of them pacific. The shared etymology of brut and brutal was unfortunate. Monoglot opponents of brutalist buildings – knowing nothing of béton brut and apprised only of the English component, brutal – were handed the ammunition of what seems like a boast of culpable aggression. Or maybe not: the French, to whom the pun was clear, have been no more appreciative of their brutalist buildings than the English.

Cité Radieuse

Before World War II, Le Corbusier's work was sleek, smooth, right-angled, rational. Post-war, he led the reaction against such architecture: he dumped a technical manual in favour of ecstatic poetry. Unité d'Habitation in Marseille, aka Cité Radieuse, was the first of his exercises in sculptural and plastic moulded concrete which, in spirit if not style, have affinities with the primitivist tendency of the arts and crafts. L'Unité gave the word brutalism a meaning. Le Corbusier ripped off countless other artists and architects, notably Fernand Léger, Pablo Picasso and most importantly Friedrich Tamms. Indeed, his later oeuvre can be viewed as a synthesis of thefts. Le Corbusier never applied the word brutalist to his own work.

Dystopia

Brutalism is the decor of dystopian films, literature and comics, just as gothic is for horror. See Alphaville, A Clockwork Orange, Blade Runner, Get Carter, La Haine. Books and films have of course impinged on the way brutalist buildings have been judged down the years, assisting in their condemnation.

Expressionism

Brutalism, as Nikolaus Pevsner pointed out with some distaste, had its roots in expressionism, the jagged, often counter-intuitive, mostly brick idiom that flourished in the Netherlands, Germany and the Baltic states from 1910 to 1930. Its greatest exponent was Michel de Klerk, whose social housing projects in Amsterdam retain, a century after they were made, a beguiling freshness. Its kitschiest exponent was Bernhard Hoetger. His Böttcherstrasse in Bremen, a street 100m long, was commissioned by the inventor of decaffeinated coffee, Ludwig Roselius, who dedicated it to Adolf Hitler. At the 1936 Nuremberg Rally, Hitler showed his gratitude by declaring it decadent.

Förderer

Vatican II was a godsend to architects. The Roman Catholic church was a generous, adventurous patron, and its buildings were to be advertisements for the church's newfound modernity. With few functional demands to take into consideration, architects enjoyed carte blanche. God can, apparently, live anywhere – and in the 1960s, he shared the widespread taste for open-plan spaces and theatre-in-the-round. The boundary between architecture and sculpture, which Le Corbusier had broached, was now comprehensively trampled. The architects who most took advantage of this were Walter Förderer in Switzerland and Germany, Gottfried Böhm in and around Cologne, and Fritz Wotruba in Vienna. Their work defines brutalism. It is accretive, ostentatious, hyperbolic in its asymmetries and protracted voids, composed of parts that do not connect or are in a fragmentary state, dramatically vertiginous, geometrically farouche, extravagantly cantilevered, discomfiting, aggressive (in so far as an inanimate object can be aggressive). There is no desire to please with prettiness or even beauty. The reaction demanded is that of awe. The quality that the greatest brutalist buildings manifest is sublimity.

Geology

Brutalist architecture did not seek to represent geological formations. It sought to create buildings that matched such formations, even challenged them. Mankind could take on nature and win, could make its own yardangs and hoodoos. Half a century ago, mankind lorded it over the earth. The practices of being friendly to vegetables and minerals, and of granting rights to animals, were far in the future – though they had, of course, been de rigueur in Germany for 12 years, from the Nazis' seizure of power to their defeat.

H

To anyone under the age of 50, brutalism belongs to the age of their non-existence. It is something that happened in history, while postmodernism is still with us. But now, having ransacked all other dressing-up boxes, architects have gradually turned to brutalism for inspiration. The most prolific

Unité d'Habitation, Marseille, France. Le Corbusier

is Jürgen Mayer Hermann, who trades as J Mayer H. His border checkpoints and service stations in Georgia might, at first glance, be taken for works of the 1960s – they are uncompromising, assertive, convinced of the artist's right to impose his vision without consultation, without accommodating consensual taste.

Imperial College London

Sheppard Robson's magnificent hall of residence in South Kensington was finished in 1963 and demolished 42 years later. It is not shown on the practice's website. Nor are its slightly later and happily extant lecture halls at Brunel University. Are its current architects embarrassed by their predecessors' work? Uneasy about how potential clients might react? Imperial College has form in this area. Some professor of a 'discipline' called Sustainable Energy in Business defends the destruction of cooling towers thus: "You have to think: how much does this enhance the landscape compared to what else we could do if we weren't having to maintain the towers?" This is the very epitome of unreflective short-termism and a not-particularly-convincing justification for sanctioned vandalism.

Jasari

The School of Advanced Proxenetism, in Albania's capital Tirana, was designed by the late Nexhat Jasari, whose other works included soundproofed containers, experimental dungeons and the Presidential Bison Run.

Saint Mary's Cathedral, Tokyo, Japan. Kenzo Tange

Konstantinov

Skopje – in Macedonia, then the southernmost Federal Republic of Yugoslavia – was largely destroyed by an earthquake in July 1963. The masterplan for rebuilding the city was undertaken by the Japanese architect Kenzo Tange. Most of the actual buildings were designed by Yugoslav architects, among them Janko Konstantinov, whose post-office complex presages the wild and delirious spomenik memorials to the National Liberation War (ie World War II). President Tito commissioned scores of these futuristic melds of architecture and sculpture, some of which have been recorded by Belgian photographer Jan Kempenaers. Many, however, were destroyed during the 1990s civil wars. Konstantinov's work also presages the weirdly joyous style of the later years of the Soviet satellites, the Leonid Brezhnev Plays Las Vegas school of architecture. Much of this has been recorded by the French photographer Fréderic Chaubin.

Luder

The three finest works of British brutalism were designed by Rodney Gordon of the Owen Luder Partnership. They were: Eros House in Catford, London; the Tricorn in Portsmouth; and the Trinity in Gateshead. The first, a block of flats, is disfigured; the other two shopping centre and car park complexes have been destroyed in acts of petty-minded provincial vandalism. One can have nothing but contempt for the scum-of-the-earth councillors, blind planners and toady local journalists who conspired to effect the demolition of such masterpieces. One can only despair at the pusillanimous lack of support from wretched English Heritage. The dependably crass Prince of Wales, the man who sullied Dorset with his planned village Poundbury, described the Tricorn as "a mildewed lump of elephant droppings", a simile as vulgar as it is visually inept. No doubt his heritage industry toadies removed their tongues in order to chortle a moment's laughter. The critic Ian Nairn was on the money: "This great belly laugh of forms… the only thing that has been squandered is imagination." Gordon's imagination was indeed fecund, rich, untrammelled. It was haunted by Russian constructivism, crusader castles, Levantine skylines. But the paramount desire was to make an architecture that had not previously existed. There are as many ideas in a single Gordon building as there are in the entire careers of most architects. The seldom-photographed street level stuff at the Trinity left the observer with the sensation of being in the presence of genius. One thinks of the burning of books.

Monstrosity

In Britain, it took more than three-quarters of a century before high Victorian architecture began to be rehabilitated through the efforts of John Betjeman, Evelyn Waugh, etc. Their pleas went unheeded. They were reckoned to be perverse and mischievous. Thousands of 'monstrosities' were destroyed. The survivors are now widely valued, and lost ones are mourned. We have learned nothing. Half a century after brutalism's heyday, the term 'concrete monstrosity' trips readily off the tongues of the unseeing, the torpid, the incurious. Places are once again being architecturally cleansed in favour of timidity and insipidity.

New

Newness and change were bound to be for the better. When British prime minister Harold Macmillan announced in 1957 that "most of our people have never had it so good", some of our people were still living in caves (in the Severn Valley), and many had no bathrooms and shared outdoor toilets. Built along brutalist lines, new flats had all those amenities, plus central heating, and were welcomed by their occupants. Social-housing projects were not yet bins for sociopaths. But they would soon become so: if blocks are unguarded, if there are no janitors, if they are not maintained… You don't buy a car and never get it serviced.

Organisation Todt

The Nazis' civil-engineering arm, named after Fritz Todt, built motorways and arranged their surrounds in order to achieve minimal damage to the landscape. These animal-lovers were nothing if not green. From the outbreak of war, its work was almost entirely martial. After Todt's death in 1942, the OT was directed by Albert Speer. Its architects included Werner March, author of the 1936 Berlin Olympics stadium, and the startlingly prolific Friedrich Tamms, who created the designs for 60 different types of gun emplacement, bunkers, shelters, flak towers, U-boat bases, etc. Tamms was, arguably, the first brutalist. He revived the expressionism that the Nazis had proscribed. The forms he used were seldom functional. Rather, they employ the imagery of might – visors, chainmail fists, anthropomorphism and zoomorphism. They were terrifyingly graphic warnings to the people of occupied countries.

Parent

The church of Saint Bernadette in Nevers, France, consecrated in 1966, is the work of architect Claude Parent and theorist Paul Virilio. For some years, they had been studying the thousands of structures that comprise the Atlantic Wall, the

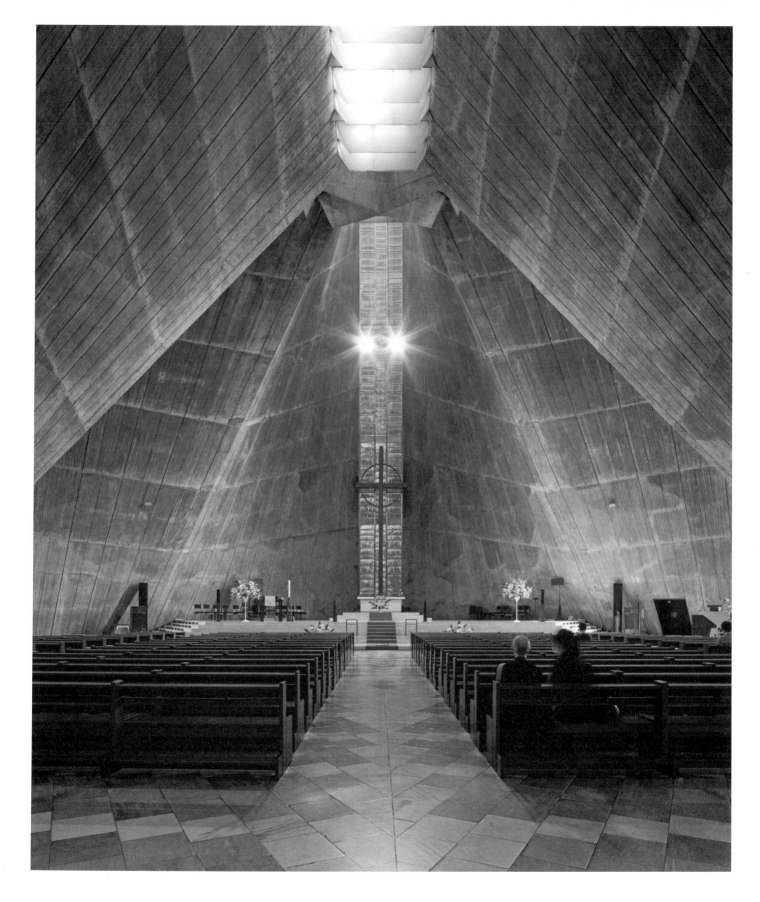

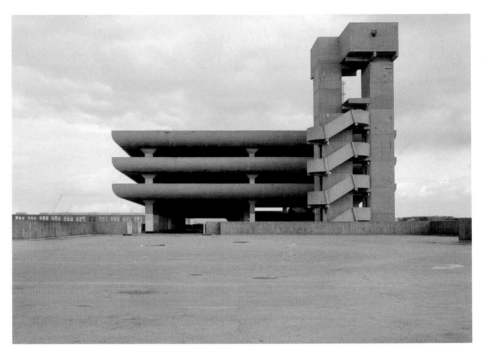

Tricorn Centre, Portsmouth,
England. Rodney Gordon

World's End Estate, London,
England. Eric Lyons

coastal fortifications built – by slave labour –
along the west of Europe from 1940-44. The
similarities between these structures and brutalist
architecture had been brushed under the carpet.
In their huge bunker-like church, Parent and
Virilio make the link explicit.

Quebec

Canada's most extreme examples of brutalism
are in Quebec City, which boasts Dimitri
Dimakopoulos's boorish Concorde Hotel; and
in Quebec Province, home to Moshe Safdie's
thrilling Habitat 67, a collision of 150 residential
units in Montreal that appear to teeter perilously.
The effect is both fragmented and monolithic:
a labyrinth made by termites with an eye for
right angles.

Robbins

The British Committee on Higher Education,
chaired by economist Lionel Robbins, sat from
1961-63. Its report recommended a massive
expansion of tertiary education. New universities
were to be built. Old universities and colleges
were to be extended. One reaction was Kingsley
Amis's observation that "more will mean worse".
Another was delight on the part of architects
who saw an incomparably rich gravy train
approaching. Denys Lasdun's University of East
Anglia is perhaps the finest of the lot. The Roger
Stevens building at Leeds – by Chamberlin,
Powell & Bon – is agreeably weird. One minor
nail, a drawing pin, in brutalism's coffin was its
rapid espousal by Harold Wilson's Labour

government, causing half-witted protest-kids
to identify it with repressive authority.

Soreq

Those protest-kids have no doubt directed
many howls of self-righteous anger at the Soreq
Nuclear Research Plant in Israel. The architect
was Philip Johnson who, in his long life (he lived
to 99 and never retired), had jumped on many
bandwagons and even started a few. One of this
creepy socialite's many enthusiasms was Hitler,
which makes an Israeli commission a matter of
wonder. While his brutalist buildings in the US
are as unconvincing as most of his oeuvre, this
temple to radiation on the dunes a few miles south
of Tel Aviv is impressive. Brutalism was the Cold
War's architectural mode, on both sides of the Iron
Curtain – Mutually Assured Construction.

Tange

Kenzo Tange's viscerally exhilarating Yamanashi
Broadcasting and Press Centre in the Japanese
city of Kofu is a vast machine that seems to be
missing vital parts. His Kuwait embassy in Tokyo
might have been assembled from several vaguely
similar extant buildings, while the Shizuoka
press centre is all cages attached to a stout pole.
Elsewhere, Tange hangs cantilevers at oblique
angles and creates buildings that look as if they are
in the process of collapsing.

Utzon

The Danish architect Jørn Utzon is celebrated for
the Sydney Opera House. His essays in brutalism

were failures, tentative and timid. Indeed, this was an idiom for which Scandinavians seemed to have had no stomach. A tragic lack of insensitivity and an excess of rationality no doubt militated against its adoption.

Vanbrugh

The proto-brutalist John Vanbrugh's buildings were widely lambasted while he was still alive. Blenheim was described as "a quarry". When he died, the Reverend Abel Evans famously wrote: "Lay heavy on him earth/ For he laid many a heavy a load on thee."

World's End

This estate of seven London towers, between King's Road and the Embankment, was designed by Jim Cadbury-Brown and Eric Lyons. More than any other London scheme, it demonstrates brutalism's debt to expressionism, explicitly that of Hamburg and Bremen. It is restless, angular, red brick, complicated.

X

Team X was a loose grouping of youngish architects, manifesto folk, who in 1953 broke with CIAM (Congrès International d'Architecture Moderne) to pursue a less rational architecture – in other words, they had understood the prevailing change of mood. The group included Le Corbusier's collaborators Shadrach Woods and Georges Candilis, who had been instrumental in changing that mood, and the Smithsons. In Rachel Cooke's book Her Brilliant Career, there is a photograph of the teenage Alison Smithson. At first glance, it appears to be Kevin Rowland in Dexy's ragamuffin period. This is worrying.

Yale

Paul Rudolph began his career, in Florida, by designing light and airy houses, mostly of modular construction. He moved from these chamber pieces to full-blown and very noisy symphonies: massive, lumbering, sullen campus buildings that manifest a spectacular indifference to what anyone thinks of them. This is sod-you-ism at its most stubborn. One is obviously led to think of clumsy robots sodomising each other. Rudolph was dean of Yale's architecture school and author of that faculty's building. Among his pupils were Richard Rogers and Norman Foster. Photoshop Rogers's Lloyds building and render it as though it were built of concrete.

Zapotec

During the 1920s, there was a California craze for neo-Mayan architecture or, more precisely, exterior decoration. The pre-Columbian modes that attracted attention in the 1960s were the Zapotec and the Inca: massive, bold, cyclopean, devoted to 45° slopes. Where building ends and natural formations begin is often moot.

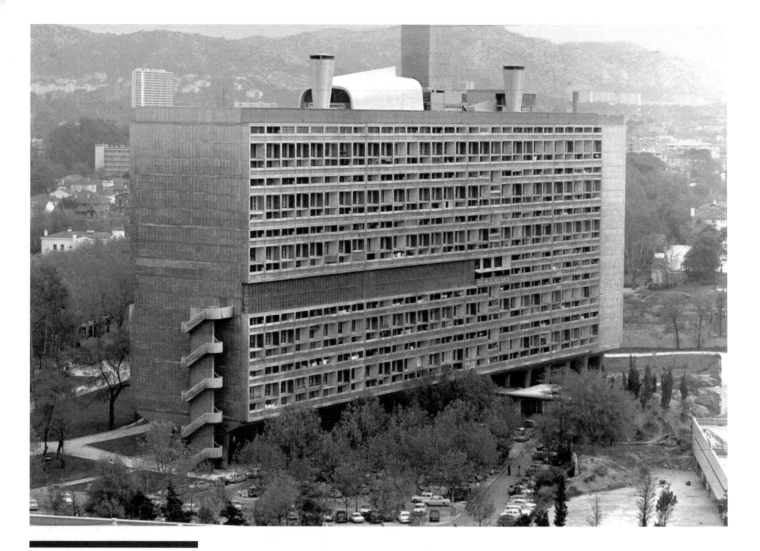

01

Unité d'Habitation

Marseille

France

1952

Le Corbusier

Housing

Countless pilgrimages were made here to one of Marseille's less dodgy districts by architects who wanted to rip-off... sorry, 'be inspired by' Corbusier's communal classic. Just think of the pilotis! The brises soleil! The portes-cochère! Architects even stole the ideas for things that didn't sound quite so exotic. The corridors of Unité d'Habitation (aka La Cité Radieuse) are rather dark and the retail floor sliced through the middle doesn't exactly buzz, but there's a good reason flats here are still wanted – and the finishing touches (like the Mondrian primary-coloured balconies) certainly help. The best details of all are at the bottom (the fat elephant legs the whole thing is jacked up on), and the top: the roof used to be for sport and the kids, but is now an art gallery (p20). The best art is, of course, the building itself, goading us, and flaunting the magnificent Mediterranean views from up on its Mistral-swept top deck. The sculptural bravado of the gym itself, the kindergarten, the paddling pool and the chimneys are the icing on top of this cake.

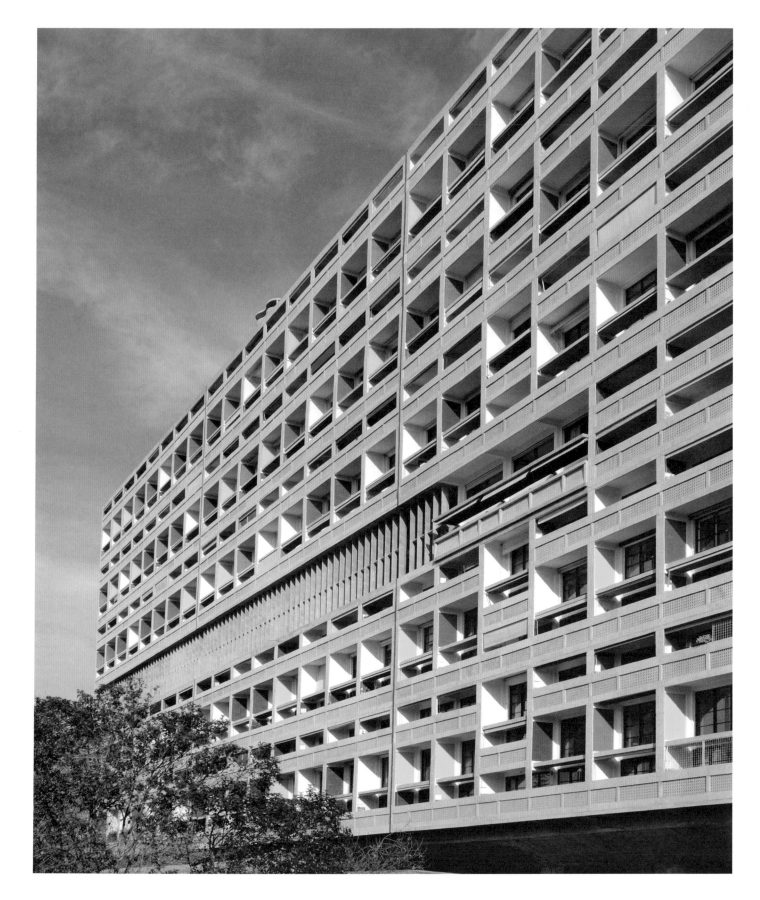

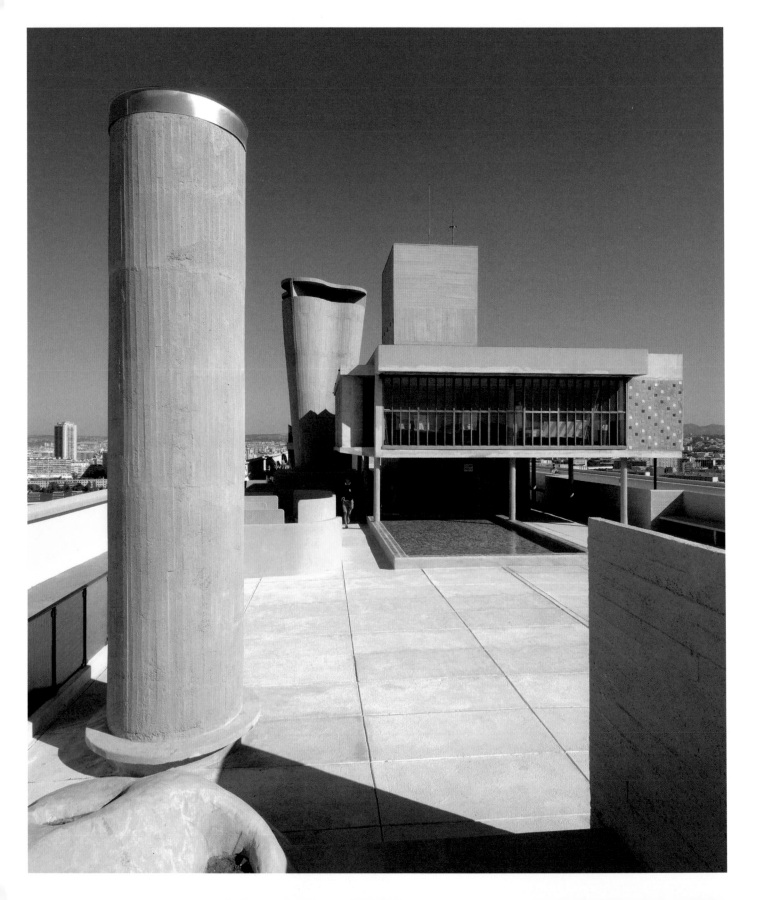

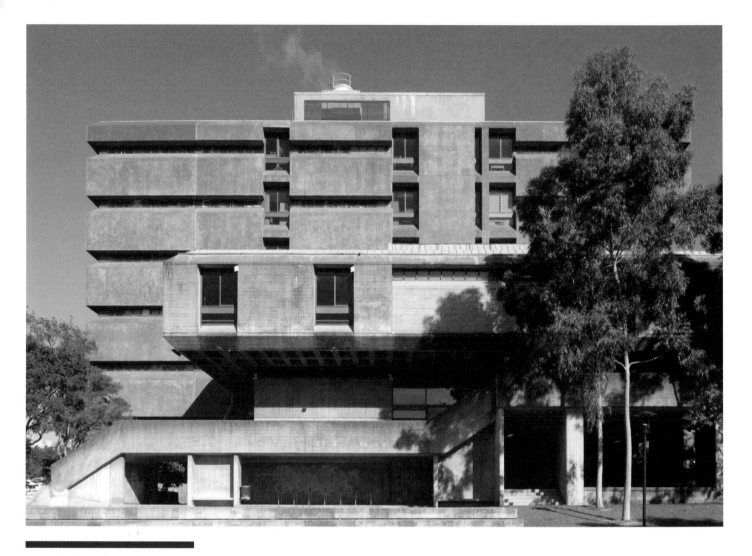

02

Sydney's energising cityscape is crawling with brutalist bugs of all shapes and sizes. The pick of the bunch is the School of Molecular Bioscience & Biochemistry at Sydney University. Set in green parkland in Darlington, the school combines a grumpy frontage with a dizzying array of steps, walkways and levels, and concrete seemingly mixed with Shredded Wheat. It seems oddly suited to the scientific experiments that take place within. Hardly anyone knows about this building – probably because it landed in the same year as Jørn Utzon's Sydney Opera House, and was totally eclipsed by it. A few steps away is Ken Woolley's Wentworth Student Union Building, which is a potent gatehouse to the university campus. While in Surry Hills there's John James's Reader's Digest Building – a chummy combination of offices, printing house and warehouse clinging to a slope in a leafy backstreet. And in the city's Central Business District there's Sydney's old Law School – a chunky corner block that seems dignified among its much older neighbours.

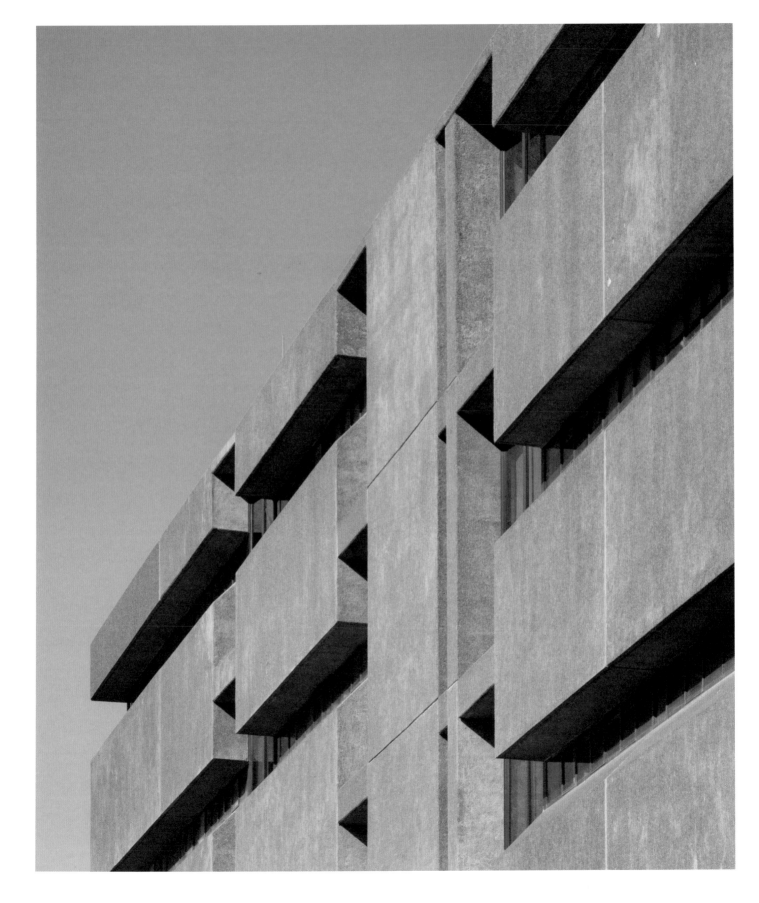

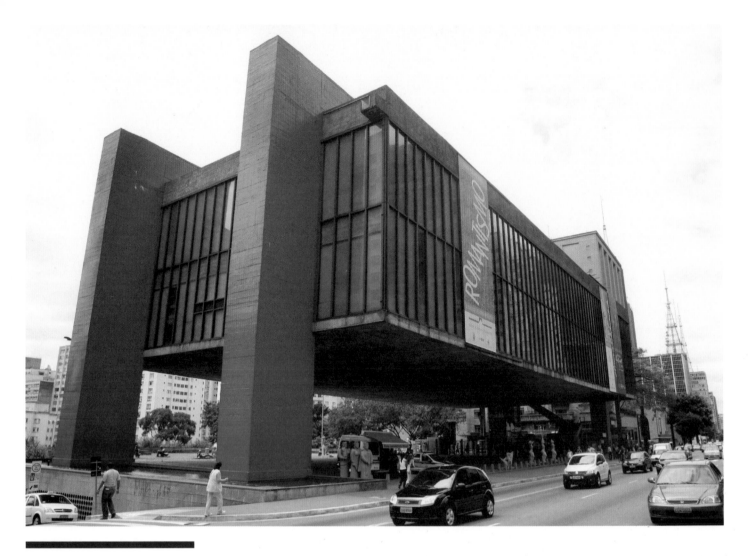

03

MASP (Museum of Art São Paulo)	SESC Pompéia
São Paulo	São Paulo
Brazil	Brazil
1968	1977
Lina Bo Bardi	Lina Bo Bardi
Art gallery	Leisure/culture

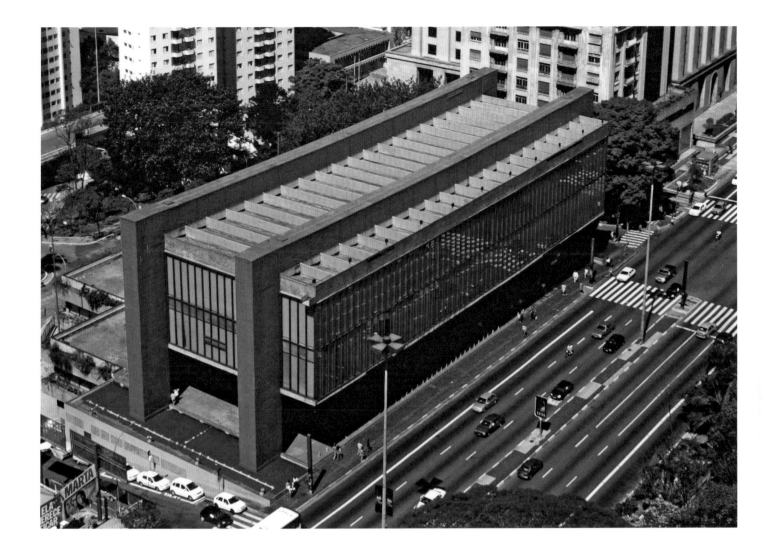

There aren't enough women's names in this book. Because there simply weren't enough female architects. But one female name that sticks out – and rightly so – is Lina Bo Bardi. Italian-born, she later fell for Brazil – and specifically São Paulo, the country's beating commercial heart and home of Oscar Niemeyer's huge and affecting Edifício Copan. Bo Bardi's building for the city's Museum of Art also packs a punch. Lined up hard against Avenida Paulista, the entire thing is supported on two pairs of what appear like parallel bars – the kind found in a gymnasium – made of Lego. They're red, the gallery box is muddy brown. Underneath is a huge and mysterious space that people gently avoid, as if it's sacred. Lina went on to whip up something else for the people – the SESC Pompéia Factory Leisure Centre (overleaf), a fun palace which featured things like sports courts and a theatre, and those precipitous walkways flying through the air. The whole thing is big, mean and muscly. And communal, too. Lina died in 1992 in the house she built for her and her architect husband Pietro Maria.

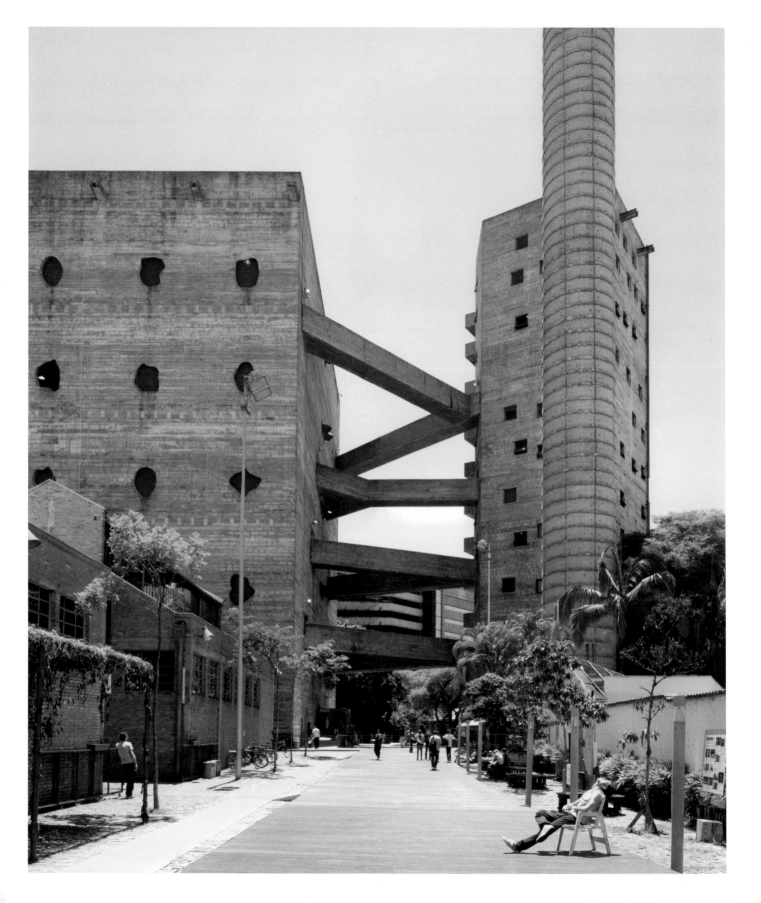

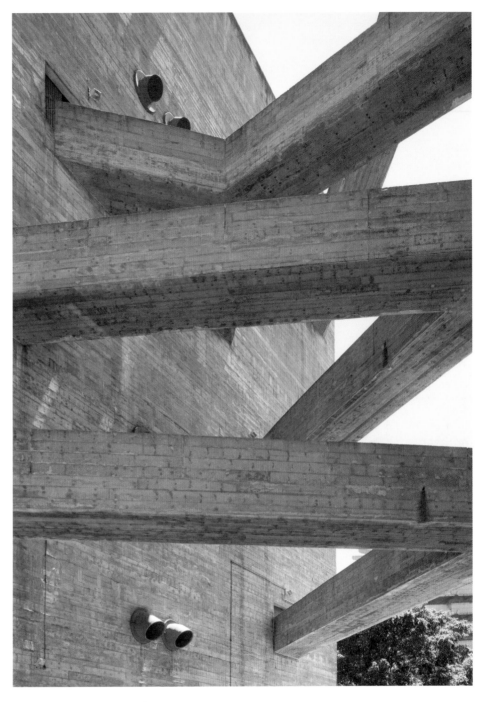

SESC Pompéia, São Paulo, Brazil.
Lina Bo Bardi

SESC Pompéia, São Paulo, Brazil.
Lina Bo Bardi

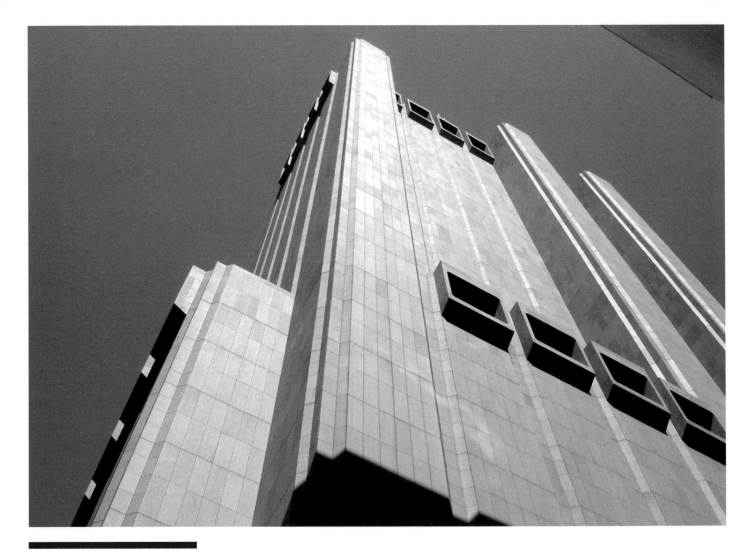

04

33 Thomas Street
(formerly AT&T Long Lines Building)

New York City

USA

1974

John Carl Warnecke

Telecommunications

It's rare to see 29-storey skyscrapers without windows, which is why this oddball is worth seeking out. In the midst of gentrified Tribeca streets, it announces itself as an unsettling concrete cliff. The tallest blank wall in the world? It certainly could be. There are strange square portal details halfway up and at the top which break up the monotony, and the oddly shiny surface could almost make you believe that it's some kind of Planet of The Apes-esque spiritual totem. What future generations will make of a ruin so mysterious is anyone's guess. If they can't locate the information about this tower being built by AT&T as a 'Long Lines Center' – a kind of vast automated telephone exchange – then they might be well and truly flummoxed. Even today, although not confirmed, the building is supposed to house telecommunications equipment and servers. It's secure and apparently bombproof. You can't go inside of course but you can wander along Thomas Street trying to fathom the enigma. What's inside? With no windows, it's an intriguing game to play.

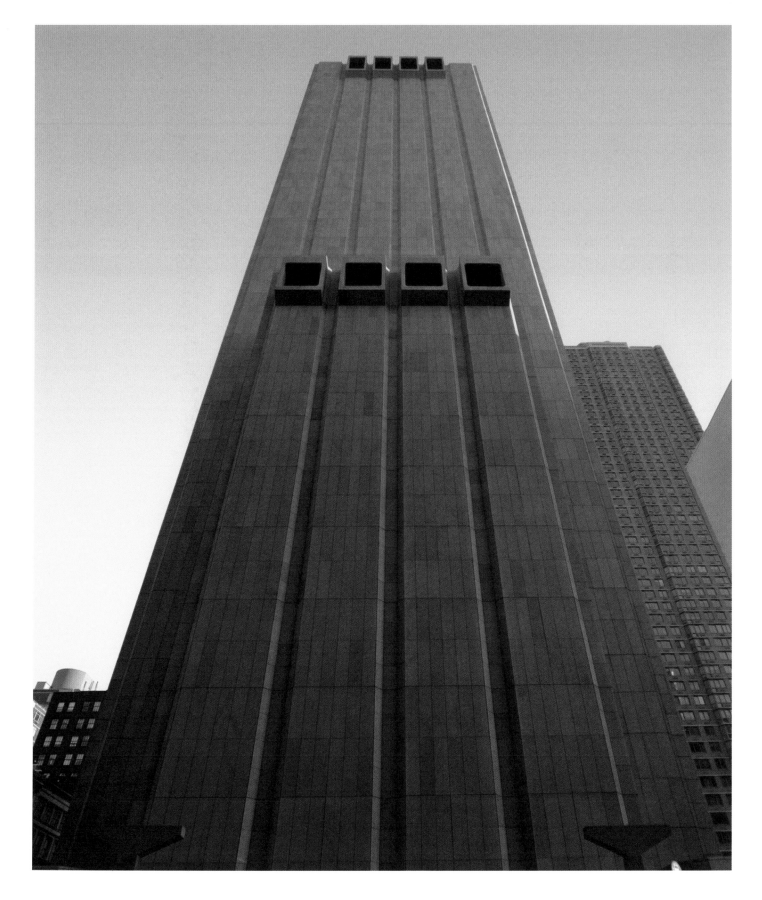

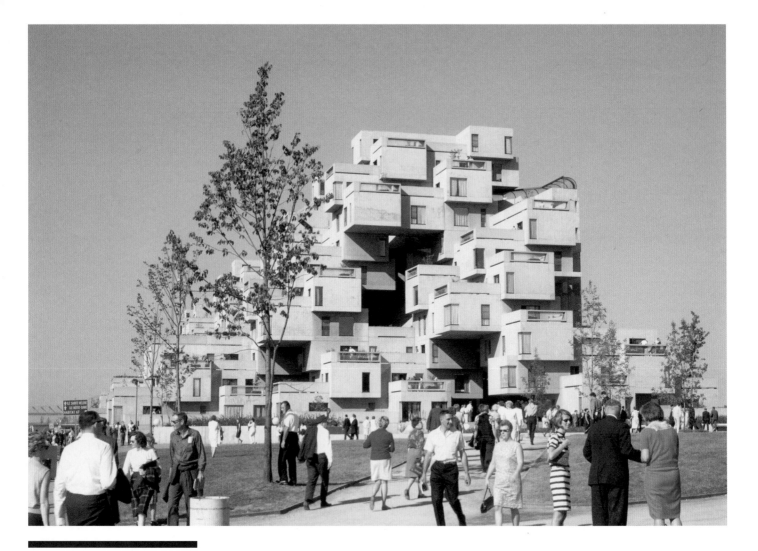

05

Habitat 67

Montreal

Canada

1967

Moshe Safdie

Housing

Cycling out on to the windswept finger of land that juts up into the St Laurent River in Montreal, you get a real eyeful. On one side, the enormous concrete grain silos where prairie wheat was stored. On the other, artificial hills of housing that look futuristic and elegant, even today. Habitat 67 was a centrepiece of the Montreal Expo in 1967, a fair which featured a glut of gutsy architectural boasts by Buckminster Fuller and Basil Spence. Moshe Safdie recently told *Clog* magazine that he was "appalled" when he first saw Le Corbusier's Unite d'Habitation (p18),

and wasn't interested in "the aesthetic of brutalism – rough concrete with rough formwork". Instead he stacked flats up like cardboard boxes and tried to create a desirable and flexible environment. That seems to have worked because today's Habitat 67 homeowners are allowed to knock through walls and create bigger units. Many have. The walkways and roof gardens mean residents interact with the well-regarded building, seeing it from many different angles. And the views across to Montreal's city centre are a draw, too.

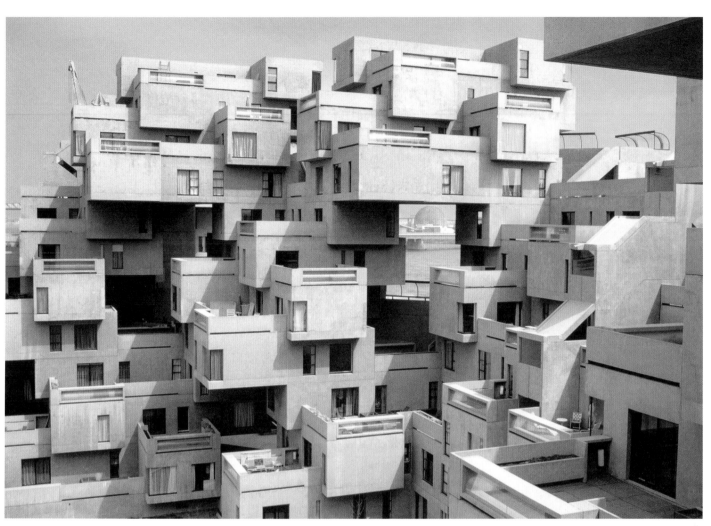

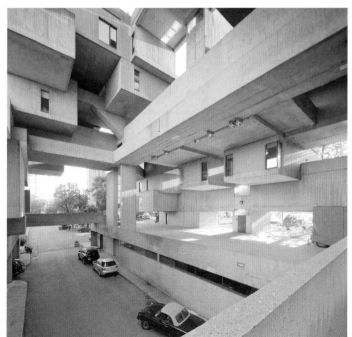

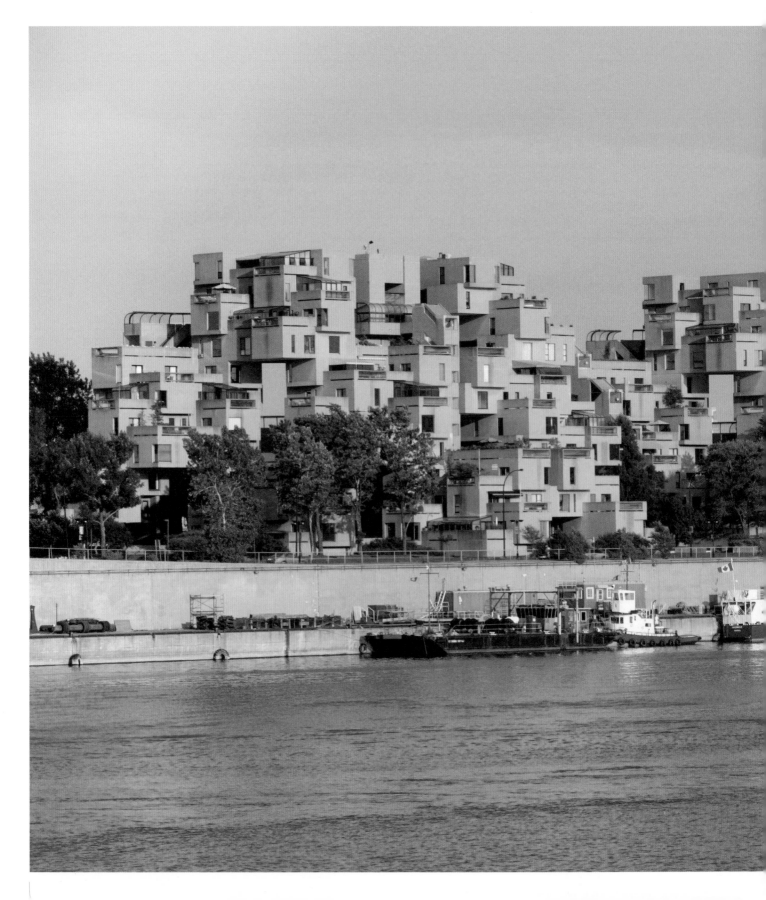

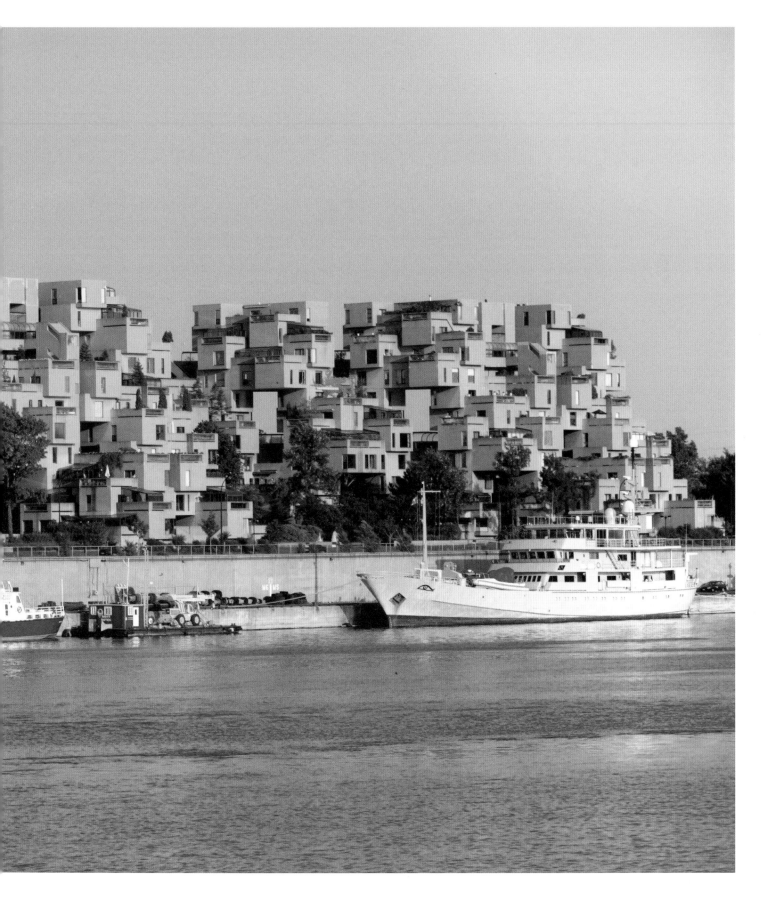

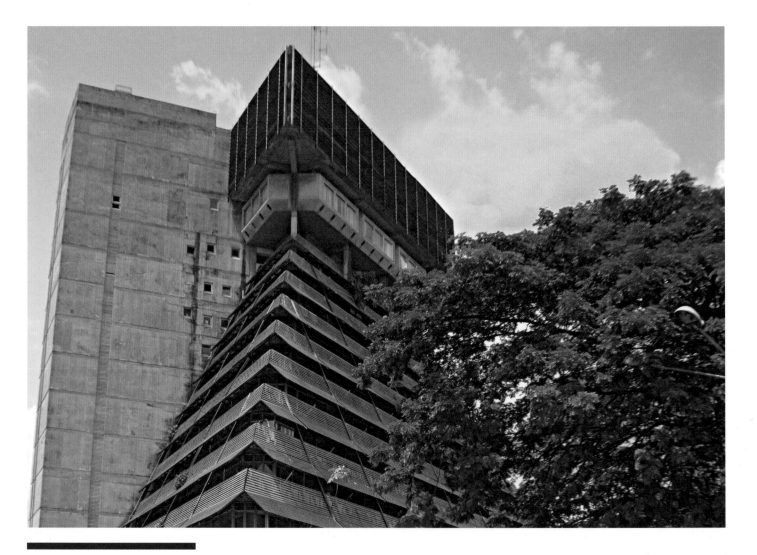

06

La Pyramide

Abidjan

Ivory Coast

1973

Rinaldo Olivieri

Retail/commercial

What are we supposed to make of a building like La Pyramide? Maybe the whole point of brutalism is that quite often there simply aren't easy answers to fundamental questions, those to which conventional architecture can toss off responses in a second. Questions like: "where's the bloody door?" or "what the hell is this thing for?" With brutalism... well, you need to do some research. But at least it all makes you think, linger, consider. The Italian Rinaldo Olivieri's complex construction in the Plateau district of the Ivory Coast's capital Abidjan certainly seems marginalised in some senses. It's been squatted, it was partially burnt down in 2015, and it has had to endure all kinds of craziness as this former French colony has lurched from boomtown to civil war backdrop. But it's endured. It's in the shape of our old friend the ziggurat and as well as the shops that are clearly visible from the outside, it contains a supermarket, a car park, offices and even a nightclub. Quite what it adds to Sub-Saharan Africa is a moot point. Mad but bold.

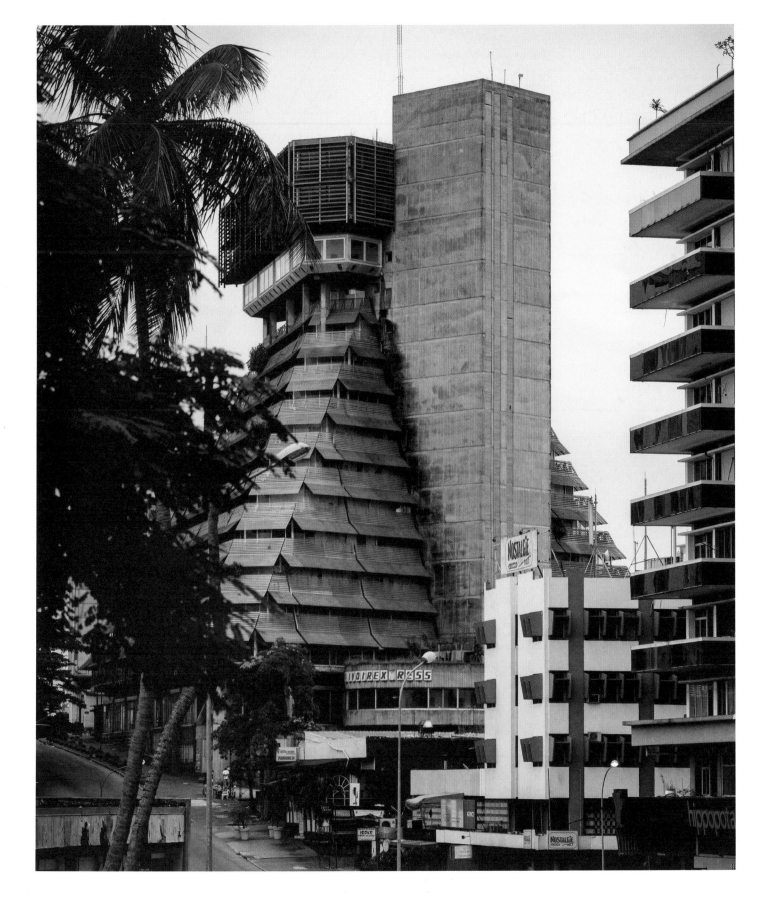

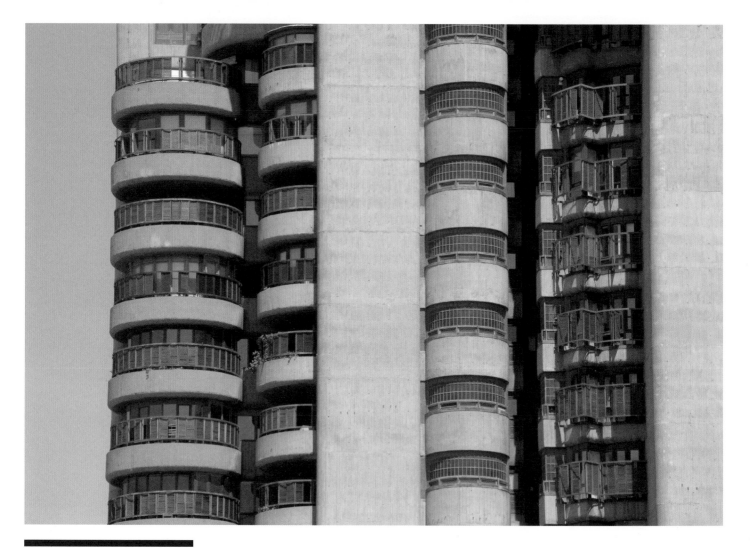

07

Torres Blancas

Madrid

Spain

1968

Francisco Javier Sáenz de Oiza

Housing

Madrid isn't short of concrete colossi – which is no surprise as Spain's capital has previous pedigree when it comes to building brash. There's the thumping brutalist Correos (post office), the former British Embassy (which is now housing) and Fernando Higueras and Rafael Moneo's Instituto del Patrimonio Cultural de España (a cultural centre oddly only finished 20 years after the original planned completion date of 1970) – the latter two are both circular, brazen, and jar pleasingly with the predominance of wedding cake architecture

in the city. The most uncompromising modern Madrid landmark though is the Torres Blancas (in real life, grey, not white). And this building too displays both a megalomania and an obsession with circles. An apartment block rising above Avenida de Americas, Francisco Javier Sáenz de Oiza's intriguing essay in sky-high living takes a little from Goldberg's Marina City model (p78) – but here the whole is irregular and asymmetrical; the tops of the tower (two were planned, only one built) are like flying saucers frozen in time.

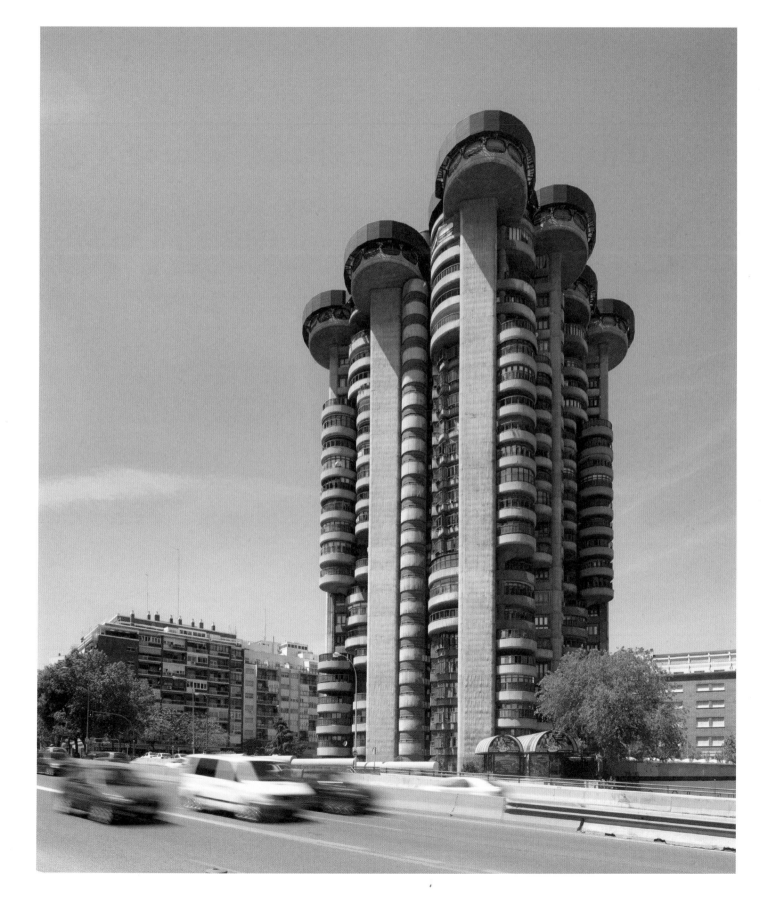

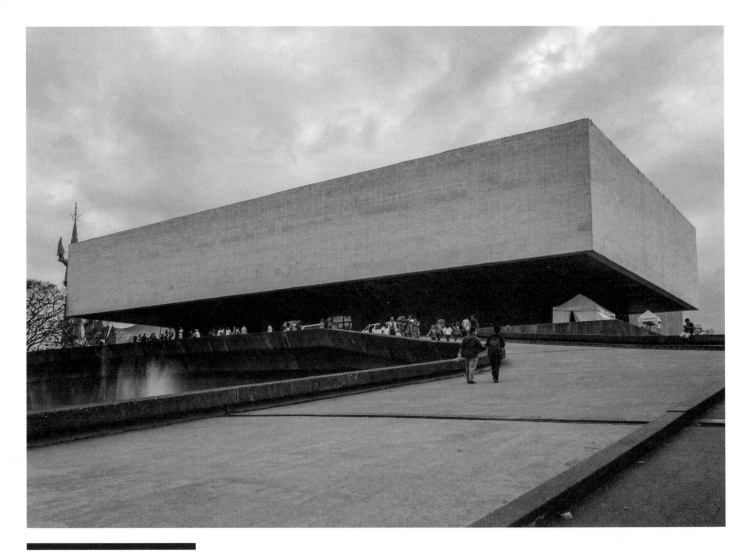

08

Cultural Center of The Philippines

Manila

The Philippines

1969

Leandro Locsin

Culture

It's apt that the CCP resembles a supersized shoebox dumped on a pedestal – because the brains behind this tawdry business was notorious calceophile Imelda Marcos, the Lady Macbeth of the Philippines. Brutalism might have been the visual allegory of the benevolent state in the West, but was equally adept at roughing up 'refined' taste as the house style of assorted crackpots, dictators and men (or women) 'of the people' worldwide. So this was, you'd probably say, a vanity project par excellence – a chance to show off Filipino culture but also to show who was boss. The enormity and quiet, yet obvious confidence of that huge box contrasted with the Whicker's World chandeliers and champagne lifestyle that went on within, as a lucky elite caroused while the Filipino poor had rather less elaborate evenings. The local architect Leandro Locsin – who spent time in the US, the Philippines' former colonial power – built several more bolshy boxes across the country, including the Philippine International Conference Centre, just across the road.

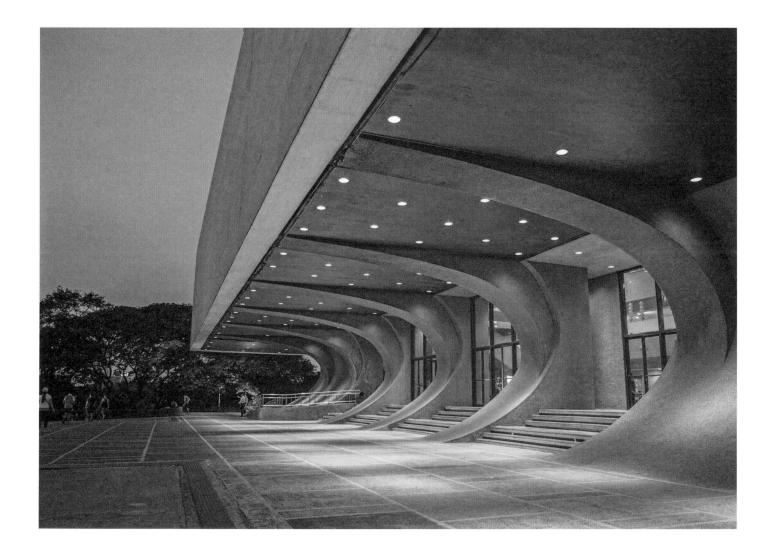

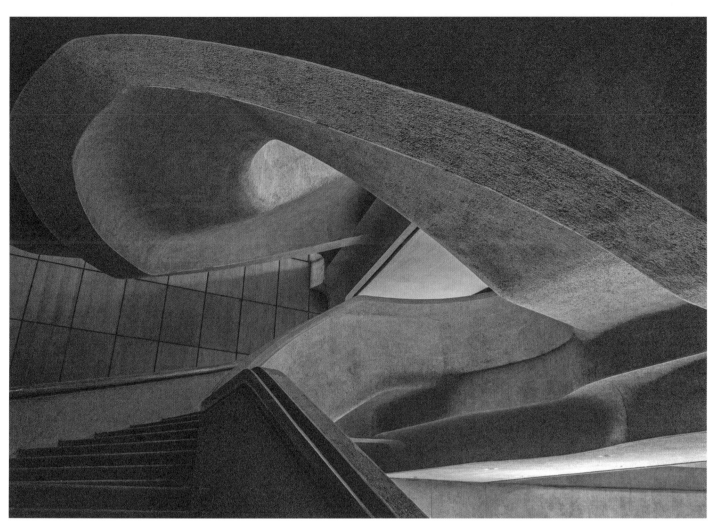

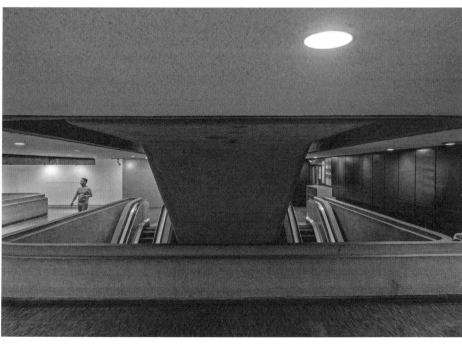

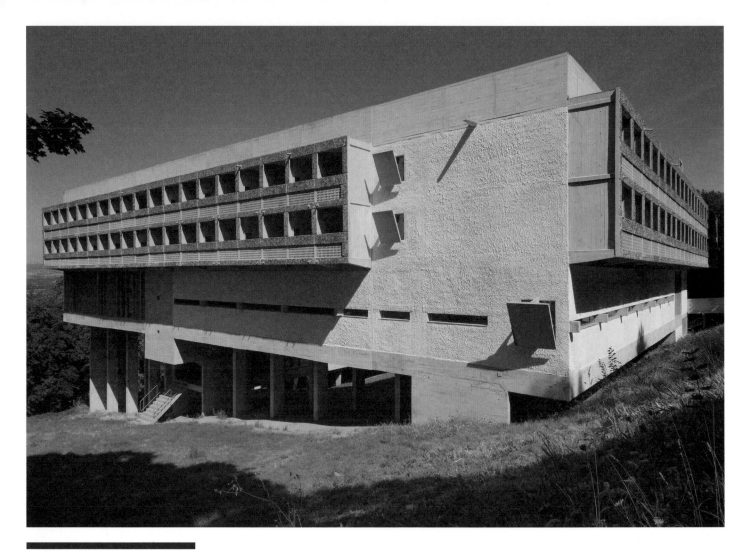

09

Couvent Sainte-Marie de La Tourette

Eveux

France

1959

Le Corbusier and Iannis Xenakis

Monastery

If brutalism was primarily about human dominance of the earth, of building something sublime from a manmade material, then here's an edifice that has a laugh with that concept. The intensely urban experience of raw concrete encasing a space is transposed to a steep, green French hill. The result is a dramatic interplay between countryside and concrete convent perched up on pilotis. The first proper head-turning moment happens in the Lower Chapel, where priests say their prayers. Red, white and yellow beams laser down from angled skylights, bathing the visitor in a brilliant light, illuminating the darkness. It's a moving experience but not necessarily a spiritual one. This is God's house, but the overwhelming feeling is that it is great art that is really making your hairs stand on end, not the presence of an imagined deity. It's intoxicating down there, all right. The other feature that demands attention is Iannis Xenakis's jaunty windows framing views, views that are differently shaped depending on the window panel. People say this is a serious building but it's actually lighter than that.

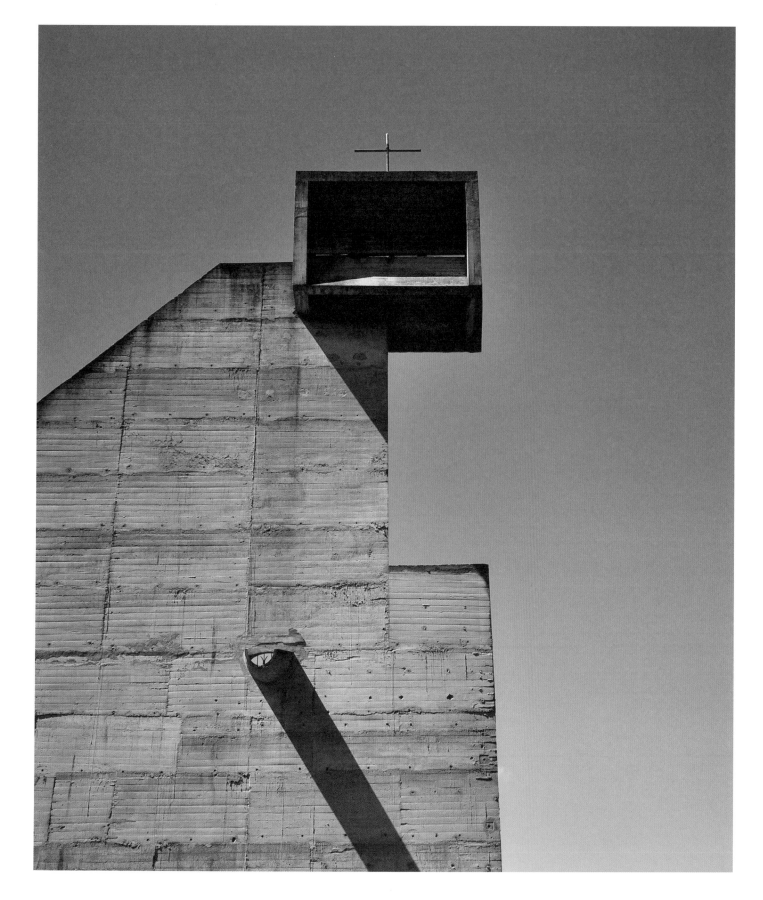

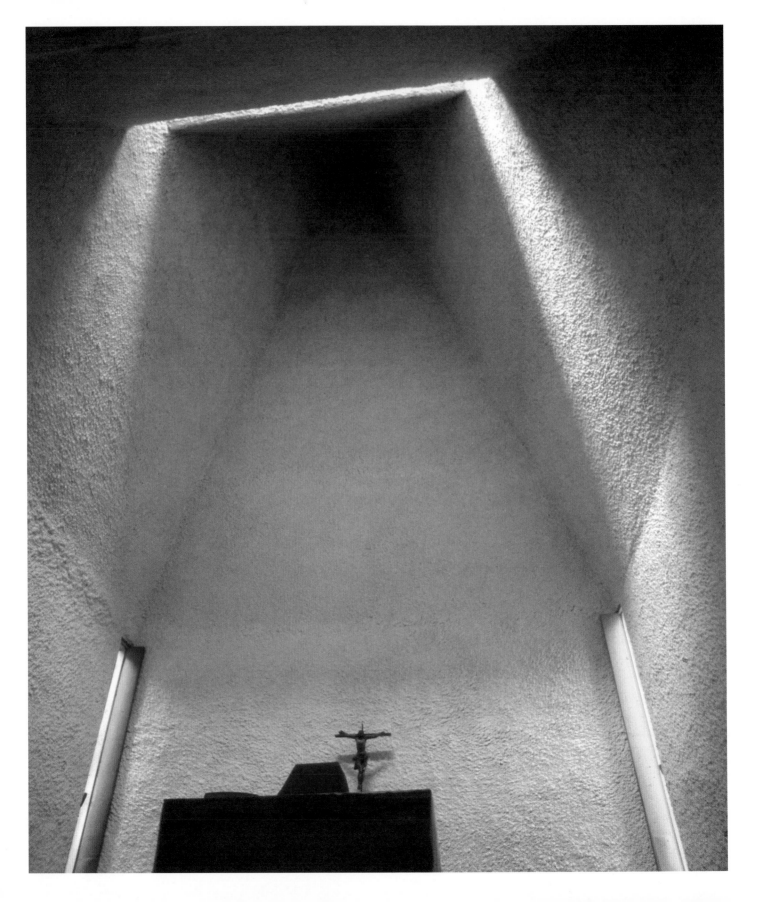

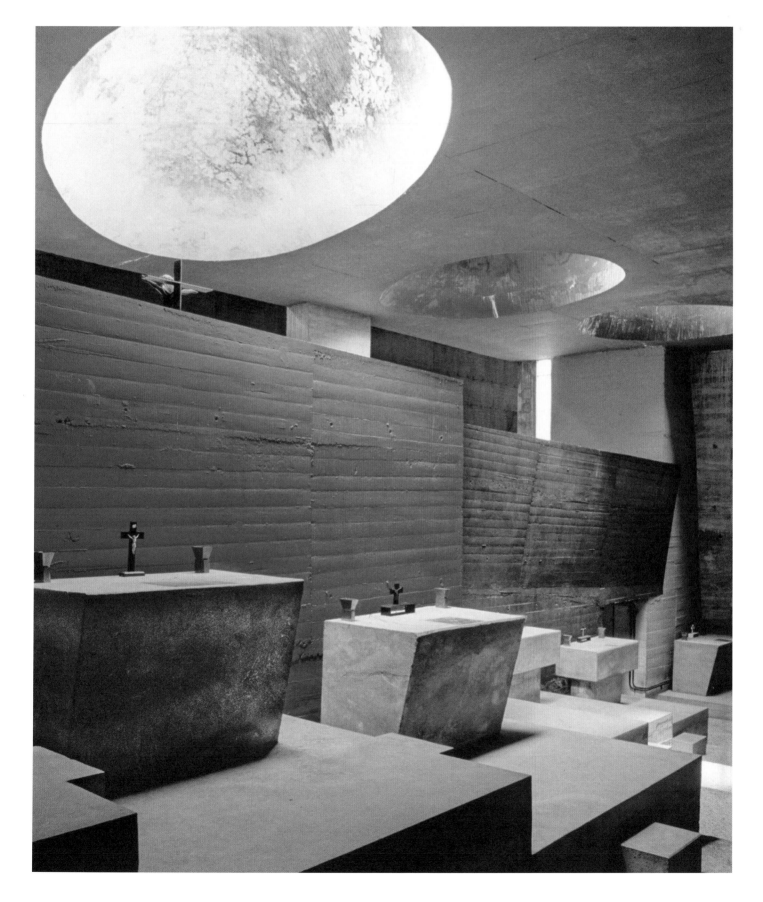

10

Nathan Phillips Square and Toronto City Hall

Toronto

Canada

1965

Viljo Revell

City government/leisure

Brutalism birthed intriguing public spaces. Some of these plazas might have become windswept later on, but they were designed with the best of intentions. In front of Toronto's sober City Hall is Nathan Phillips Square, laid out for citizens to frolic in with a pool, lively concrete arches, a Henry Moore sculpture and a lavish walkway running all around its edges. The skating rink that pops up on top of the pool in the bitter Ontario winters raises a smile; in summer office workers eat salads here. Toronto has other interesting public spaces too – its underground city isn't as famous as Montreal's but gives protection from January chills. It's a strange but viable zone beneath the streets. And out at the University of Toronto, Scarborough, John Andrews (who also designed the city's enormous CN Tower) conducted his own experiments: the result was an academic superstructure for students, complete with squares and plazas and split levels, extra-long buildings and a grandiose feel. People use all these spaces today – they've become normalised parts of the evolving city.

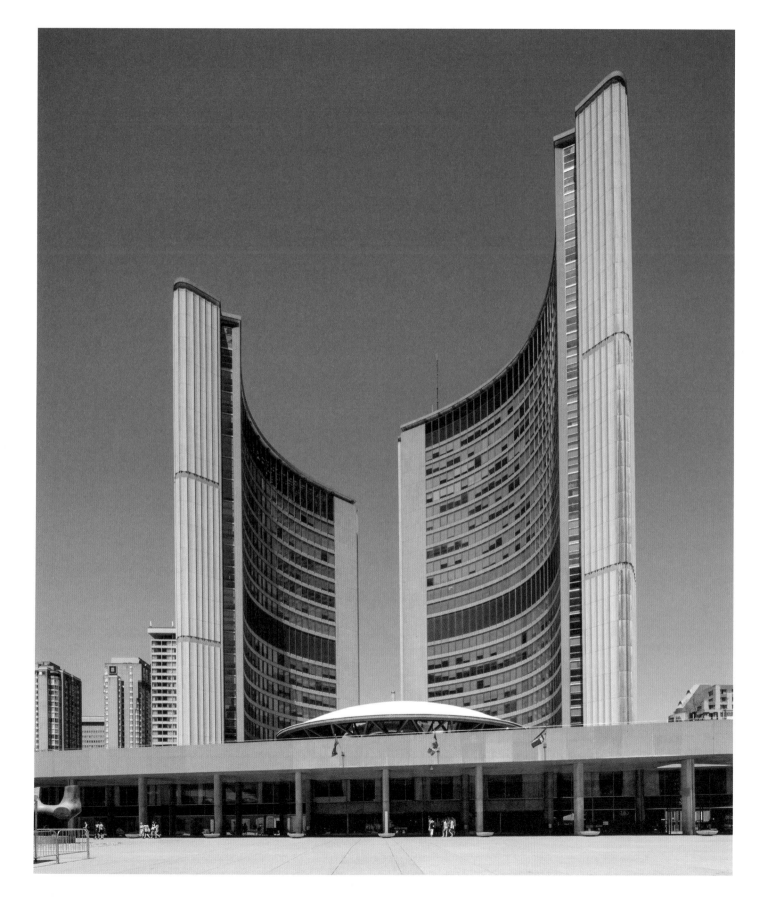

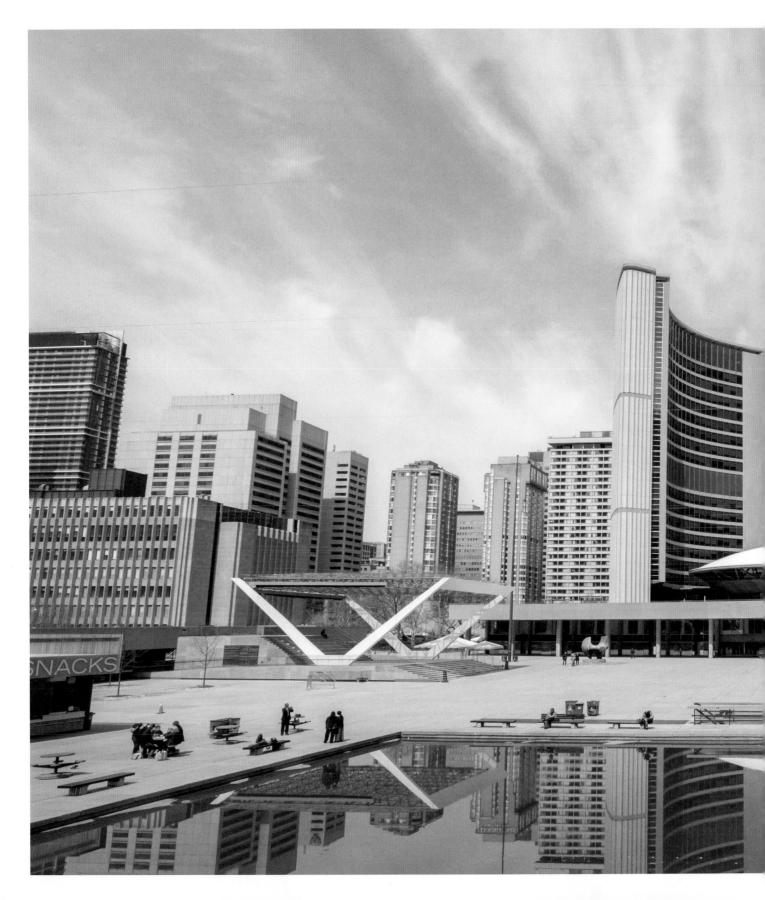

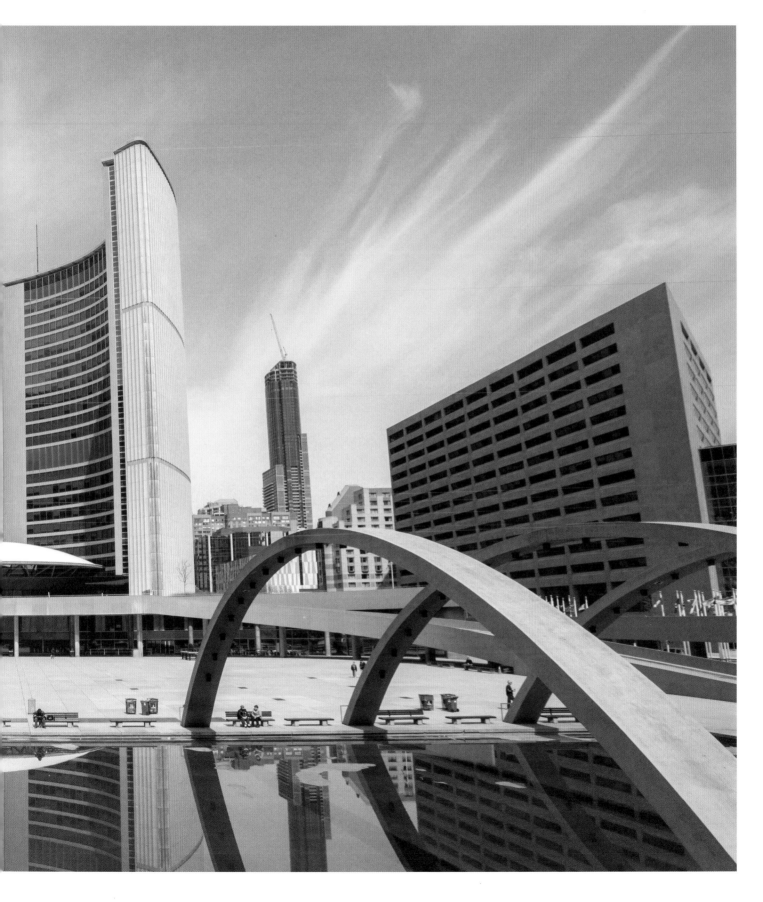

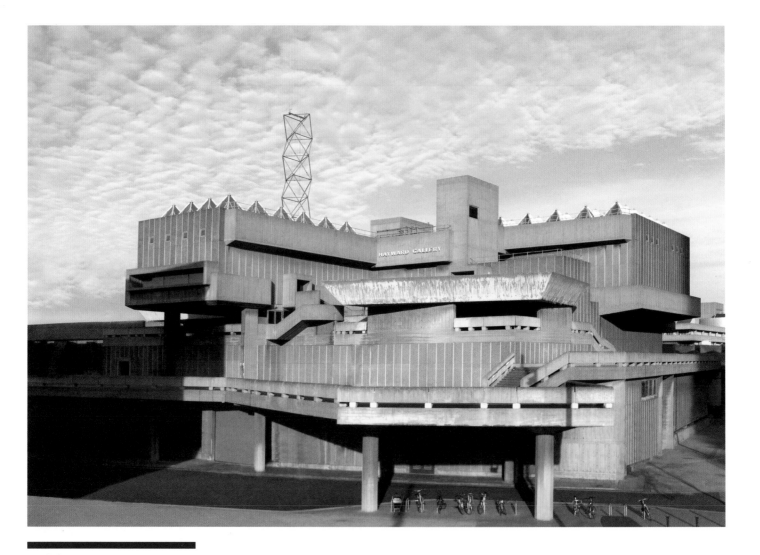

11

Hayward Gallery	**Queen Elizabeth Hall**	**National Theatre**
London	London	London
England	England	England
1967	1967	1975
Hubert Bennett, Norman Engleback,	Hubert Bennett, Jack Whittle,	Denys Lasdun
Ron Herron, Warren Chalk for LCC	FG West, Geoffrey Horsefal for LCC	Theatre
Art gallery	Culture	

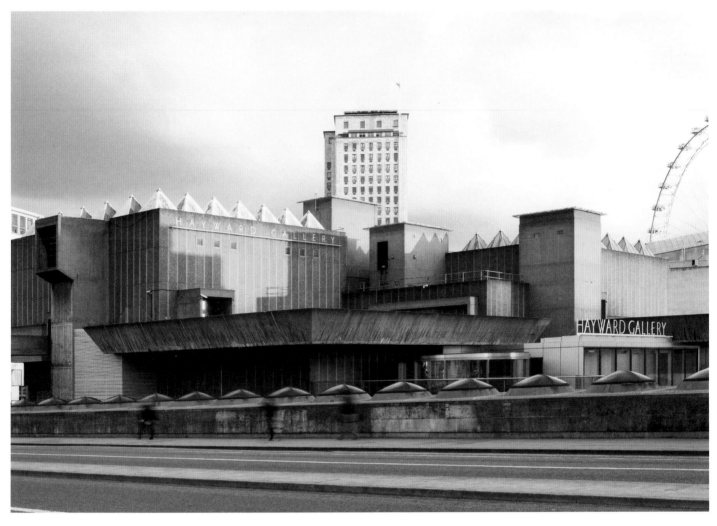

Hayward Gallery, London, England.
Hubert Bennett, Norman Engleback,
Ron Herron, Warren Chalk for LCC

Three buildings challenge lovers of art, music and theatre on London's South Bank, where the capital's high arts settle by the Thames. Denys Lasdun's National Theatre is suave and smooth. The theatres themselves work well and the public areas both inside and out are always full and friendly. The river terraces offer serene views of the capital's rather older monuments. Lasdun was the acceptable face of brutalism and controversy hasn't dogged his building the way it has our other two contenders. The Queen Elizabeth Hall is much more muscular, it makes a racket. Apt, as so do musicians performing inside its hall. Its public spaces are more complex: the undercroft has become a haven for skateboarders, while the formerly off-limits roof now features a café. The Hayward is a thrill ride. It appears as a curious cartoon monster; a spiky-headed Jean-Michel Basquiat doodle in three dimensions. The walkways and level shifts between the Hayward and the QEH create fascinating, and sometimes baffling, walks, spaces and views. These are three modern landmarks of London.

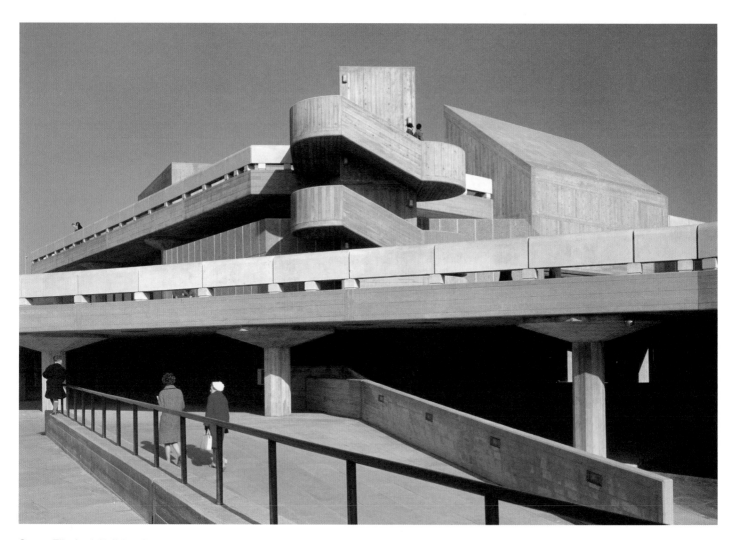

Queen Elizabeth Hall, London,
England. Hubert Bennett, Jack
Whittle, FG West, Geoffrey
Horsefal for LCC

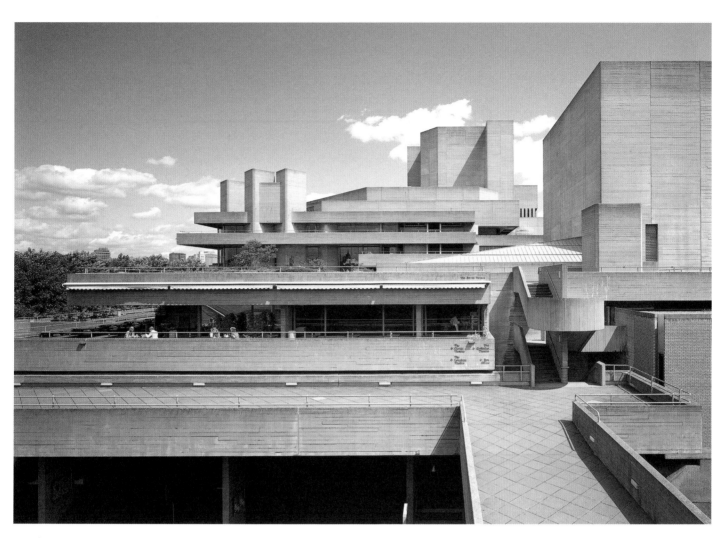

National Theatre, London, England.
Denys Lasdun

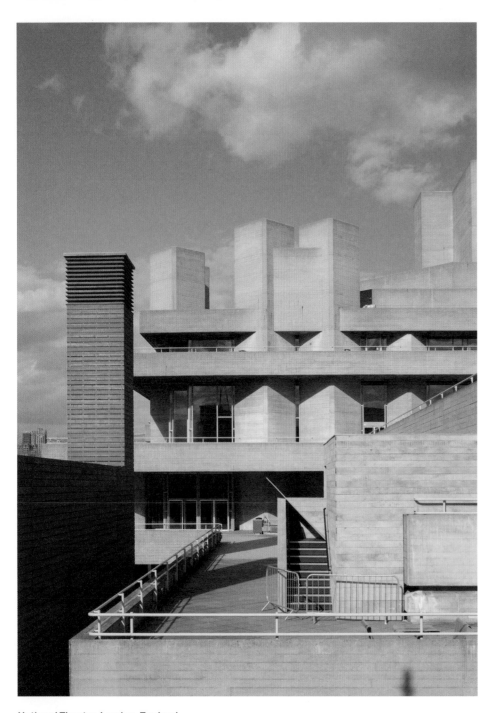

National Theatre, London, England.
Denys Lasdun

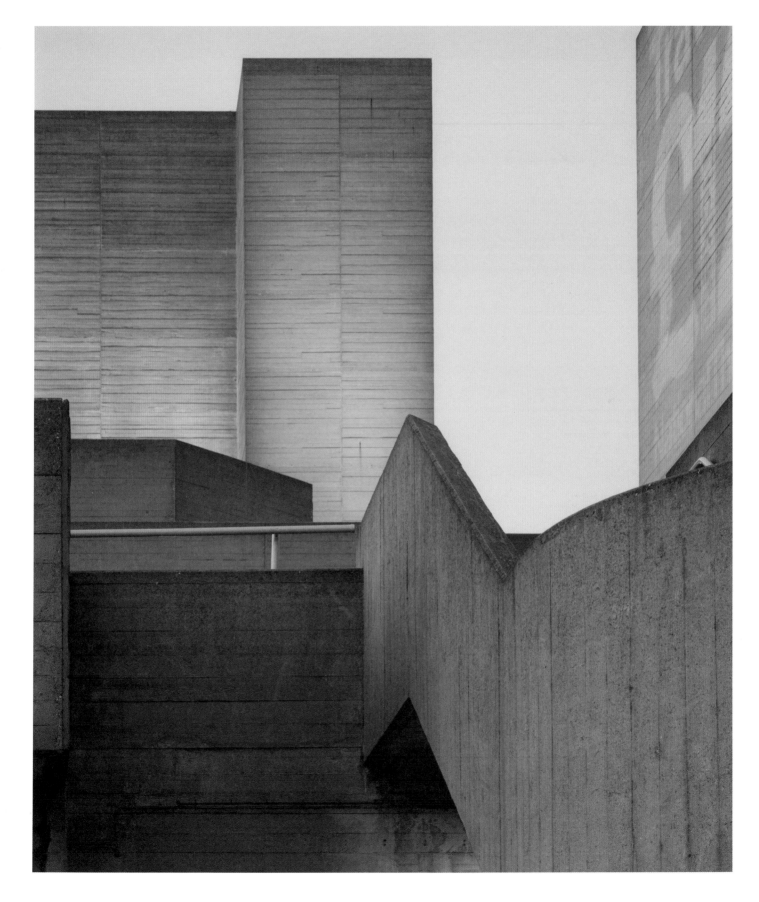

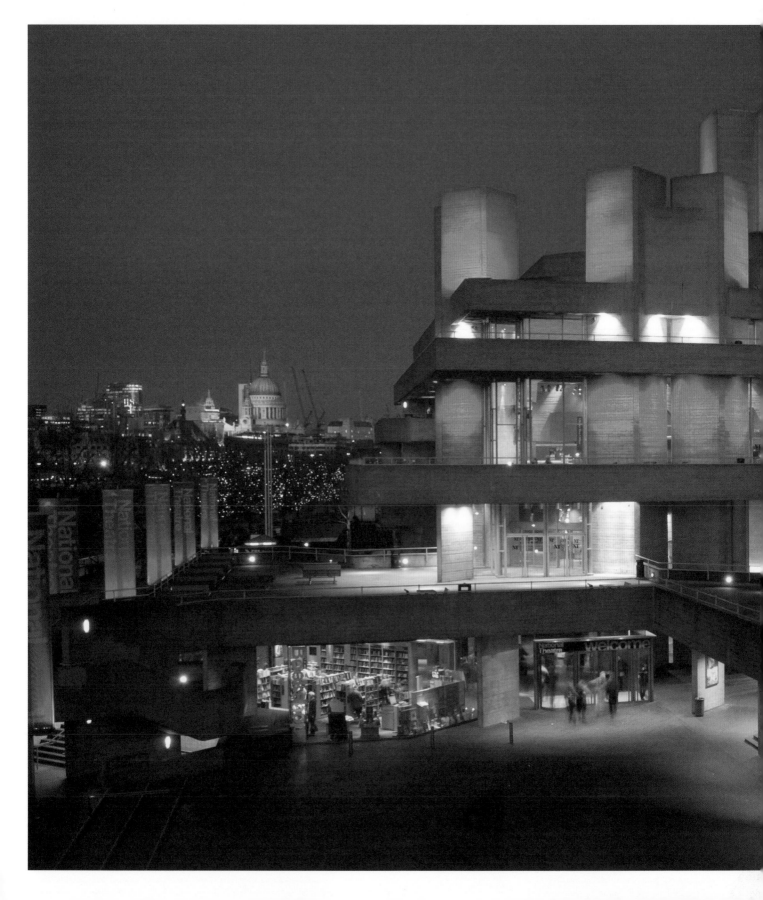

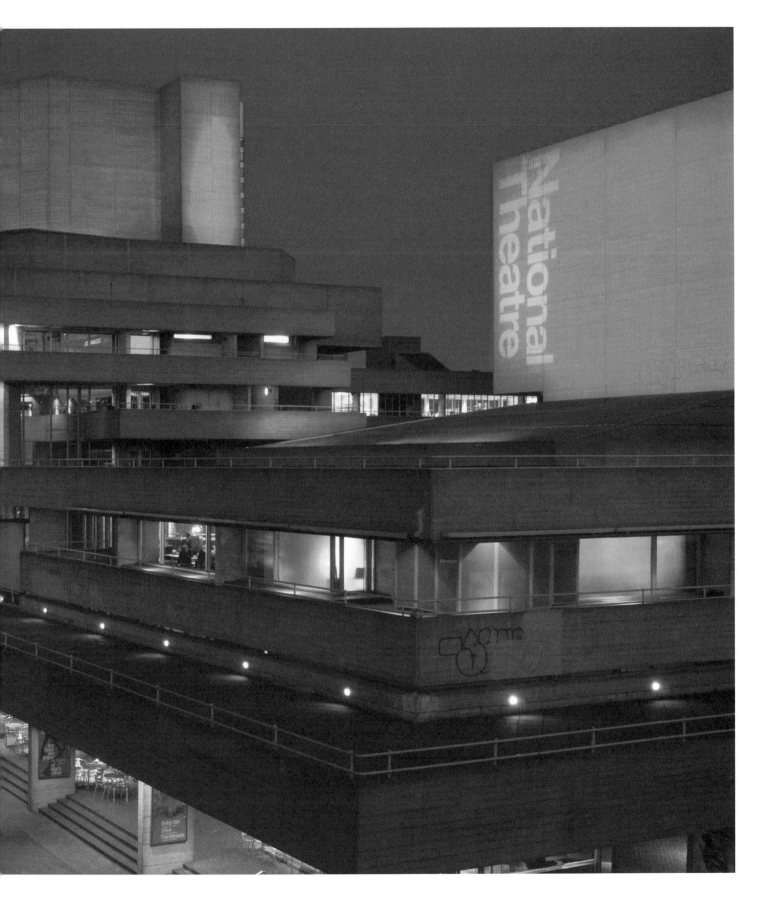

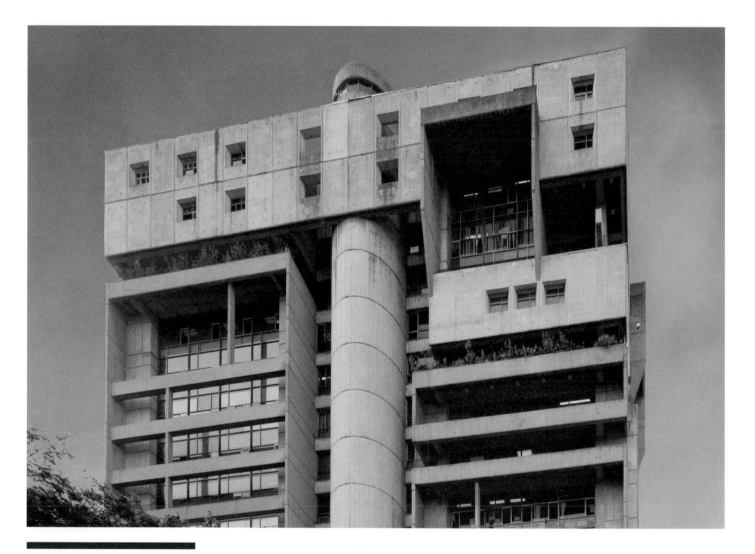

12

CCSS

San José

Costa Rica

1980

Alberto Linner Diaz

Government

This overlooked beauty is to concrete aficionados what Latin America's mysterious cities of gold must have been to the sword-wielding, cholera-carrying conquistadors of an earlier era: a sight that just has to be beheld. Unless you end up in Central America for some kind of work (flying planes? Cutting bananas?) you might never get the chance to see it in the hard, heavy flesh. The Caja Costarricense de Seguro Social Annex (or CCSS) is both a mouthful and an eyeful. It's an exercise in how to do cheap with panache.

There's a spirit and ambition in the way that Nicaraguan architect Alberto Linner Diaz disrupts the vertical and horizontal flows of the structure with brises soleil and balconies. There's a real riot going on, distractions that attract the eye. Linner's imagination shows what concrete was capable of becoming in the mind of an architect who wouldn't settle for something off the peg. It's interesting too that this social services department building went up right at the very end of brutalism's time as a mass style, just as it was falling hard from favour.

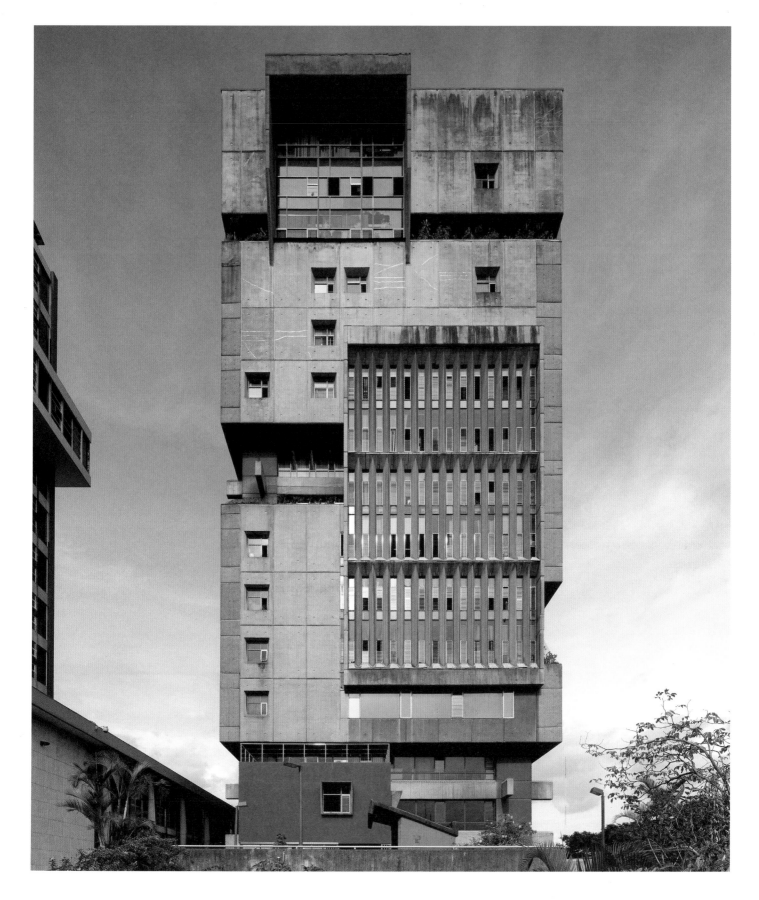

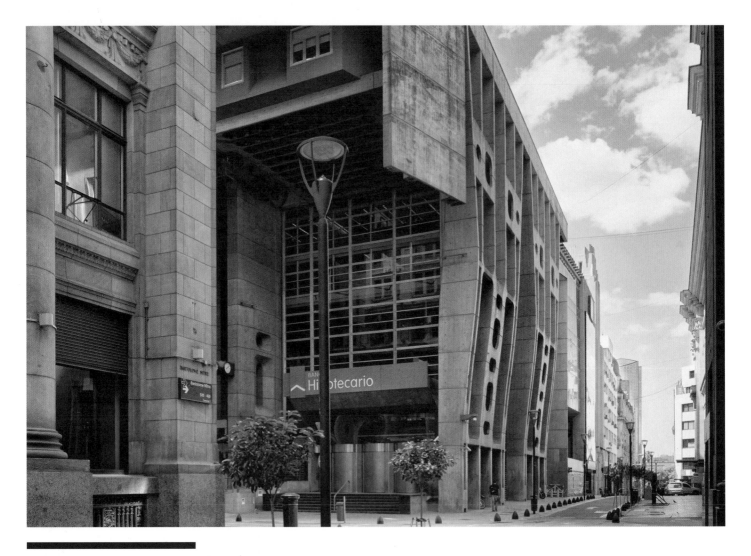

13

Banco de Londres y América del Sur

Buenos Aires

Argentina

1966

Clorindo Testa / SEPRA

Bank HQ

Argentina's economy has been on a never-ending, stomach-churning rollercoaster ride since the country's independence from Spain two centuries ago. And the Banco de Londres y América del Sur's eccentric headquarters in Downtown Buenos Aires has something of the fairground about it. Like many of the city's inhabitants it is not sober. The building is part menace, part madness – but then that's capitalism for you. Rather than duck shoots or drinking, inside it's the rather more prosaic world of administration that takes place for today's owner of the building, the Banco Hipotecario. And rather than 'blank face' brutalism, the exterior of this HQ – the punch card facade hints at the then nascent world of computers – points towards a high-tech architecture that financial institutions would come to devour. Richard Rogers's Lloyds Building in London and Norman Foster's HSBC HQ in Hong Kong can trace a lineage back to this building. The designer was Clorindo Testa of the practice SEPRA – he also did the National Library of Argentina, of which Jorge Luis Borges was director.

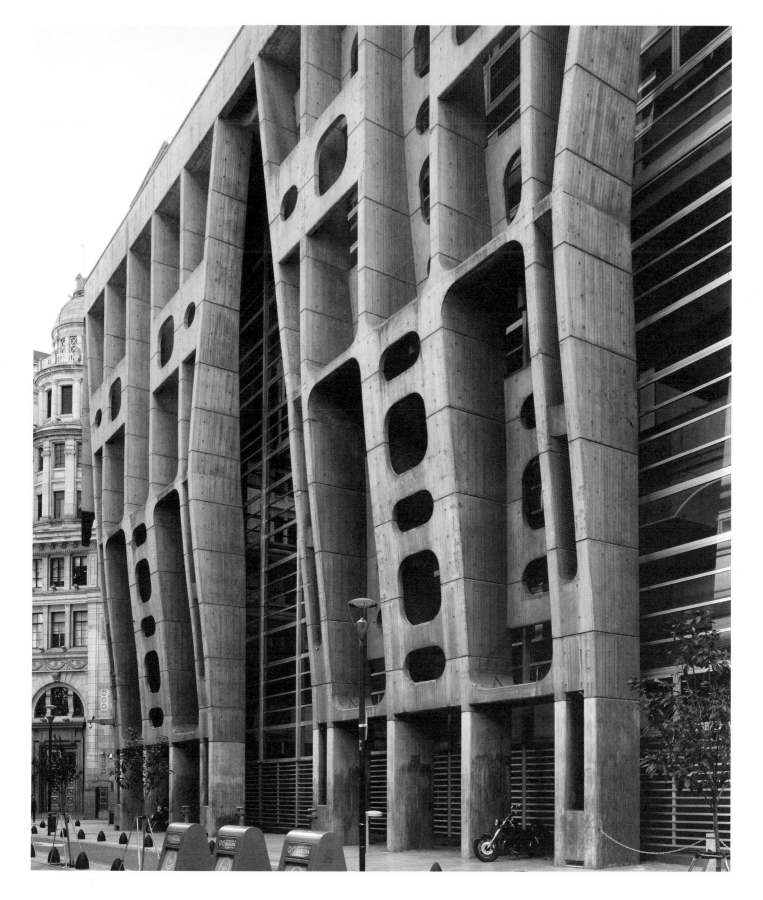

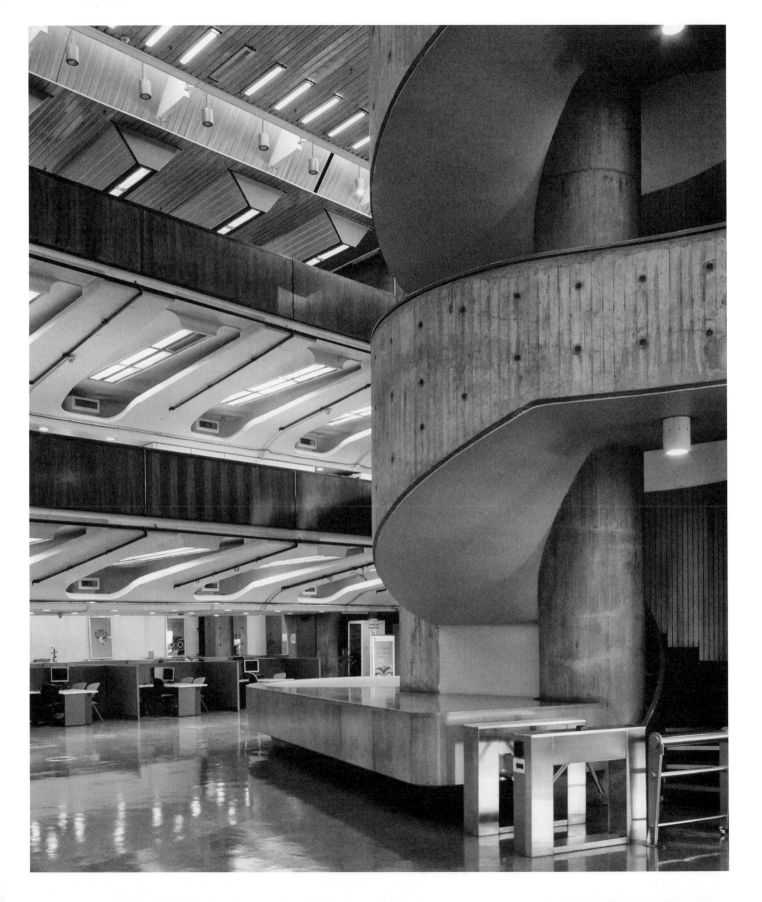

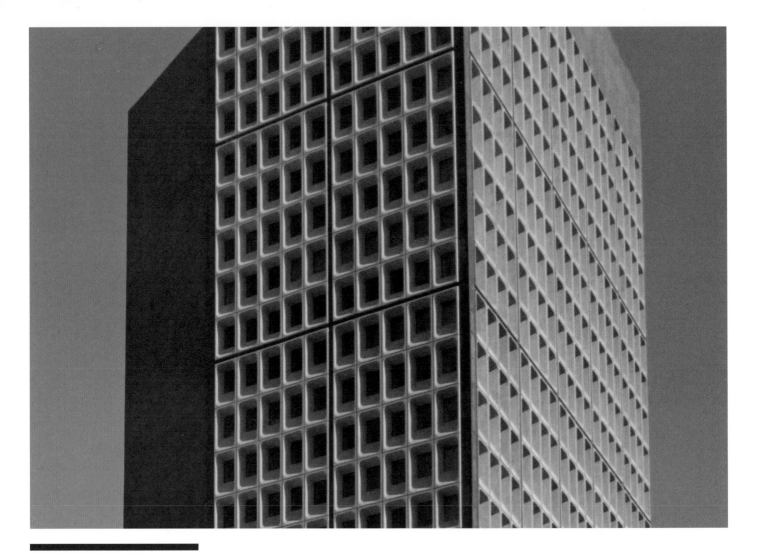

14

**The 9 (formerly the Cleveland
Trust Tower)**

Cleveland

USA

1971

Marcel Breuer

Hotel/housing

A skyscraper is a test of an architect's mettle. In the case of many recent starchitects, the results in China and the US look as rushed as a stroppy teenager's homework – and often display the same level of flair. Marcel Breuer's sole skyscraper – in gritty Cleveland – is repetitive, but there's refinement too. It's worth noting that the plan was to have two blocks facing each other, which is why the single built example is so incongruous. Now known as The 9, but originally offices for the Cleveland Trust Bank, it tells an interesting tale about the whims of fashion. Today, brutalist beasts have a growing following – especially among middle-class design aficionados. This one has recently been converted into apartments and a Marriott boutique hotel. In London, something similar is happening: the old Camden Town Hall Annex is the new home for London's first Standard Hotel. And down the road from that, Denys Lasdun's former social housing, Keeling House, is now executive penthouses for the well-off. Many architects have moved in there.

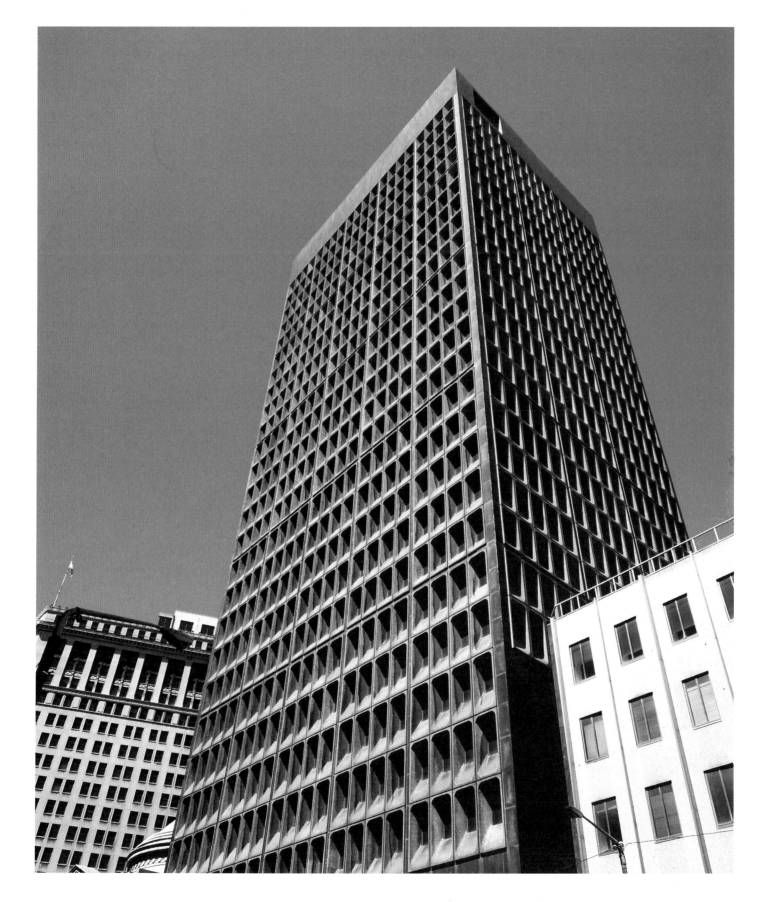

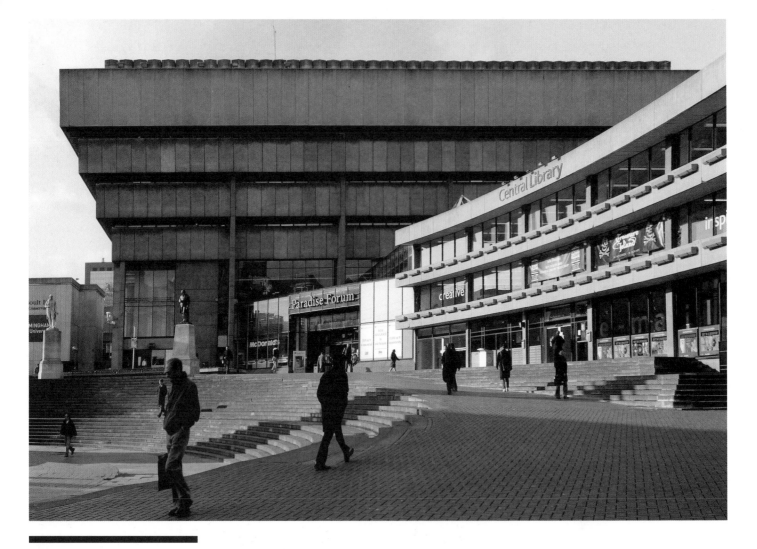

15

Birmingham Central Library

Birmingham

England

1974

John Madin

Library

Birmingham's motto is 'Forward'; it's obsessed with constantly evolving. History isn't a concept that Brum cares for. This progressive ethos created a thrilling cityscape of flyovers and skyscrapers in the 1960s – a statement of intent. That autophilia might have been misplaced but the love of the future was not. That optimism allowed buildings like this to rise like secular cathedrals to the new age of knowledge. Brum's architecture entrances and appals – but it's never boring, never predictable. The city is a one-off, an eccentric.

The city's 1974 library was designed by John Madin – the nearest thing Brum had to a '60s starchitect. This was his chef d'oeuvre, a great temple straddling a roundabout. Alleyways and squares and steps make it a maze – but in the middle, a central courtyard plucks calm from the chaos. But what did later Brum councillors do? They filled the court with fast food and pubs – and then proposed knocking the whole place down. But this is too important a building to ever lose.

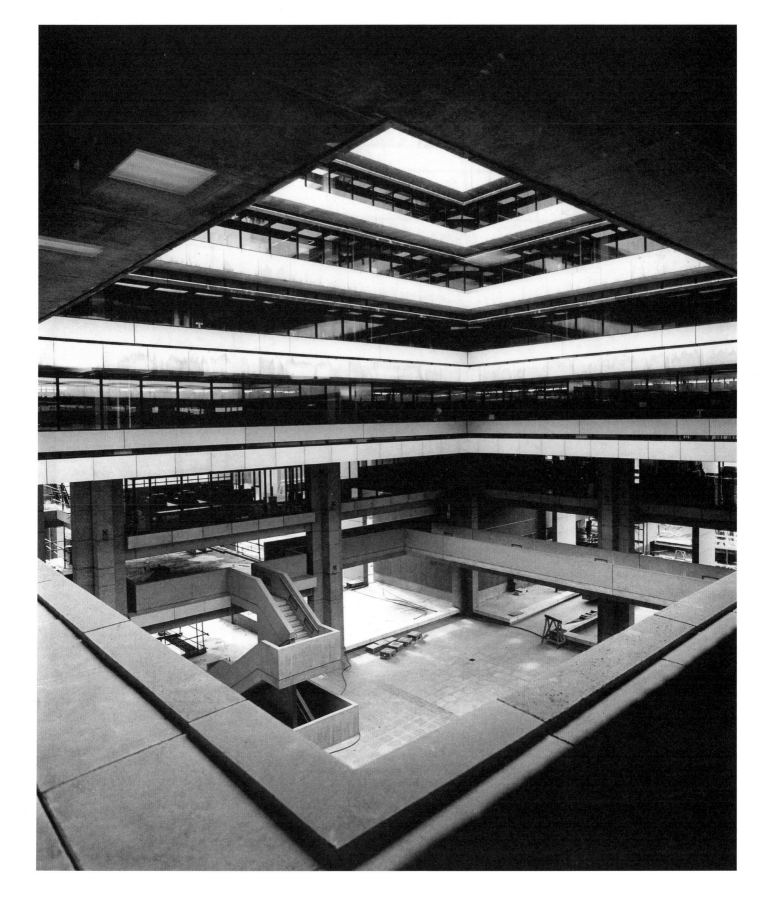

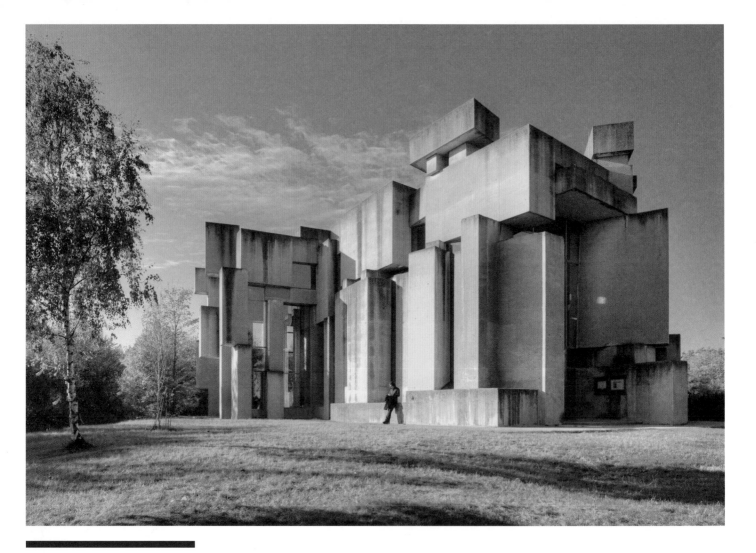

16

Fritz Wotruba was a sculptor, not an architect. And this church on the bucolic fringes of Vienna, where city blends into country, is probably best understood as a giant sculpture that one can worship inside. The stacked-up elements – huge slabs and cubes – conjure up thoughts of something like Stonehenge, perhaps. That Neolithic monument was probably a place of devotion for the ancient English just like the Wotruba Church is for the Viennese today. It's certainly an arresting piece of work, which argues with its neighbours yet also perversely seems to offer a kind of sanctuary from the city and the modern world, despite its design being in thrall to progress, to urbanism, to expressionistic shots across the bows of Viennese chintzy 'good' taste. Wotruba's most well-known work, then – yet he himself failed to see it completed, dying a year prior to the ribbon being cut. Today it's a place to pay homage to a man who produced sculptural work that has lived on after his own death – and an austere haven in which to contemplate whatever is to be contemplated.

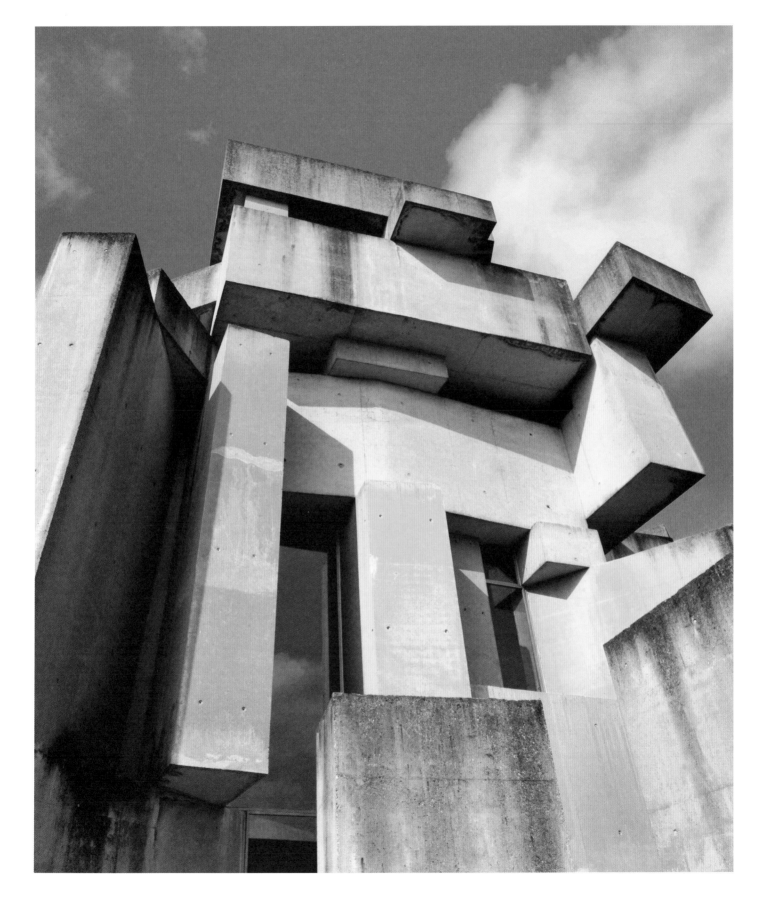

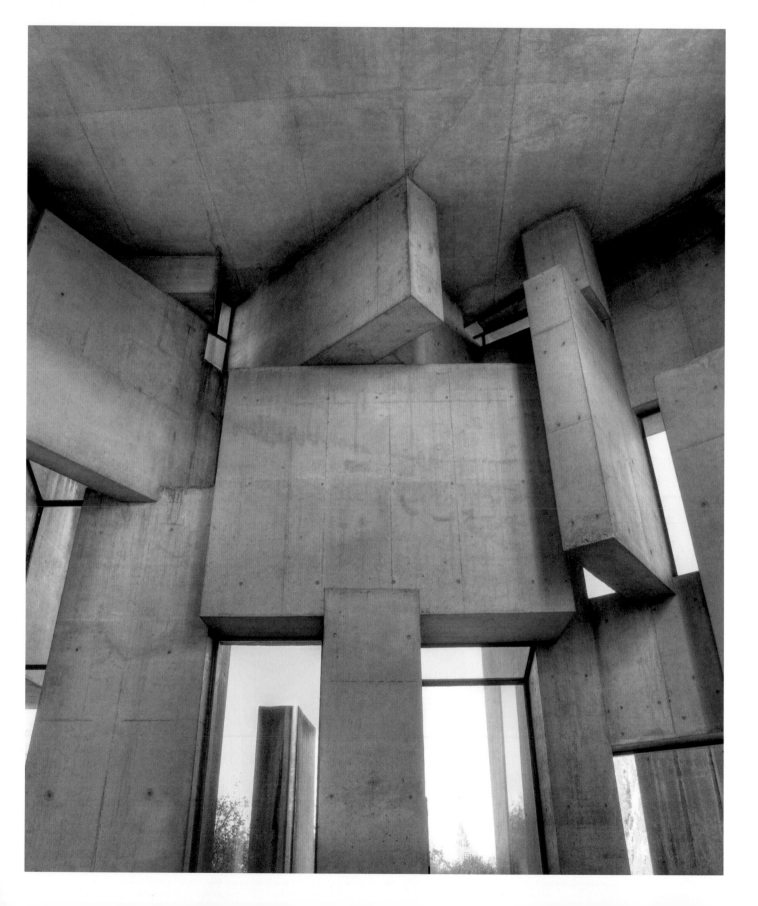

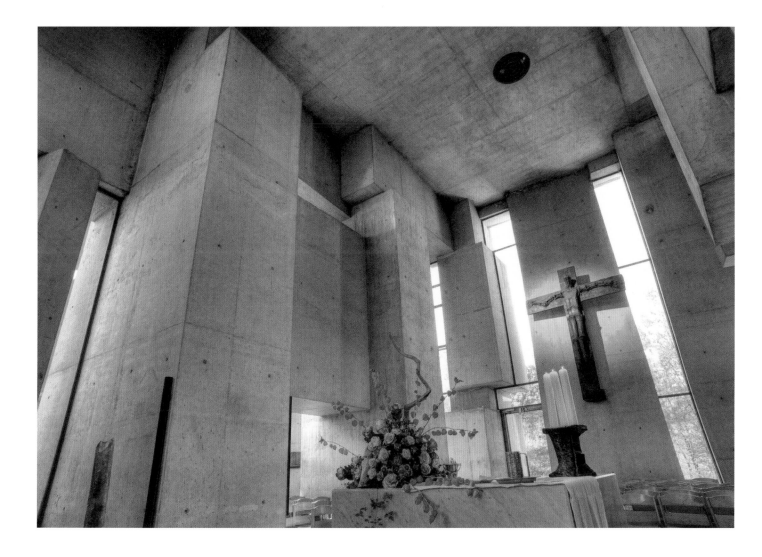

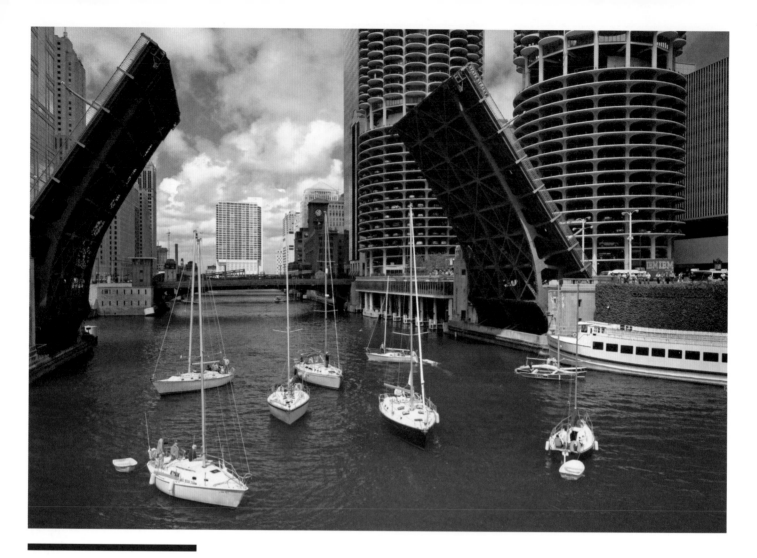

17

Marina City

Chicago

USA

1964

Bertrand Goldberg

Housing/leisure/car park/hotel

From a bobbing boat on the Chicago River, competing visions of the modern world present themselves. One by the master: Mies van der Rohe's rigorous, austere IBM Plaza, and one by his student, Bertrand Goldberg's pair of concrete corncobs, Marina City. While Mies favoured the minimal, the rectangle, glass and pricey metal finishes, Goldberg liked curves and was happy to build in concrete. Both worked together in Berlin and ended up in Chicago, where each would stamp their mark on the city. Mies built offices and a university. Goldberg built homes and hospitals. His high watermark was the Prentice Women's Hospital: bold, innovative, distinctive. But that has bitten the dust. Which leaves Marina City – its curved balconies and parking decks like communion wafers make one wonder whether it's brutalist at all. The sheer scale of the site and the scope of the ambition of these flats persuades us that it is. A music venue, hotel, restaurants and yes, a marina for boats on the river, makes it attractive to live in today.

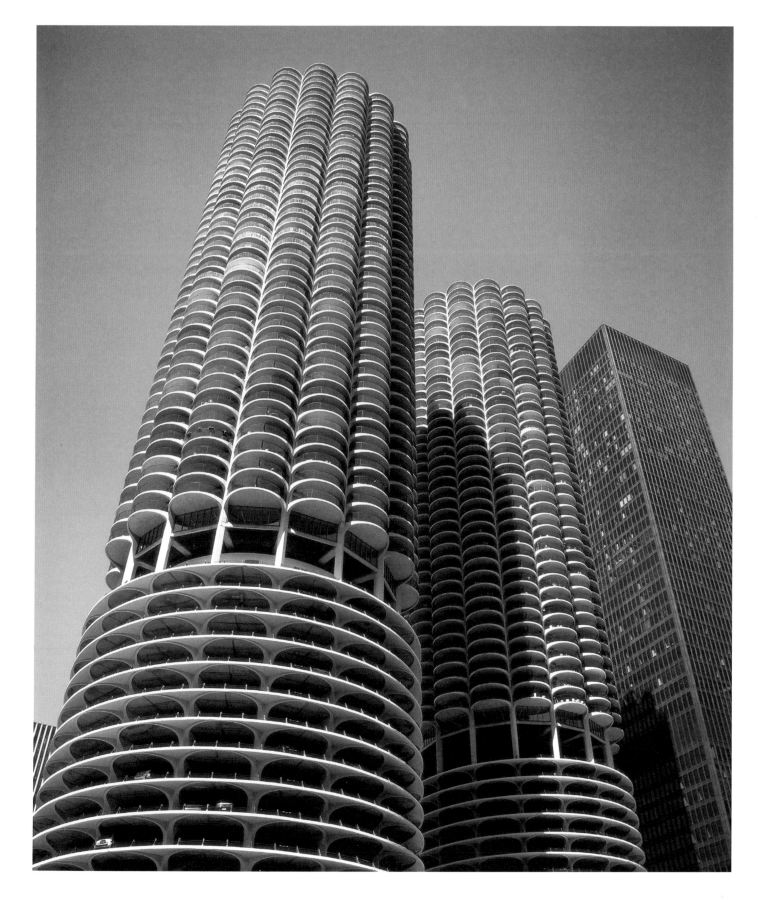

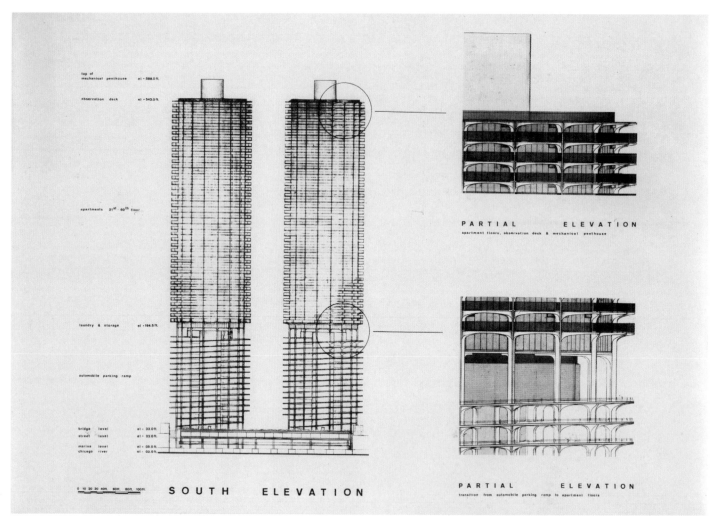

top of
mechanical penthouse el +588.0 ft.

observation deck el +543.0 ft.

apartments 21st-60th floor

laundry & storage el +194.5 ft.

automobile parking ramp

bridge level el +33.0 ft.
street level el +22.0 ft.
marina level el +08.0 ft.
chicago river el +02.0 ft.

0 10 20 30 40ft. 60ft. 80ft. 100ft.

SOUTH ELEVATION

PARTIAL ELEVATION
apartment floors, observation deck & mechanical penthouse

PARTIAL ELEVATION
transition from automobile parking ramp to apartment floors

Above: South elevation drawing
and detail of apartment floors. Right:
Construction view, c1961. Below:
Apartment layout plan, c1963

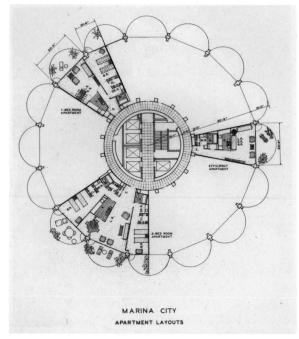

MARINA CITY
APARTMENT LAYOUTS

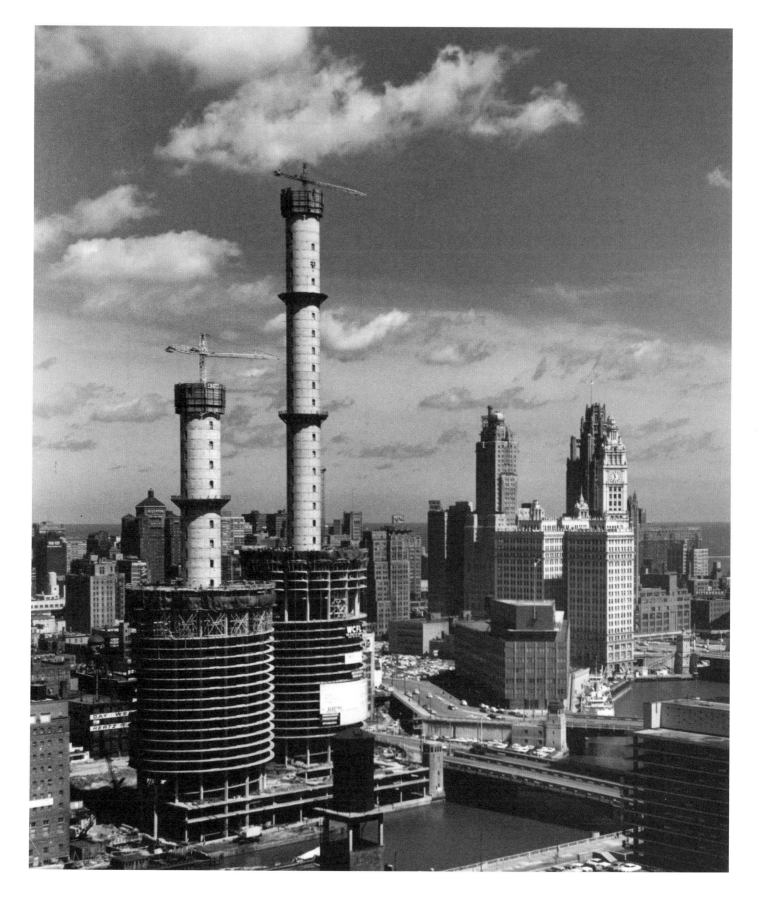

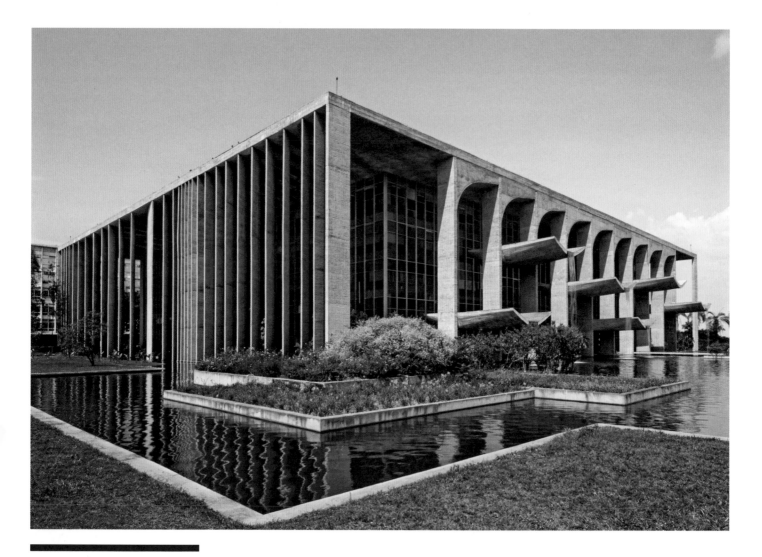

18

Palácio da Justiça

Brasilia

Brazil

1957

Oscar Niemeyer

Government

Brazil's custom-made capital is an exercise in XXL excess. Six-mile-long avenues that are as wide as a village, block upon block like dominoes lined up. Brasilia's got a kicking over the years – for being unfriendly to pedestrians, for being dead on the inside. Today's Brasilia is beginning to feel much more like a real city – with bars and pavements and a metro system. The brilliantly swaggering Aussie critic Robert Hughes decried the place as "a ceremonial slum" in his otherwise bravura 1980 BBC TV series The Shock of The New, in which he trashed utopia's political meddlers and philosophical advocates. But that was when modernism was at its lowest ebb – smashed around, faith in it lost. Try to study Lucio Costa's intriguing plans, try to see Oscar Niemeyer's Palácio da Justiça as more than a failure. The latter's fat concrete tongues spouting water into a lake offer a monumental reaction to what was considered a big job – plus a way to cool off from the actual (and philosophical) heat.

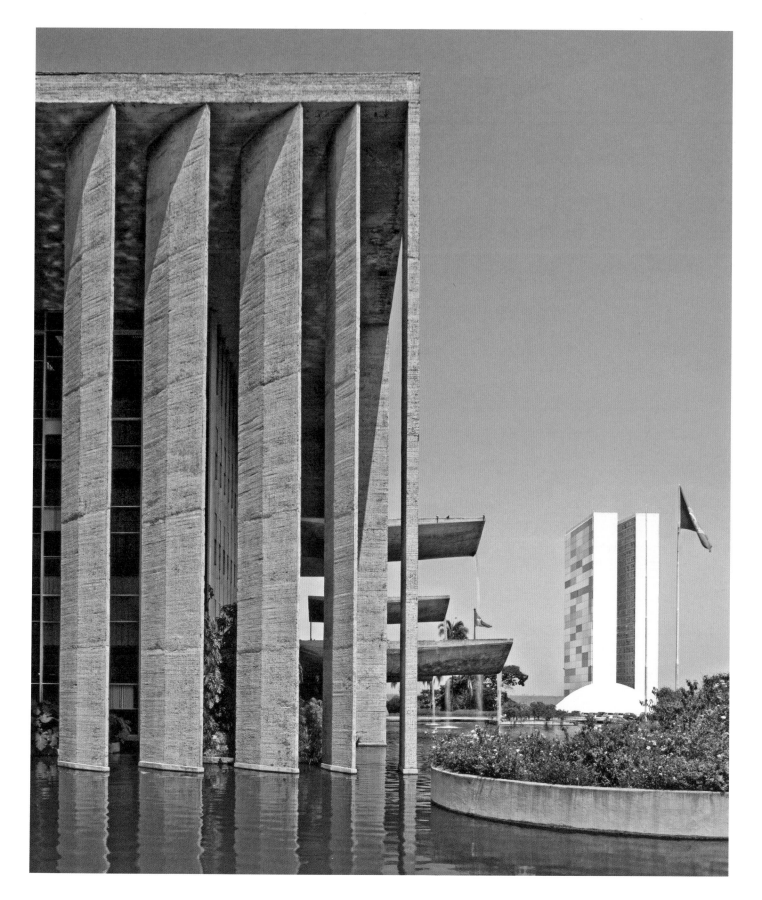

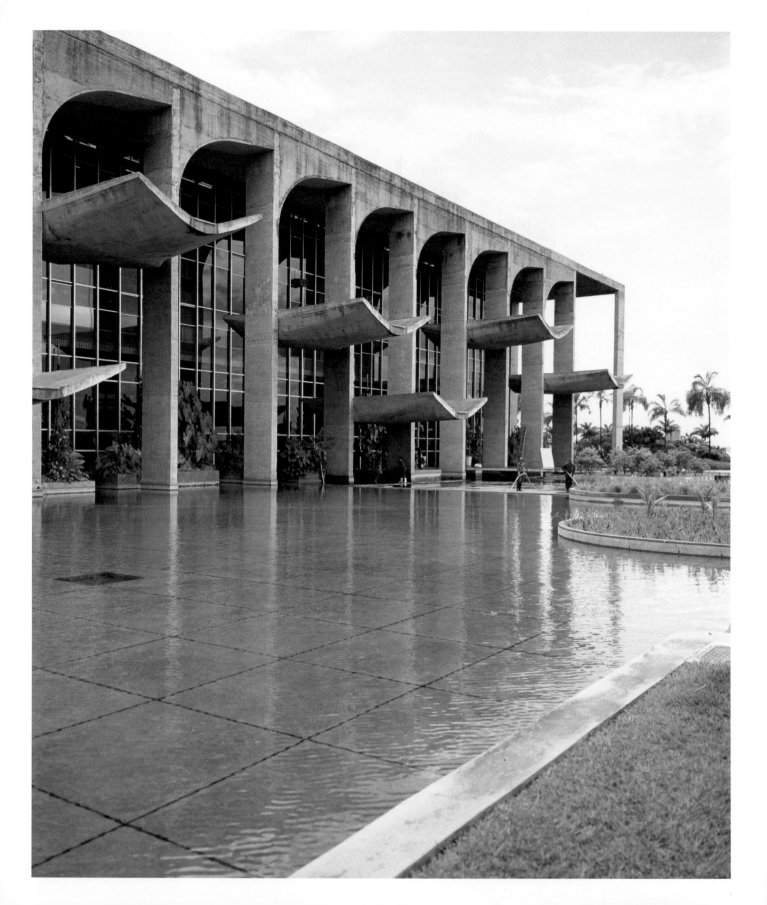

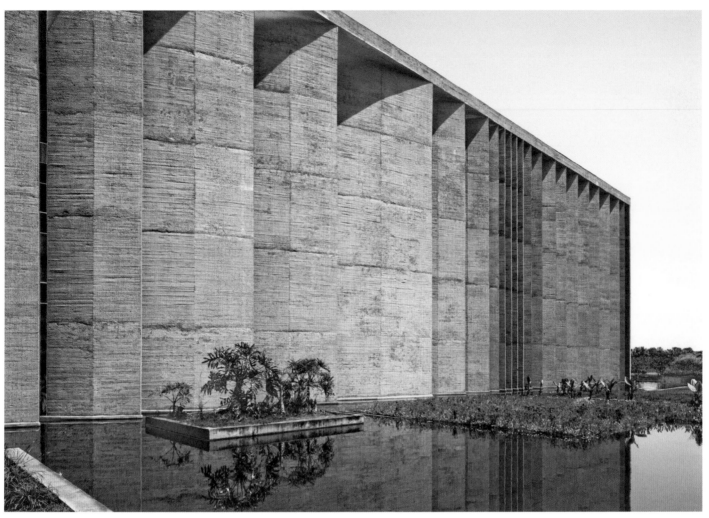

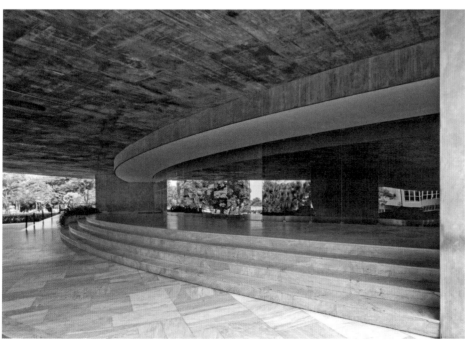

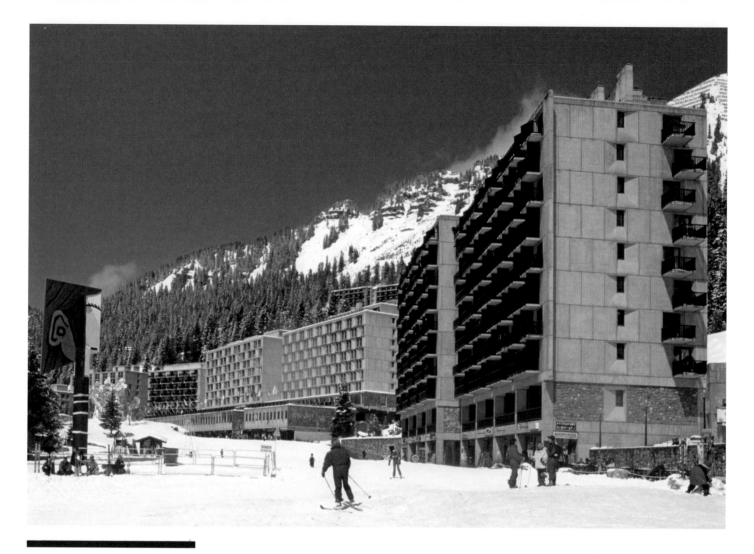

19

Flaine

Haute-Savoie

France

1959-78

Marcel Breuer

Ski resort

The rigour and solidity of concrete transposed to the mountains: Flaine pits man against the earth in the most stark way possible. Here is Marcel Breuer's masterplan for a modern ski resort duelling aggressively with the massif and adding something entirely different to the staid French Alps, which are otherwise chock-a-block with rah-rahing upper-class winter sports enthusiasts. Here's the toughest-looking weapon we've got (reinforced concrete) going head to head with the toughest-looking weapon nature's got (rock millions of years old, shaped into thrusting, scarred peaks). Blocky hotels built over two decades are cockily cantilevered over cliffs that make vertigo sufferers stiffen, ski runs slalom between great walls and into tunnels, then break free into car-free streets dusted with snow: it's all a sort of surreal dance of buildings and their users. And it's a million miles from the Alpine kitsch of wood-panelling. Flaine began from the same mental zone that other grandiose holiday resorts of the same period emerged: places like Benidorm in Spain and Albenas in Bulgaria.

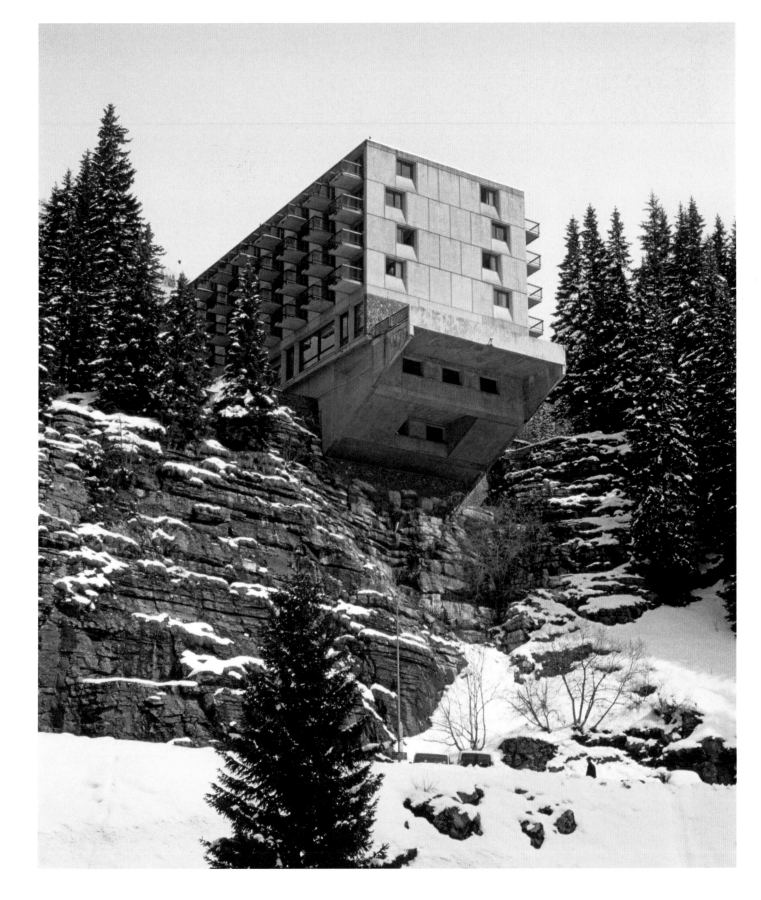

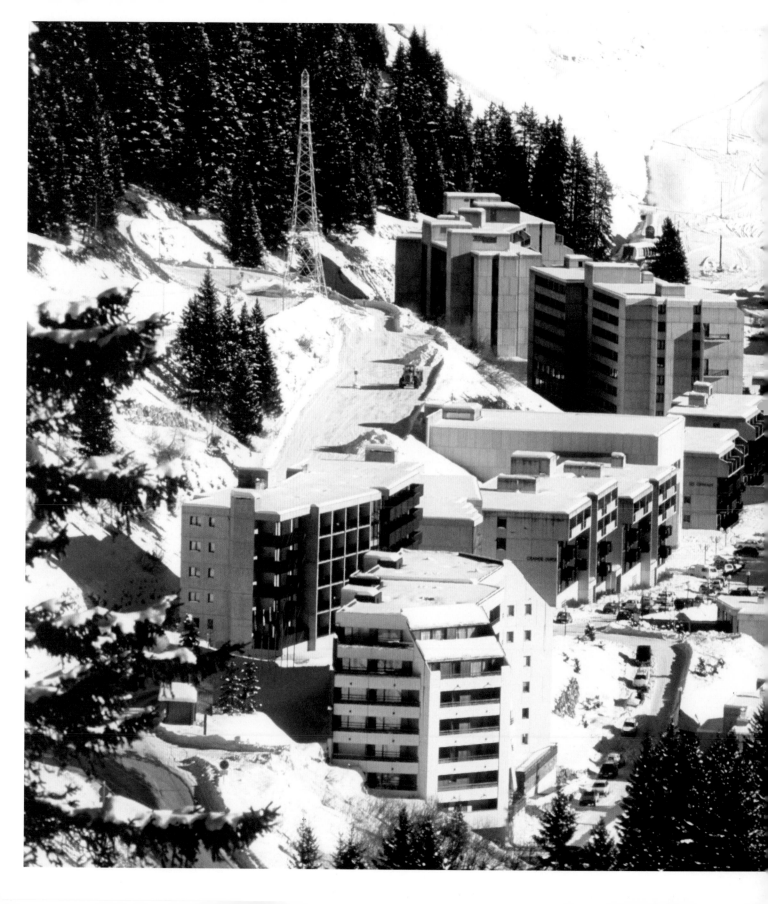

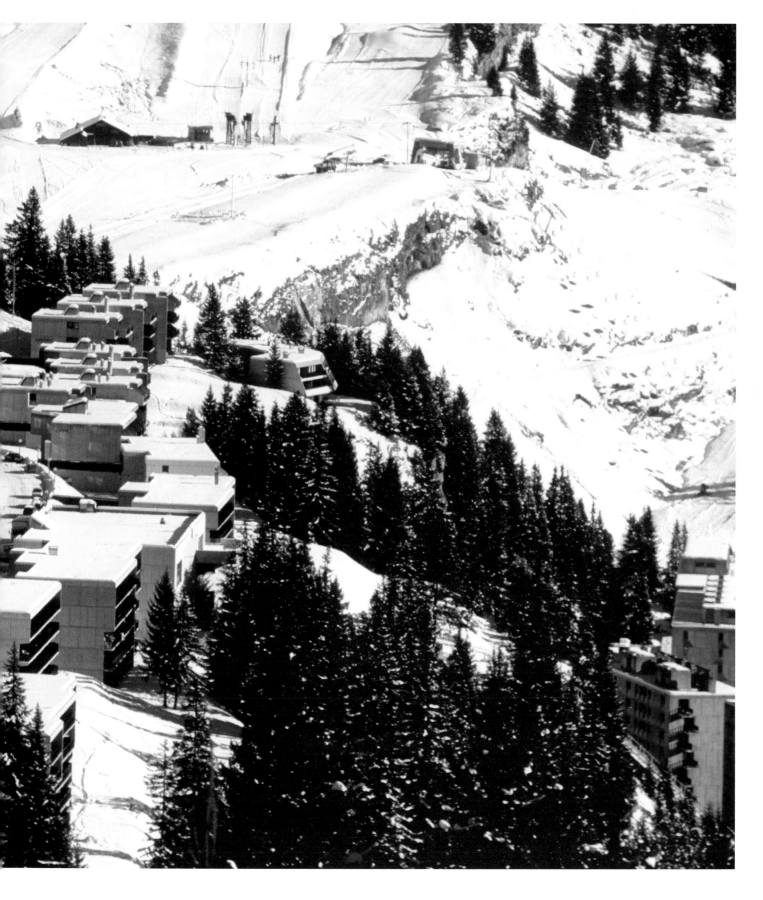

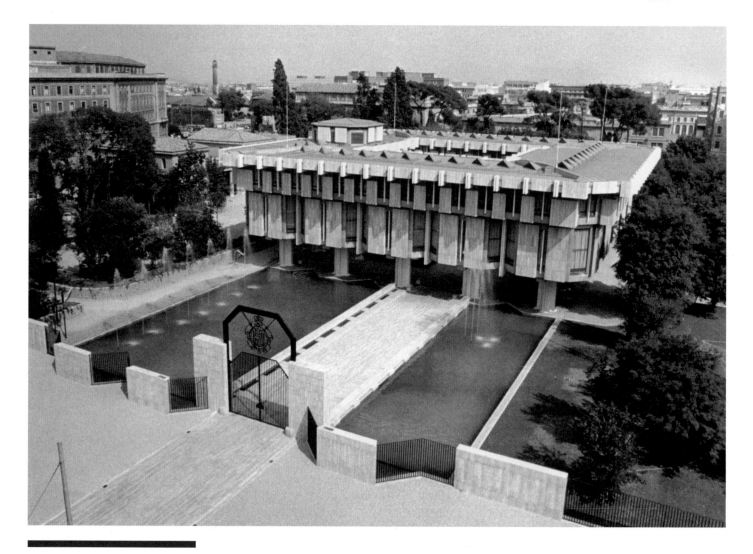

20

British Embassy

Rome

Italy

1970

Basil Spence

Embassy

Embassies are a chance to flog an aesthetic, an idea, to the world. What are embassies anyway if not a little corner shop displaying wares, fostering trade and, of course, replacing the passports of tourists who imbibe too much moron juice? In the 1960s, when brutalism was approaching a 'house style' of the big state, it was de rigueur to deploy ball-busting buildings that showed – in no uncertain terms – that the governments of countries concerned were calling the shots. Kenzo Tange's 1970 Kuwait Embassy in Tokyo was a pile-up of

steps and protruding office boxes, something like a tower of diving boards placed at the end of a swimming pool. This is not a bad thing at all. Basil Spence went for something more formal with his British Embassy in Rome, more fitting for serving cream teas to bigwigs in the Roman heat. A courtyard was surrounded and attacked by the new embassy on stilts; its decoration symmetrical and stiff. It was a kinder, leaner, Aperol-fuelled little brother to Spence's horribly overbearing Home Office in London.

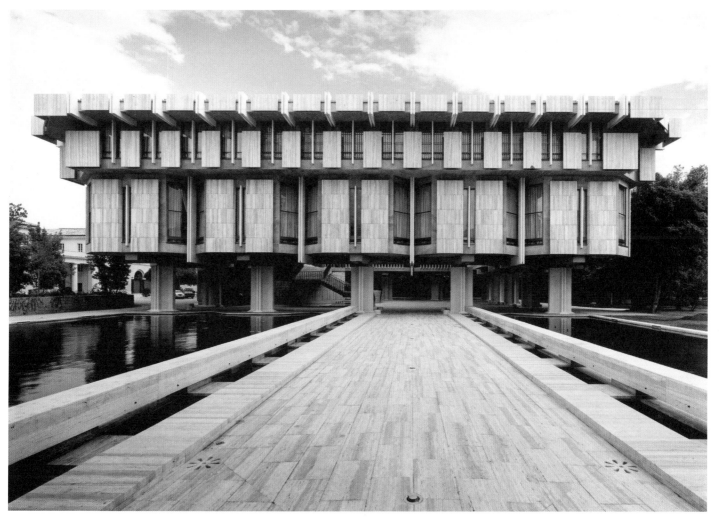

91

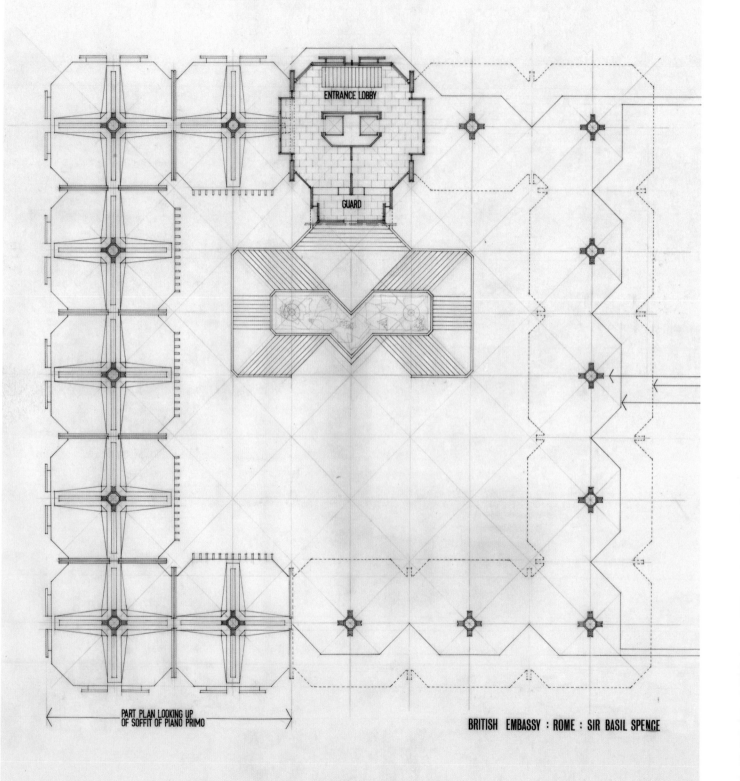

ENTRANCE LOBBY

GUARD

PART PLAN LOOKING UP
OF SOFFIT OF PIANO PRIMO

BRITISH EMBASSY : ROME : SIR BASIL SPENCE

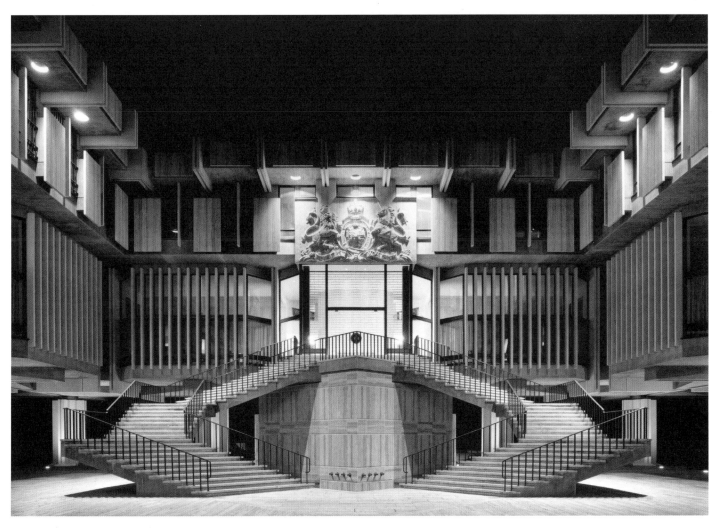

Left: Building plan, 1963

21

Munich Olympic Village and Park

Munich

Germany

1972

Günter Behnisch, Frei Otto (stadium);
Heinle, Wischer und Partner, Eckert
und Wirsing (Olympic Village)

Housing/sport

Munich's Olympic Village was supposed to be a harbinger of peace and solidarity, but of course it became something more horrific during the 1972 Olympics, when Israeli athletes were murdered in their quarters. A memorial marks the spot, but today the village stands up incredibly well. Peace and harmony has finally been achieved, the spaces between the buildings are inviting; trailing plants give the whole place a loved appearance. It shows that big brutalist estates can be calming, especially the water features. The Olympiastadion U Bahn

Station is muscular and solid; its repetitive vertical and horizontal lines are an enjoyable smack in the face for the waiting traveller. The Olympic Park merges 'big concrete' like the Olympiaturm among well-cultivated parkland. The late Frei Otto's tensile roof swooping over the Olympic Stadium itself appears light enough to float away, a nice contrast to the heavy concrete elsewhere. Surely the most imposing and most urban Olympic park and village yet built; satisfying proof that brutalism is a big-scale planning solution that can work.

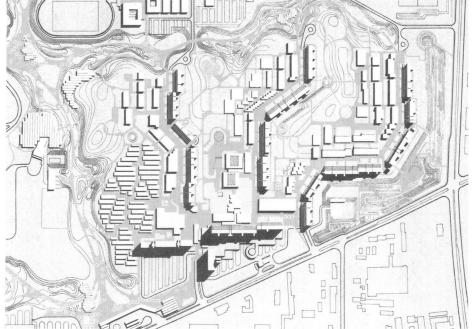

Left: Olympic Village site plan

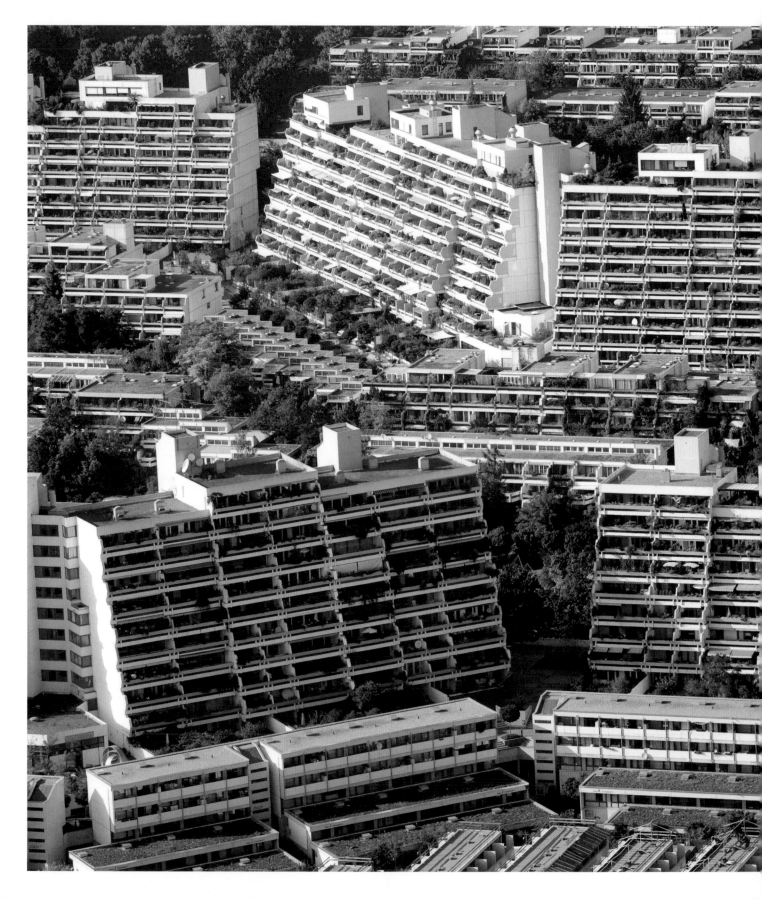

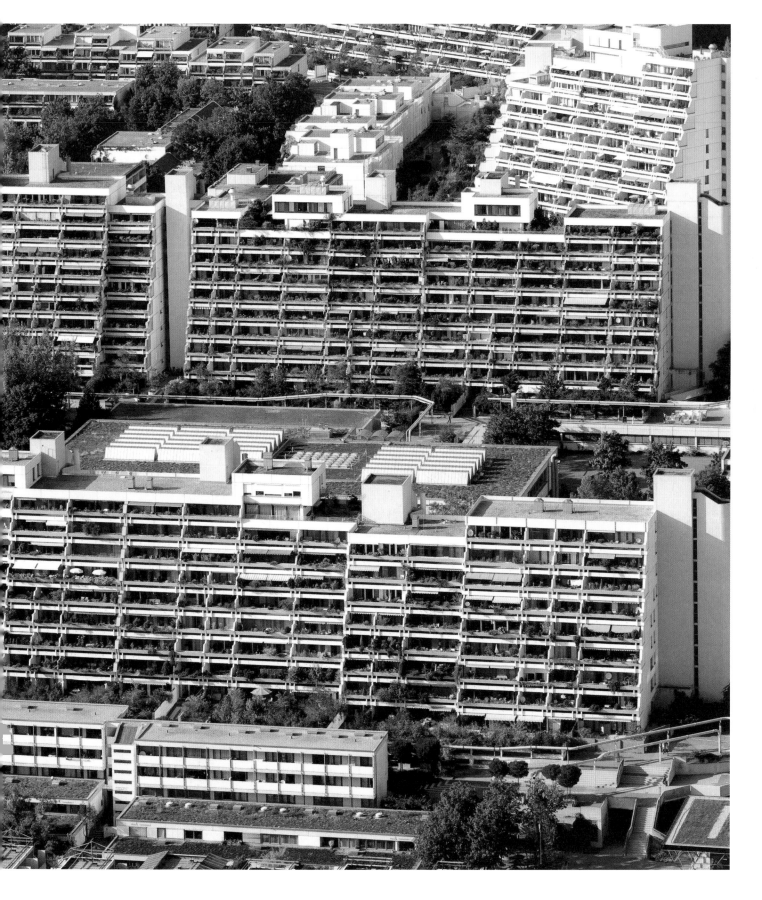

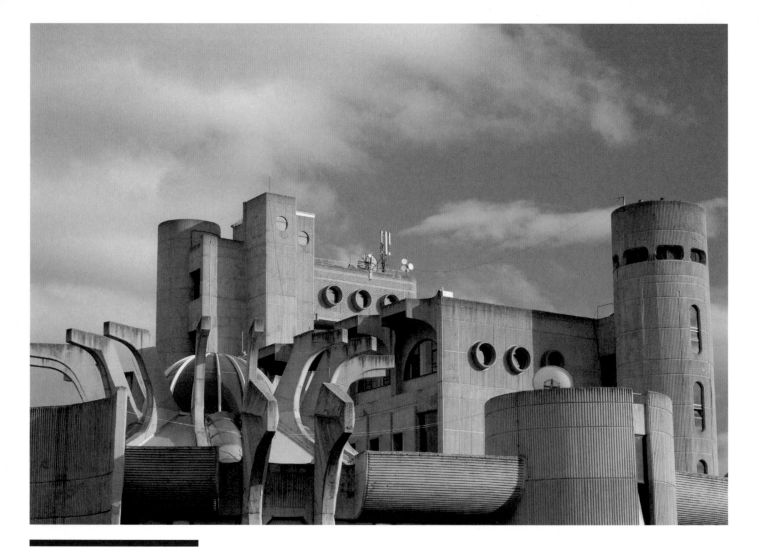

22

Skopje Post Office

Skopje

Macedonia

1974-82

Janko Konstantinov

Offices/post office

Following a devastating earthquake in 1963, architects were gifted a tabula rasa in the Macedonian capital. Skopje's rebuild was to be dramatic: Kenzo Tange won the competition to masterplan the new city, and his visions were eye-opening. If wholly built, it would have been the biggest brutalist city in the world. In the event the plan as a whole faltered, but many individual structures went up. And they have a real vigour about them. The most notable is Janko Konstantinov's Central Post Office & Telecommunications Centre.

The complex comprises bulky blocks of offices and an abstract post office at its centre, which brings to mind some kind of demented concrete flower opening to the sky. All very imaginative – as were many of the other brutalist buildings that appeared in Skopje. Macedonia doesn't seem to agree, and its rolling 'Skopje 2014' improvement programme was nothing less than a cold shoulder to the city's concrete legacy, covering up buildings with neoclassical facades while dropping nationalistic statues in front of others.

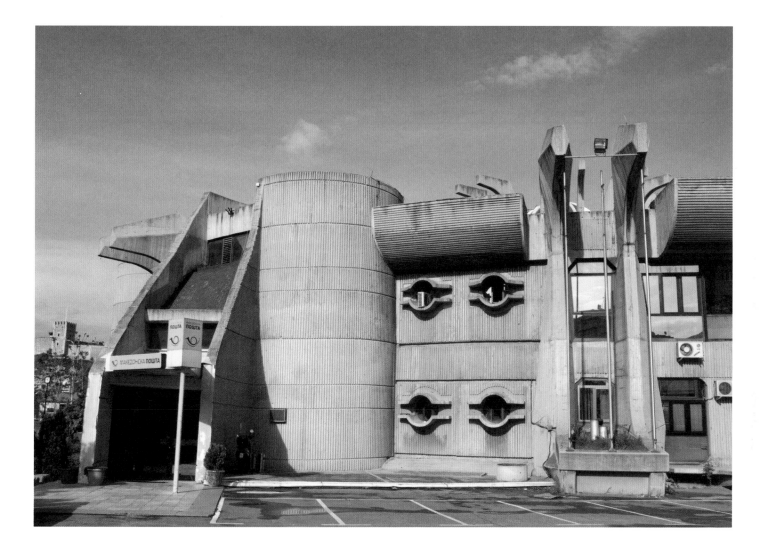

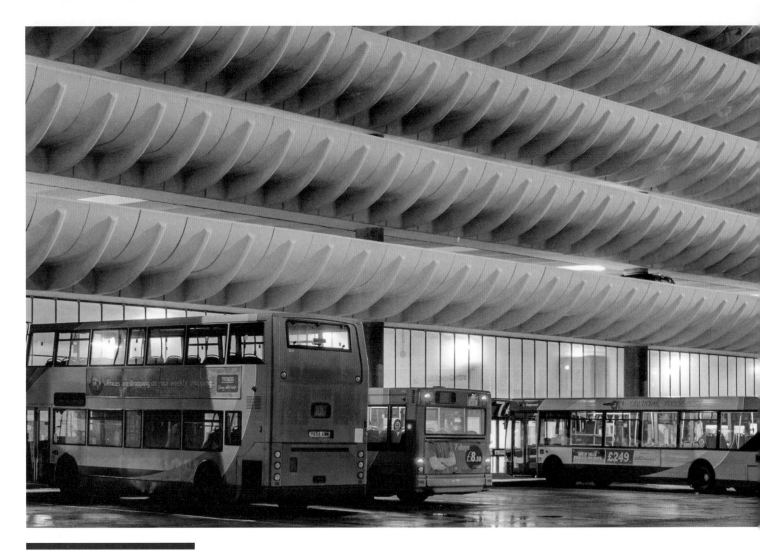

23

Preston Bus Station

Preston

England

1969

Keith Ingham, Charles Wilson,

EH Stazicker / BDP, Ove Arup

Bus station/car park

The curved edges of the car park decks that flick upwards like 1960s quiffs are the stand-out stylistic feature of this chunky bus station (once the biggest in Europe) and parking structure in the northern English town of Preston. Preston was a place that wanted to build big in the 1960s, in competition with grander north-west English rivals like Liverpool and Manchester. Other things that work well here are the bespoke signs and the 70-odd bus gates themselves – local people actually like using and looking at this building and

managed to save it from the wrecking ball. The local council planned a redevelopment that would have meant curtains for the bus station, but in 2013 it was (surprisingly) listed by the British government and is now protected from destruction by trigger-happy developers. Evidence then that brutalism can actually work, that people do like it, and that its fortunes in conservative Britain of the 2010s seem on the up as we finally see what value concrete buildings can have in our cities.

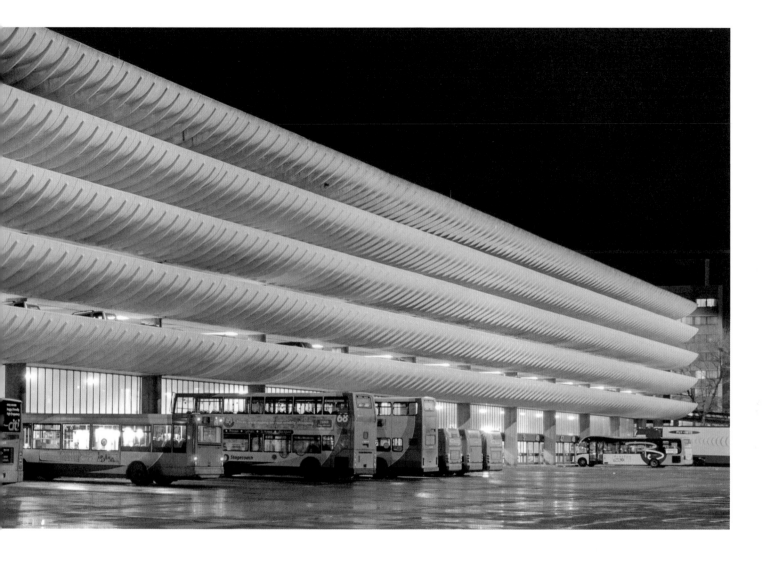

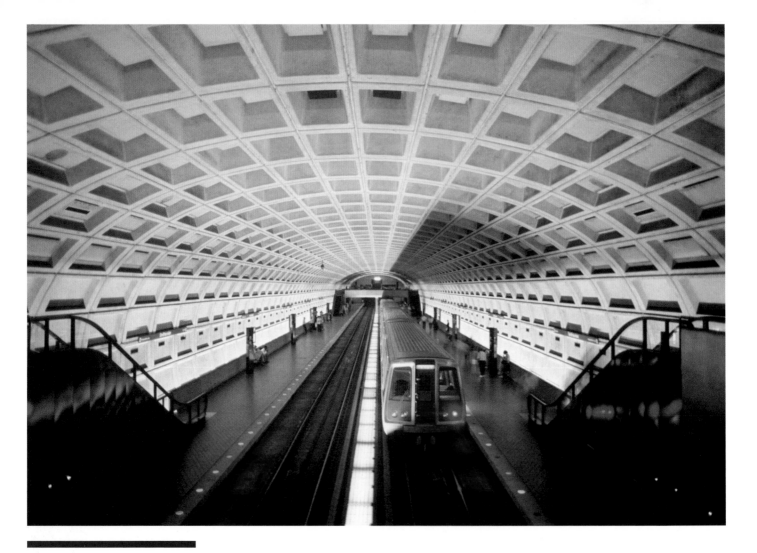

24

The nuts and bolts of unglamorous infrastructure projects are often glossed over in conventional architectural texts. But the bridges and shafts of the post-war public building boom have an intriguing life of their own. The Washington DC Metro is, like Moscow's Metro before it, defined by its architecture. Using it is like being eaten by a ground-dwelling monster. Descent is made through unsettling throat-like tubes: the elevator shaft at Dupont Circle is blank, yawning, interminable. Passengers emerge in the belly of the beast: the platform halls with their coffered ceilings and soft lighting are striking, especially at Metro Center and Pentagon City. Harry Weese whipped up the system's look and feel; he was also responsible for the notorious skyscraper prison, the 28-storey Metropolitan Correctional Center in Chicago, opened in 1975. But the following year, when the first section of the DC Metro opened, America's capital got something even more impressive. It can be sinister though: no wonder an infamous murder in the HBO TV series House of Cards takes place down here in the gloom.

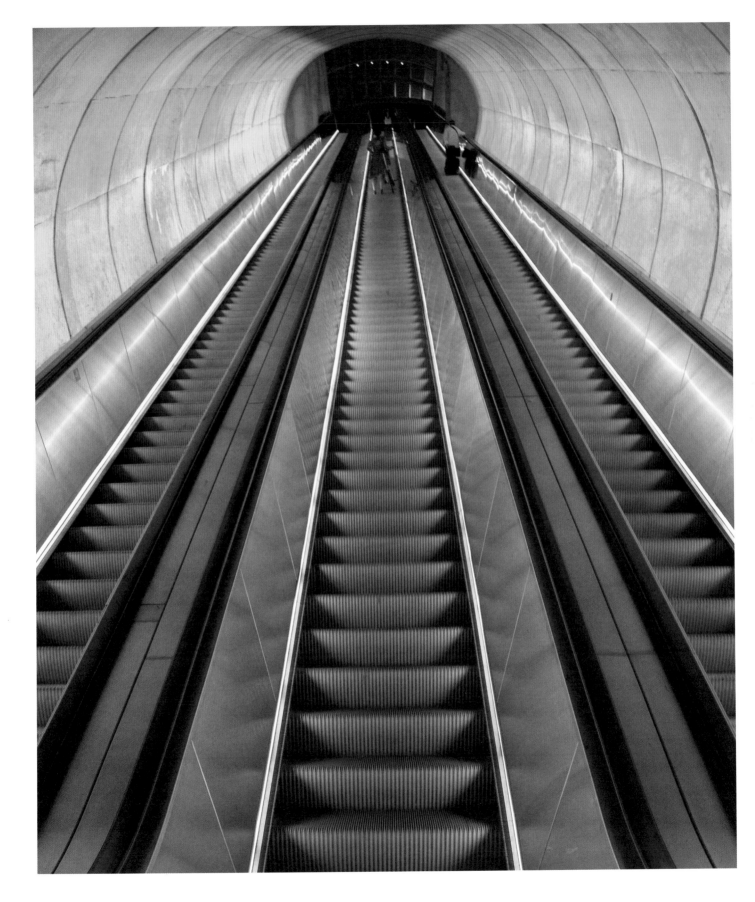

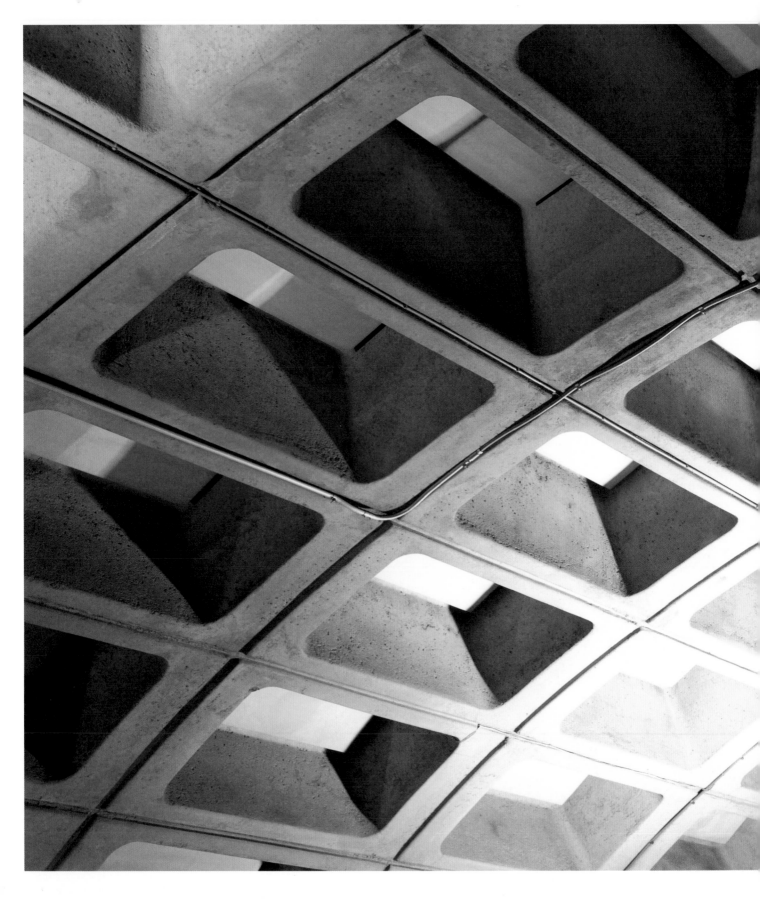

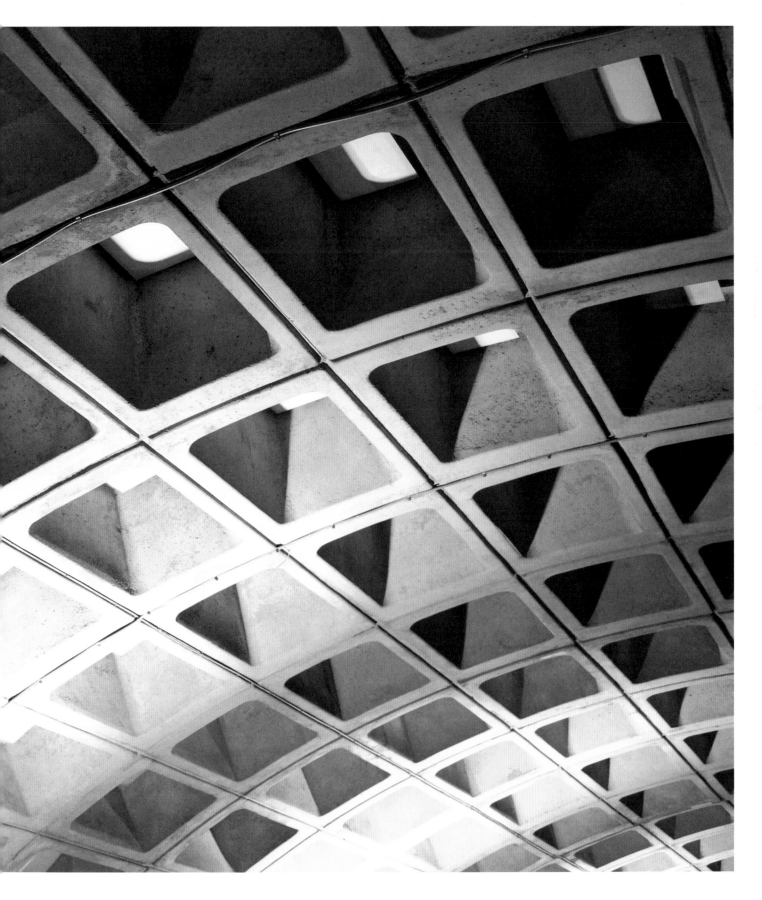

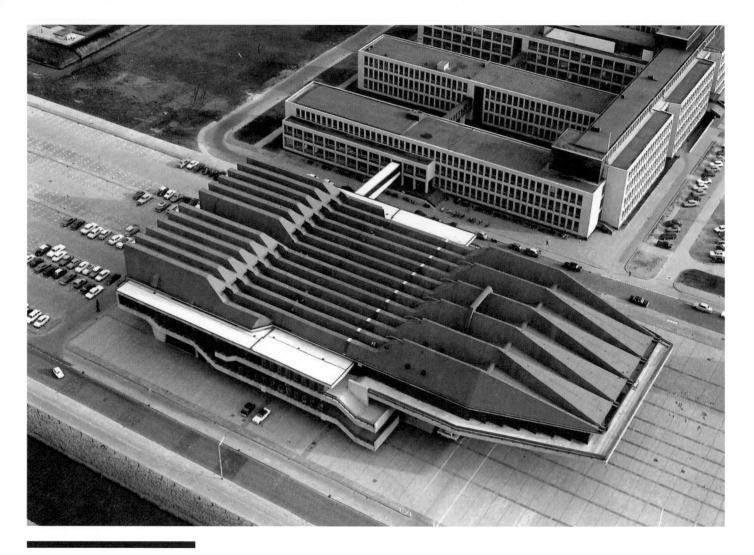

25

Aula at Delft University of Technology

Delft

The Netherlands

1966

Jo van den Broek and Jaap Bakema

Education

What are the noises emitted by the creatures many brutalist buildings allude to? Everything from growls to howls. The animal this building evokes, though, would say: 'Rebbit'. This ranine one-off should be sited right next to a giant pond, with a huge concrete fly circling above. It's actually one of the main additions made to Delft University of Technology when the institution expanded in the 1960s. It's an unapologetic landmark in a city more known for delicate porcelain and its school of technically adept painters. Jo van den Broek

and Jaap Bakema's no-nonsense work is filled with lecture theatres, offices and halls which, today, host graduation ceremonies and conferences attended by men from the nearby big city of Rotterdam who wear suits and drive mid-range saloon cars. Are those conference-goers moved by the stately oddity of the Aula? Are any of the university's students? It's hard to know. Even the most bold of buildings can so easily retreat into the background; they can become normalised when they're anything but normal.

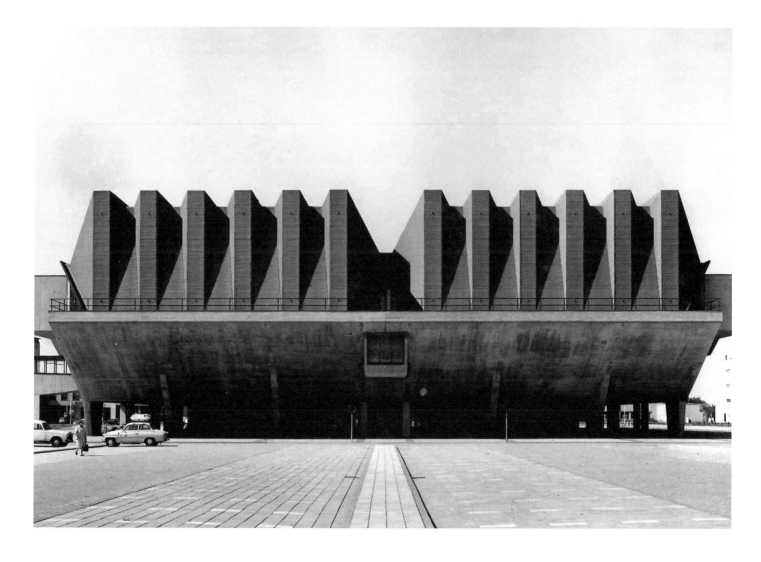

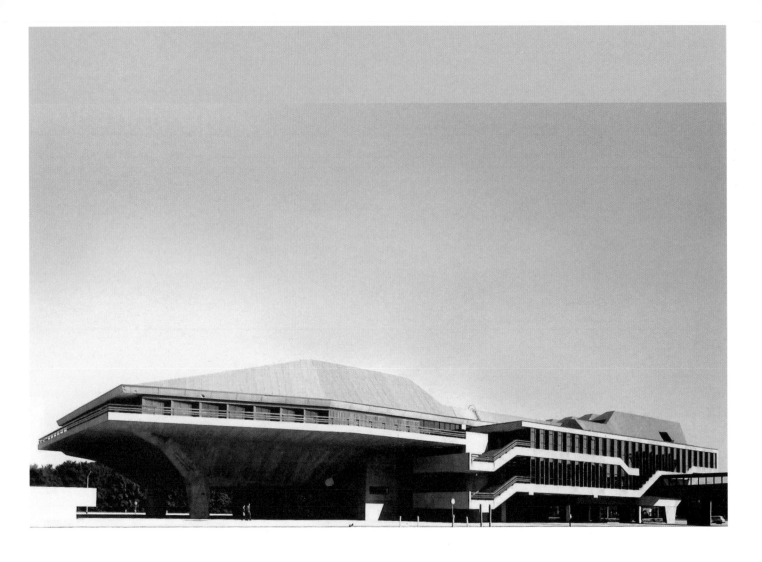

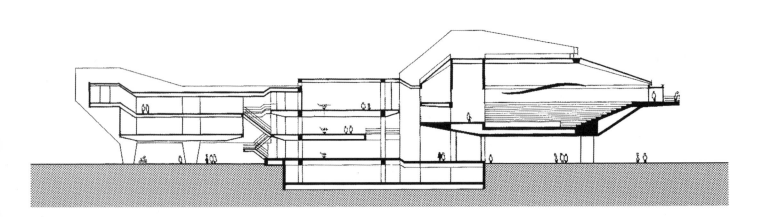

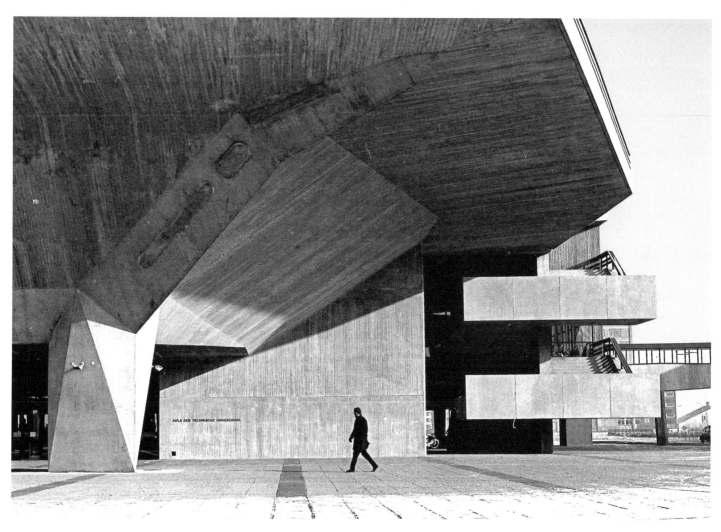

Left: Section view

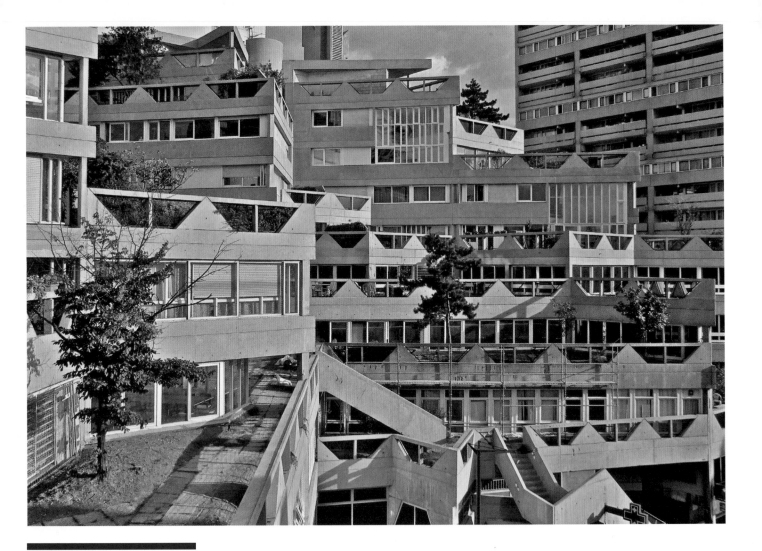

26

Centre Jeanne Hachette and housing

Ivry-sur-Seine

France

1975

Jean Renaudie and Renée Gailhoustet

Housing/retail

Paris isn't short of gargantuan grands projets, of manifestations of men's lust for 'legacy'. But here's a piece of overblown urban spectacle that really bends the mind. The dramatic superstructure of this concrete colossus rears up over the pleasant Paris suburb of Ivry-sur-Seine (this is no La Haine-style banlieue) with a sense of puffed-chest Gallic swagger. The shape of the thing is informed by triangles; indeed the architects (Jean Renaudie and Renée Gailhoustet) were obsessed with them. They appear everywhere – on fences, stairwells,

in the shapes of the ramps and the apartments that jut out. From one of the high vantage points, the Centre Jeanne Hachette (and housing on top) – which leaps over an entire boulevard and down the other side – looks like some kind of giant kaleidoscope pattern. The roof gardens up high are oddly serene, but nearer to the ground, there are weird angles and malevolent portals. Inside the shopping mall normal life goes on regardless: pain aux raisins are munched by pensioners and Gauloises smoked with gusto by Carrefour workers on a break.

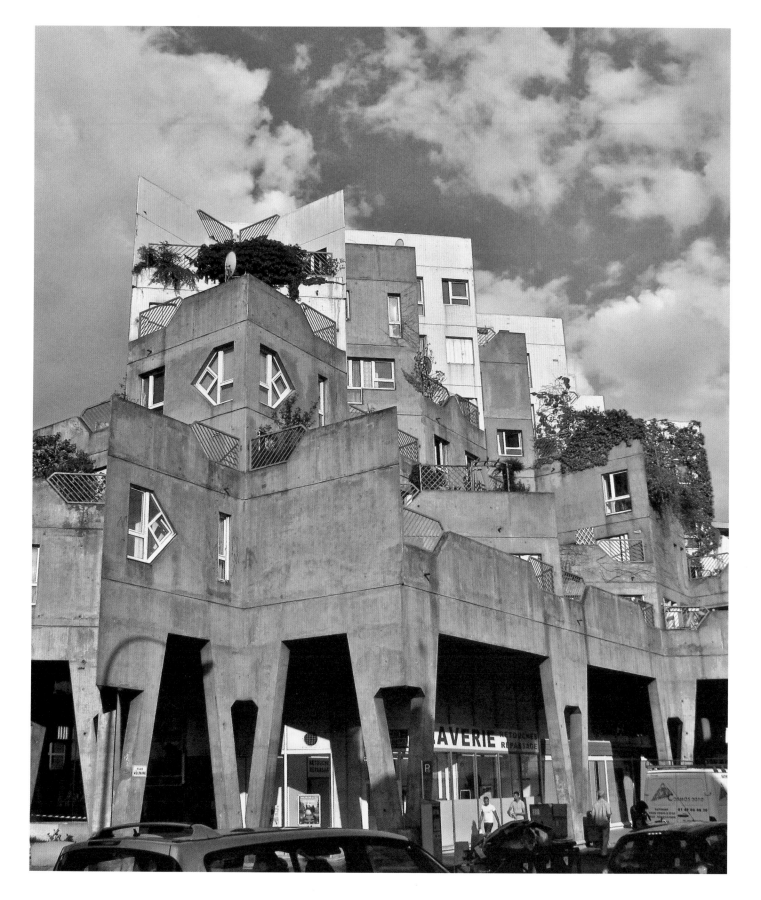

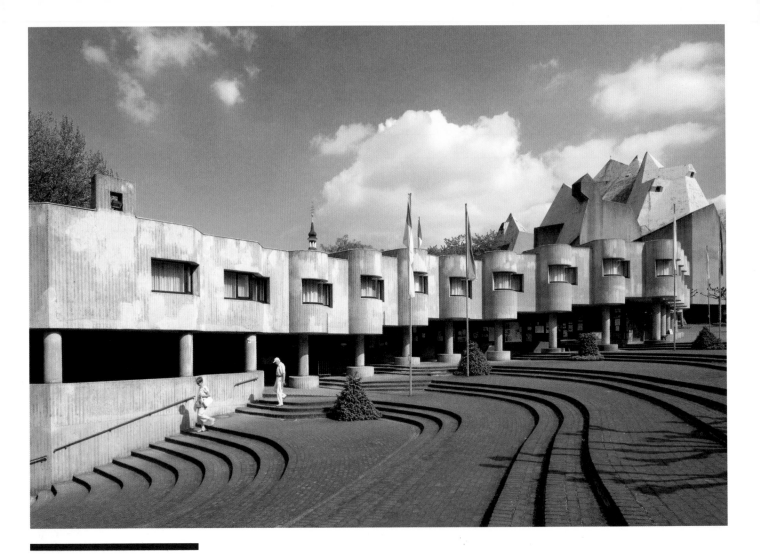

27

Pilgrimage Church

Velbert-Neviges

Germany

1972

Gottfried Böhm

Church

A building that's a glass of cold water in the face. It possesses the similar sort of forthright, devil-may-care (pardon the pun) attitude that cathedrals would have dazzled pilgrims with in the middle ages. This church in North Rhine-Westphalia has a kind of Star Wars sensationalism about it – militaristic imagery (visors and helmets), kitschy sci-fi menace and a sandy colour scheme that would be on point on a desertified planet far from our solar system. The design is by Gottfried Böhm, who pushed the expressionistic envelope elsewhere too – such as with the 1968 Iglesia Youth Centre Library in Cologne. Germany is blessed with a slew of good brutalist churches. There's the Maria-Magdalena Kirche in Freiburg (p182). And in Berlin there's Kreuzberg's stirring St Agnes Kirche by Werner Düttmann. This 1967 edifice has harsh plain frontages and uncompromising bulk – tough love in action. St Agnes Kirche was derelict for years but has recently been converted into an art gallery with a family flat that features purple carpeted walls crammed in too.

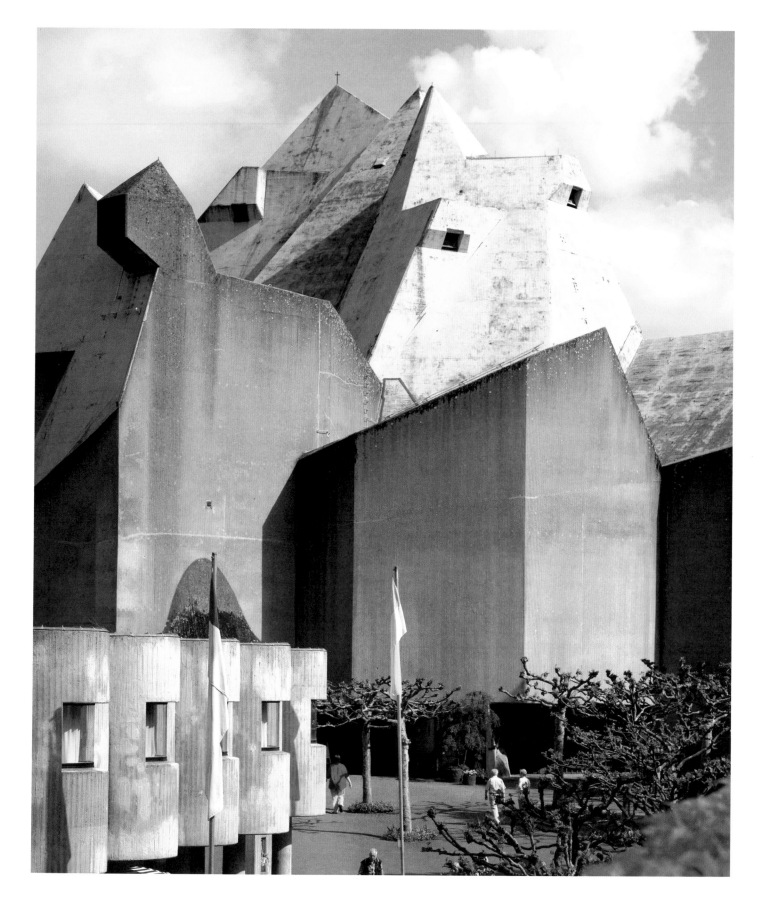

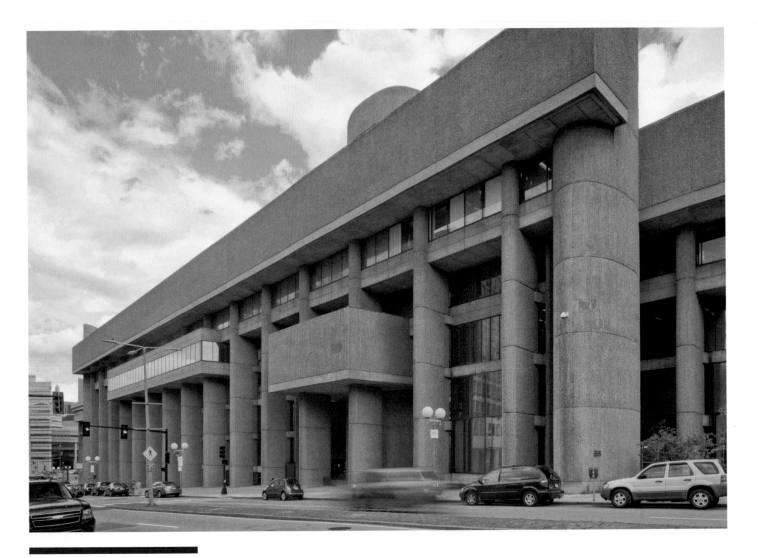

28

Government Service Center

Boston

USA

1971

Paul Rudolph

Government/offices

Is this what Americans mean by 'big government'? The implication of buildings like this is clear: the state will help you, but on the state's terms. It's a thought process perhaps best summed up by the neatest visual joke in this complex: a trio of stairwells which form into a face. It's a sprite's smile staring down, both sinister and sweet, reminding all to toe the line. Paul Rudolph's whole mishmash, complete with eerie courtyards, was never completed – at its heart was to have sat a thumping concrete tower block of yet more offices. It might

have turned out a bit like CF Murphy's Blue Cross Blue Shield Building of 1960 in Chicago, but more madcap still, with even more reams of exposed concrete. The Government Service Center is part of the Government Center zone, whose other famous resident is Boston City Hall by Kallmann McKinnell & Knowles. That inverted ziggurat includes a mayor's office reached by its own private lift. The squat, chubby City Hall seems poised, ready to shimmy across its huge plaza like a dad limbering up to dance at a daughter's wedding.

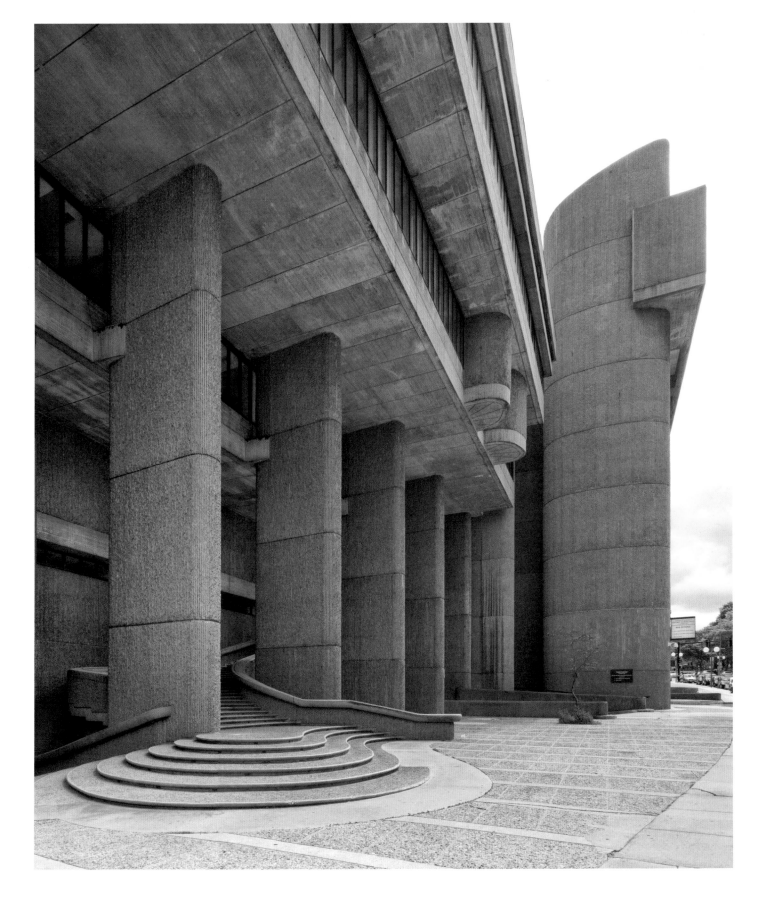

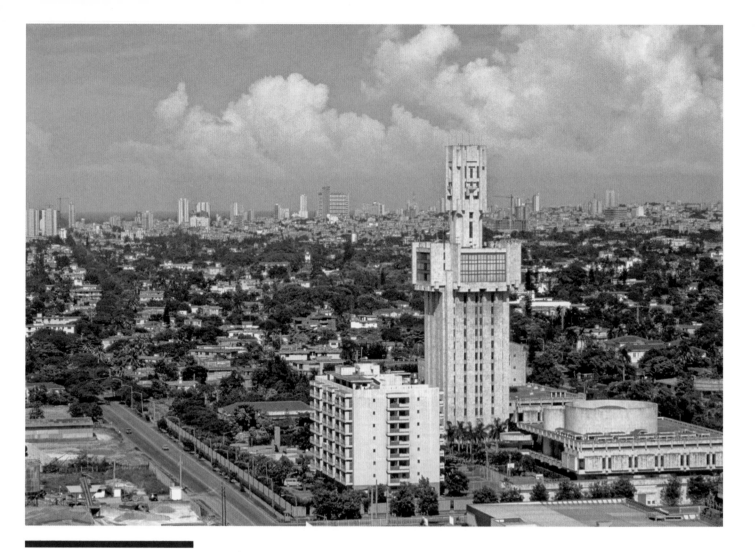

29

Havana

Cuba

1987

Aleksandr Rochegov

Embassy

While the Americans were busy fomenting counter-revolution and delivering exploding cigars to Fidel Castro, the Soviets took more of a benign interest in Cuba and its tropical wares: funding the anti-colonial epic Soy Cuba, with its stirring soundtrack and exquisite tracking shots, and building the mother of all embassies on the Havana seafront. Cubans ended up referring to this brute as 'La Espada de Rusia'. Sure enough Aleksandr Rochegov's tall tower does have something of the sword about it. The whole complex is huge,

a demonstration of Soviet influence at America's backdoor. Now it's Russia's embassy, not the USSR's. But the thing that's really worth noting is that brutalism and its bellicose buildings like this were universally associated with what lay behind the Iron Curtain. In fact the style was utterly globalised – you were as likely to see Americans building like this as you were countries of the Eastern Bloc. Along the road in front of the embassy are American and Russian cars too, but they're all old, 1950s Corvettes and 1980s Ladas.

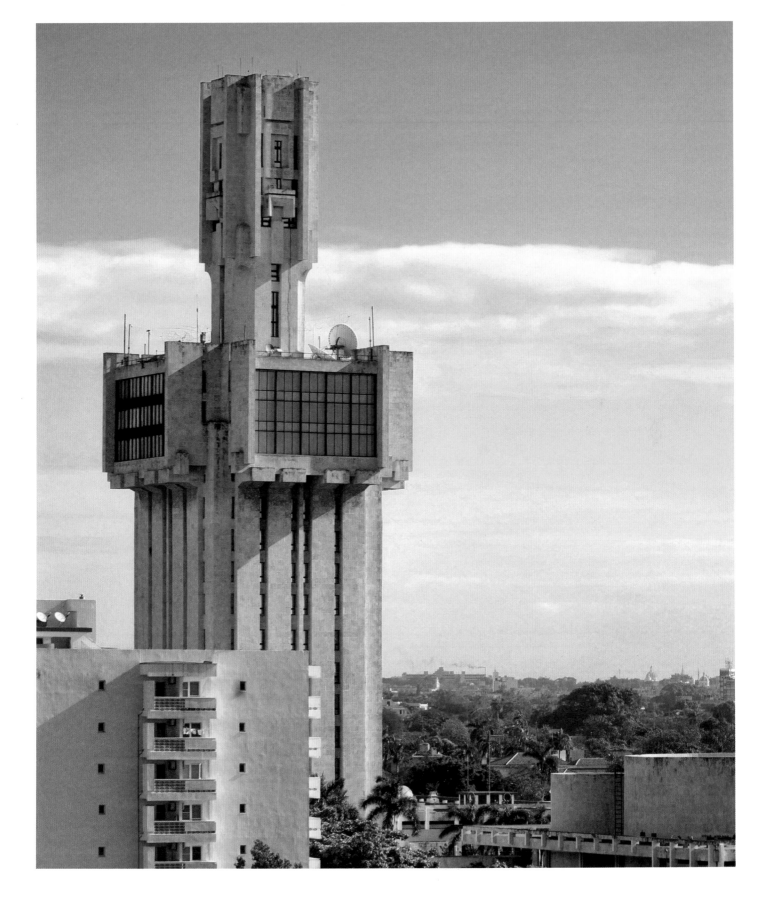

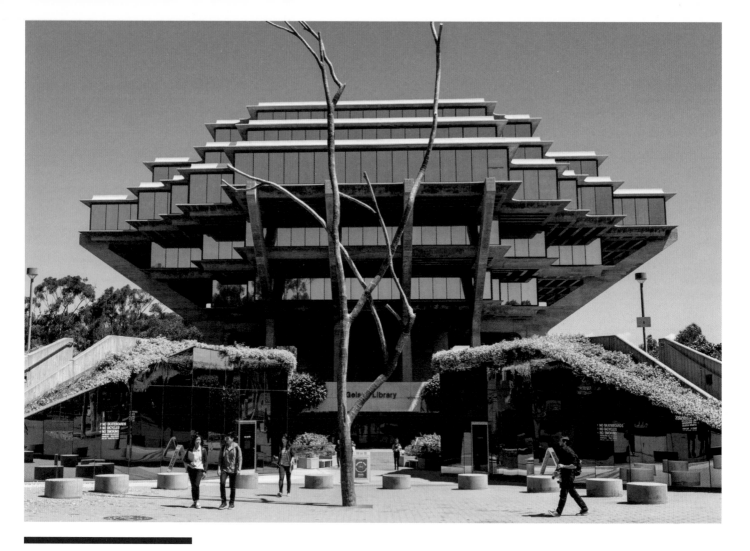

30

Geisel Library, UC San Diego

San Diego

USA

1970

William Pereira

Library

This is America. You want a brutalist icon with stardust sprinkled over it? You got it. In 1995 this university library was named in honour of Dr Seuss – Theodor Seuss Geisel. Geisel and his wife had helped out the library, and his books had inspired a generation of American kids to switch off the TV and read. Its architect William Pereira was a former Hollywood art director (on This Gun For Hire and Jane Eyre). Pereira also designed CBS's Los Angeles studios and after the Geisel Library he put up San Francisco's thrusting Transamerica Pyramid in 1972. But this is his masterwork. The treehouse feel of parts raised up, of boxy dens on concrete branches, mixes superman modern and something far more primal, more natural – oddly natural. The library is the centrepiece of a campus that boasts many other examples of interesting modern architecture. And this building is unique – an instantly recognisable addition to the San Diego skyline, an attempt to do something different that seems to have paid off handsomely. If brutalism needed a celluloid idol, this would probably be it.

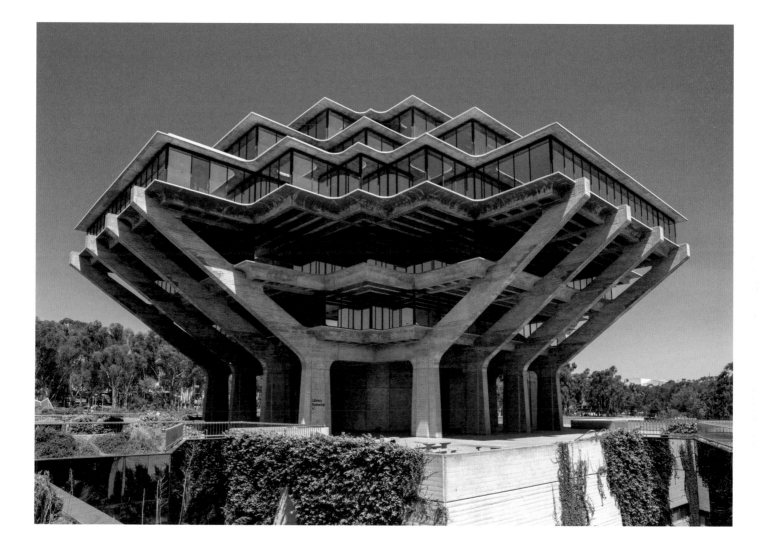

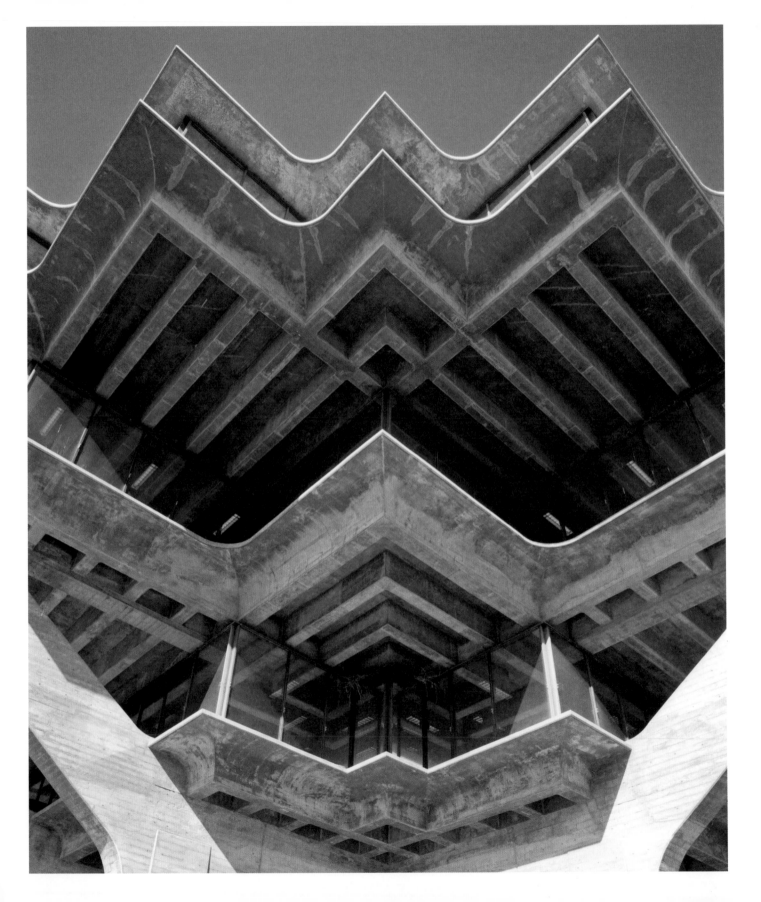

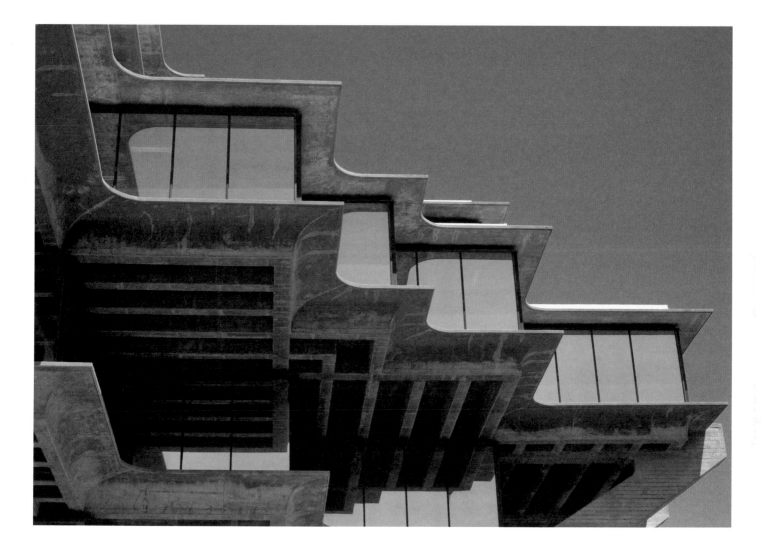

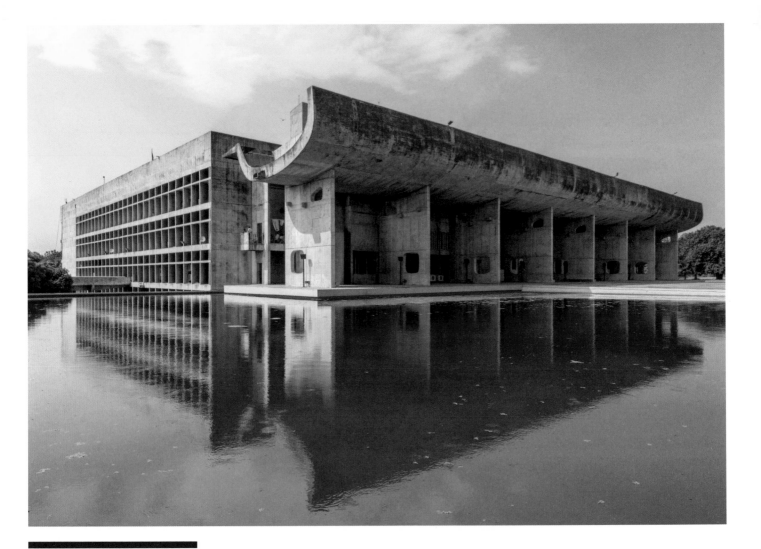

31

Palace of Assembly

Chandigarh

India

1956

Le Corbusier

Government

Under an unyielding Indian sun stands a cluster of Le Corbusier curios that few tourists trek to. Instead, the solid headquarters for various arms of the state government are mostly peopled by well-dressed Indian functionaries going about their business in a surreal landscape created by Europeans. Europeans had ruled over India and Europeans clumsily split the country – and that's why the state of Indian Punjab needed a new capital, because its previous one had been ceded to Pakistan by dopes wielding rulers in central

London. According to writer Jonathan Glancey it was the renowned British modernists Maxwell Fry and Jane Drew who lured the Swiss to come and design here. No doubt Corb was licking his lips at the prospect of getting the chance to wrap his sweaty mitts around a whole new city project, a Brasilia or a Canberra. Chandigarh is rather more laissez-faire than those two but Corbusier's Palace of Assembly sits pretty next to a lake, topped off with a jaunty concrete quiff that subtly suggests a Miro painting.

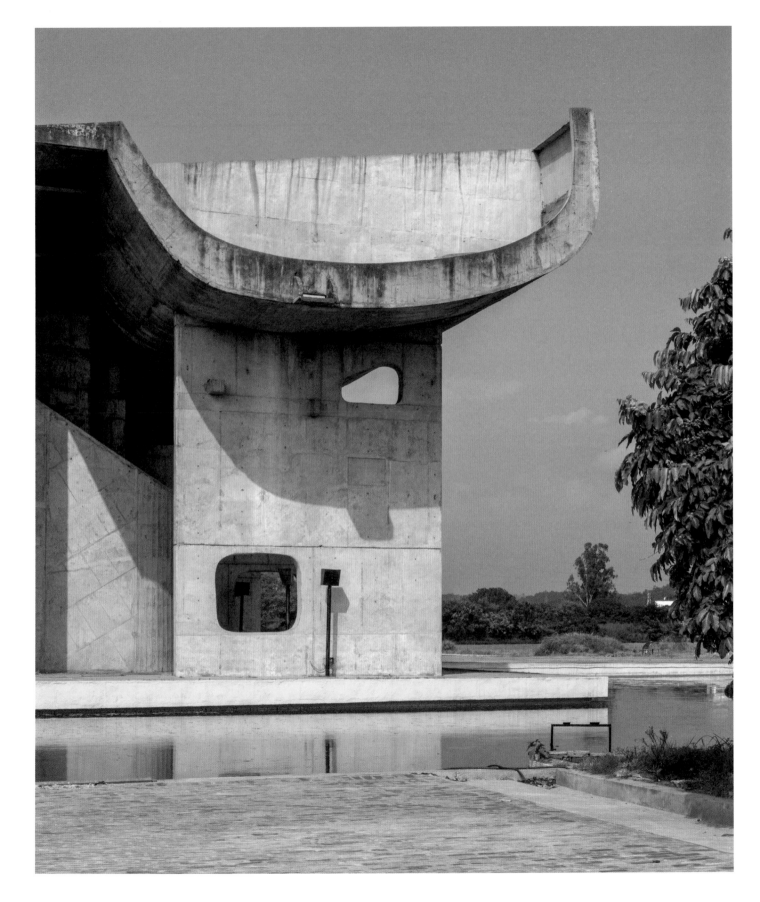

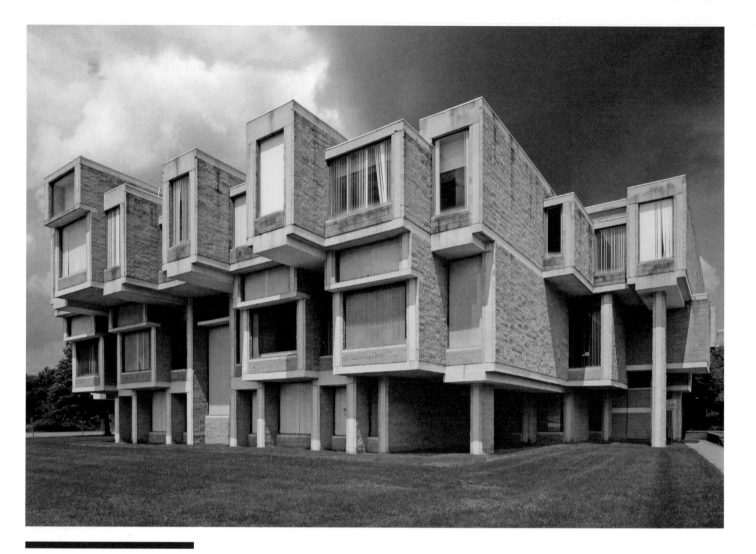

32

Orange County Government Center

Goshen

USA

1967

Paul Rudolph

Government/courts

Why do buildings have to be boxes? Paul Rudolph mulled this question over and ultimately challenged it. Here in Goshen he formulated a plan for offices and a courthouse which were anything but cookie-cutter. The form of the facade is heavily pixellated, and there's a certain space-station chic about the protuberances, none of which seem that necessary – they simply add interest. There's a comparison to be had with Nelson 'Rocky' Rockefeller and architect Wallace Harrison's grandiose wheeze in nearby Albany, the Empire State Plaza. That was a mix of international-style state-agency skyscrapers with the scale and scope of brutalism and some smaller buildings boasting piloti and exposed concrete. That whole epic plan was part of the Robert Moses slash-and-burn era – a Brasilia in New York State. Now turn your attention to Rudolph's gift to the people of Goshen – it is positively mild-mannered by contrast; low, charming, eccentric and worthy of keeping. Yet this building has been under threat for years – part of it was demolished in 2015 to, erm, improve it. It simply needs maintenance, and understanding.

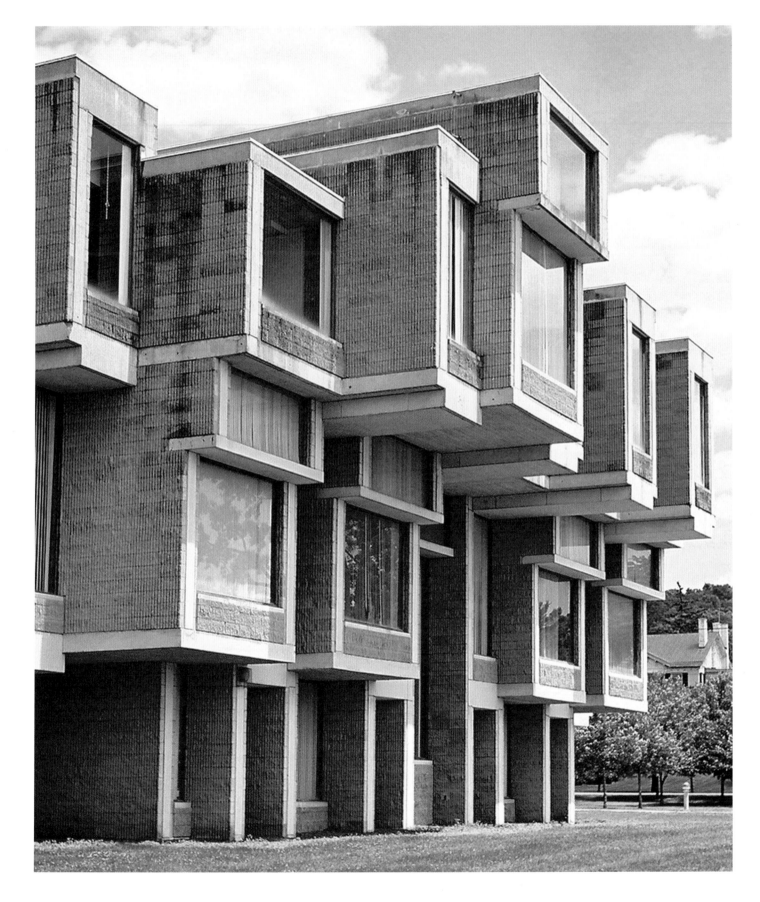

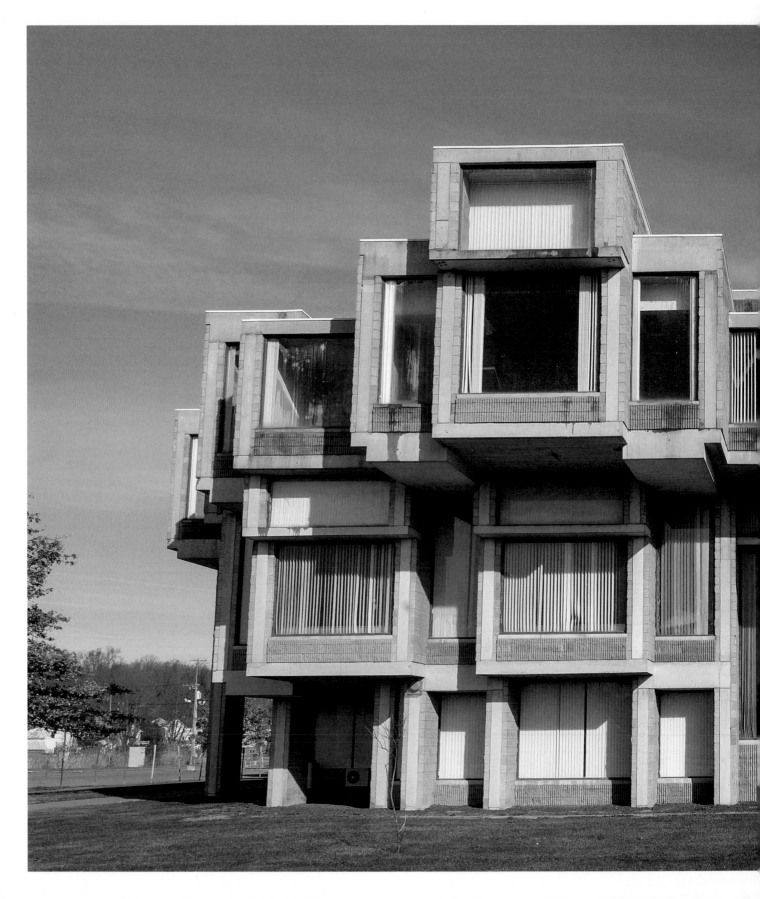

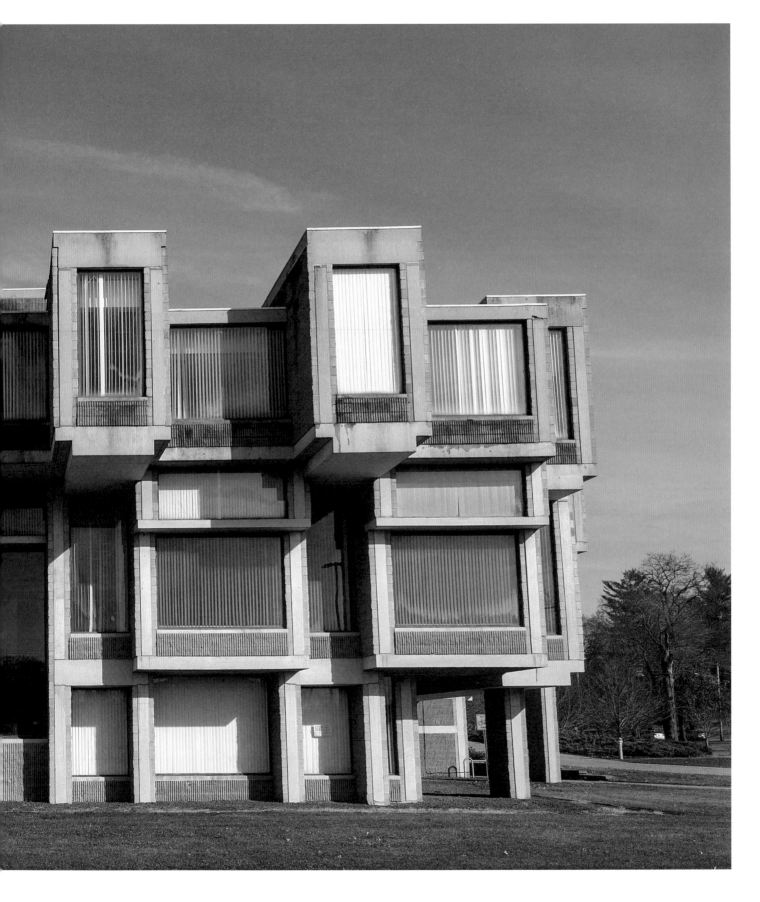

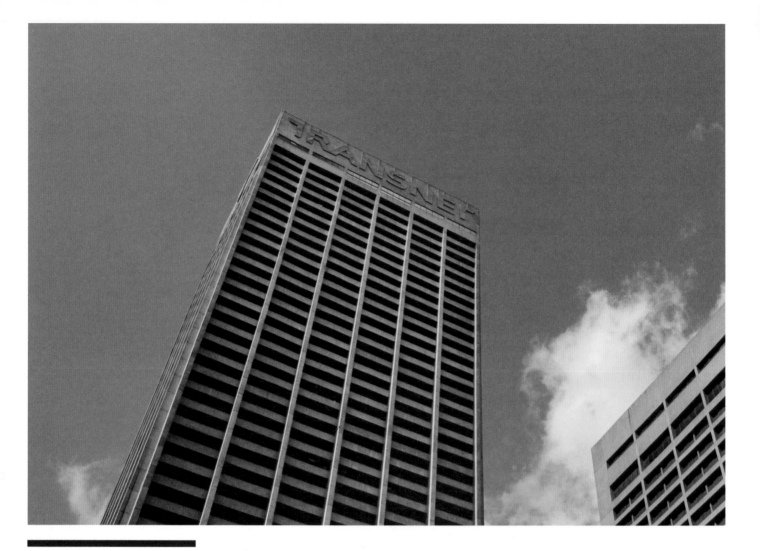

33

Carlton Centre

Johannesburg

South Africa

1973

Skidmore, Owings & Merrill

Offices/viewing gallery/hotel

From the viewing gallery at the top of the Carlton Centre – the 'Top of Africa' as they call it (it's the tallest building on the continent) – you can drink in the fiery, feisty streetscapes of rough-and-ready Jo'burg. It's apt that the New York of Africa got this American-style superblock of tall office tower and hotel, both in gritty yellowing concrete which apes the colours of the nearby goldfields – the architects are American and the styling is too. The grid of streets and the double-deck M1 Highway you can peer down on are pretty American as well. But before you order a hamburger on autopilot, check out Johannesburg's other bits of brutalism – the stocky Hillbrow Tower is a communications aerial which belongs in East Germany. Next to it, the Ponte City Tower apartments seem as though they belong on another planet 200 years in the future. They are awe-inspiring. The Carlton Centre dates from South Africa's shameful apartheid era, but today everyone is welcome. Africa's most dense, westernised urban environment seems apt for all these buildings.

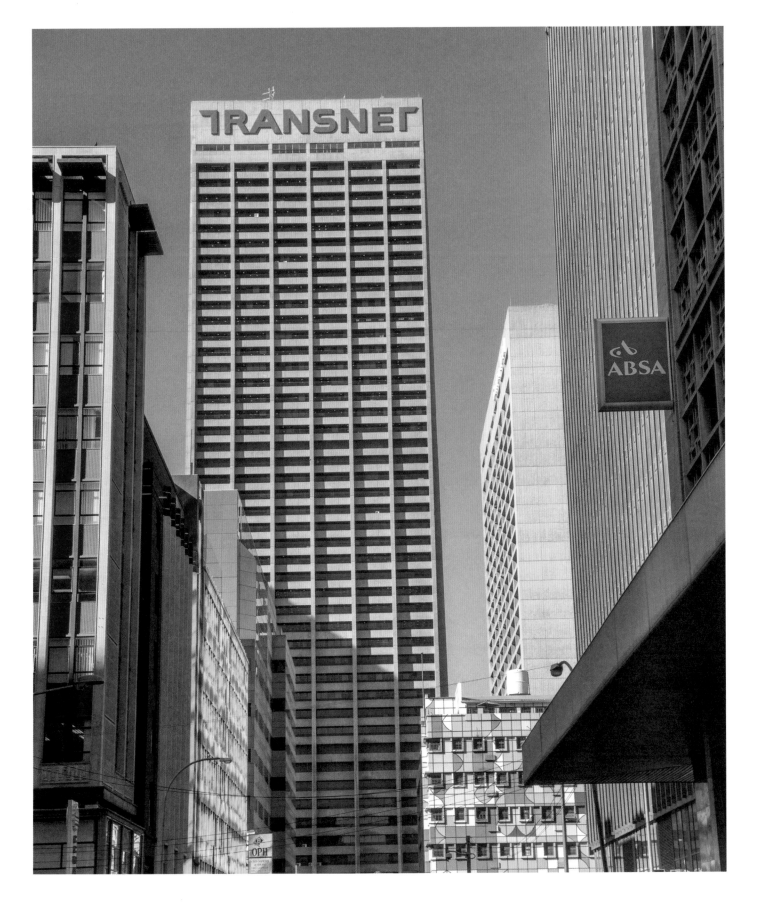

34

Birmingham New Street Signal Box

Birmingham

England

1964

Bicknell & Hamilton with WR Healey

Railway signalling

In the era when this railway signal box was conceived, grandma's idea of the height of teatime chic was to serve crinkle-cut chips. Also known as 'wavy fries', these delicacies were reserved for special occasions only. Could it be that Bicknell, Hamilton and Healey were inspired by the humble crinkle-cut chip? The crinkle motif is deployed right around this neat monument to the era of white heat and 'never having had it so good'. The building, which houses railway signalling and telecommunication equipment, rewards repeated viewing from different angles. It's solid and exciting and brightens up Birmingham's core. The box is part of the 1960s modernisation of Britain's West Coast Mainline, where Victorian rail infrastructure was mercilessly trashed and new stations built in their place. New Street Station itself has been modernised recently, but some of that '60s spirit lives on in the interesting and underrated modernist stations at Manchester Oxford Road, Stafford (where the exposed concrete is uncompromising) and London Euston – which is wrongly unloved.

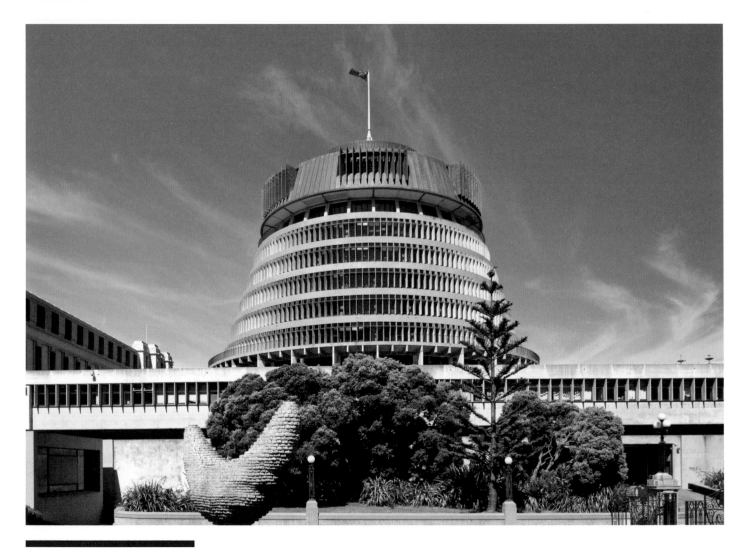

35

The Beehive (New Zealand Parliament, Executive Wing)

Wellington

New Zealand

1977

Basil Spence et al

Government

Basil Spence was an establishment man with a moustache and a military record, a jolly decent fellow who the state trusted to get on with the job. The Executive Wing of the New Zealand Parliament in Wellington is one of his most elegant designs – shapes like this remind a chap of his egg cup or tea mug. The chummy cylinder houses offices for NZ's PM and meeting rooms for cabinet sessions. There's no danger of this one being pulled down, as it's quite liked in the NZ capital– though elsewhere, Spence hasn't always fared so well. His 1962

Queen Elizabeth Square blocks at Hutchesontown in Glasgow's Gorbals were demolished, and only fragments of his interesting 1966 terminal at Glasgow Airport are visible under the layers of deadening modernisation that have been slopped on over the years. Hyde Park Barracks in London has been under threat for some time, no doubt due to the astronomical value of the land it sits on, as much as any supposed aesthetic concerns about the place – which is actually a rather fetching slice of high-density housing.

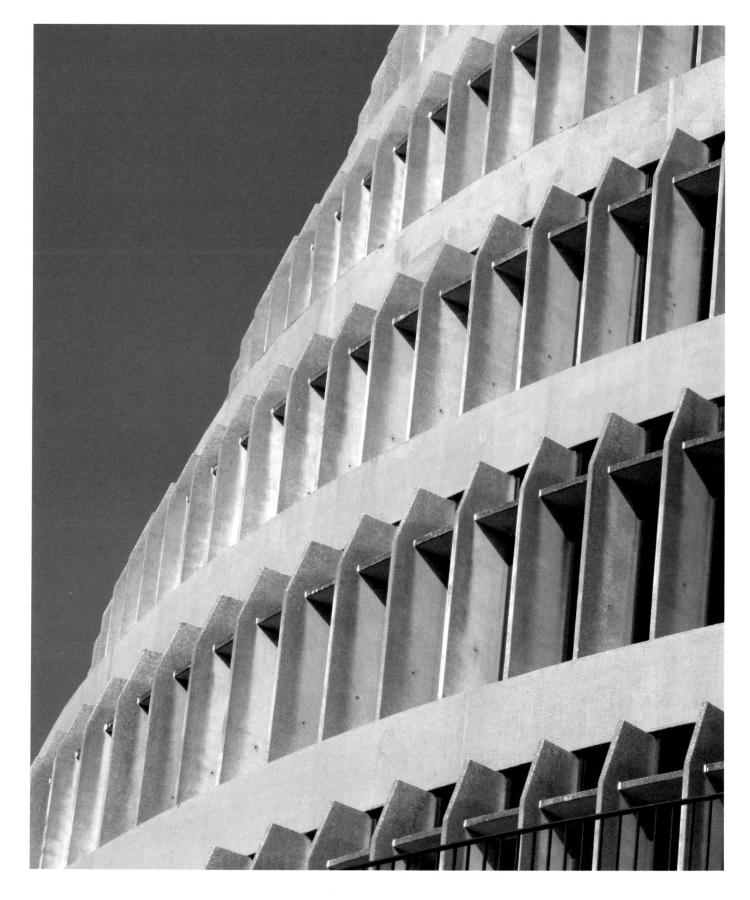

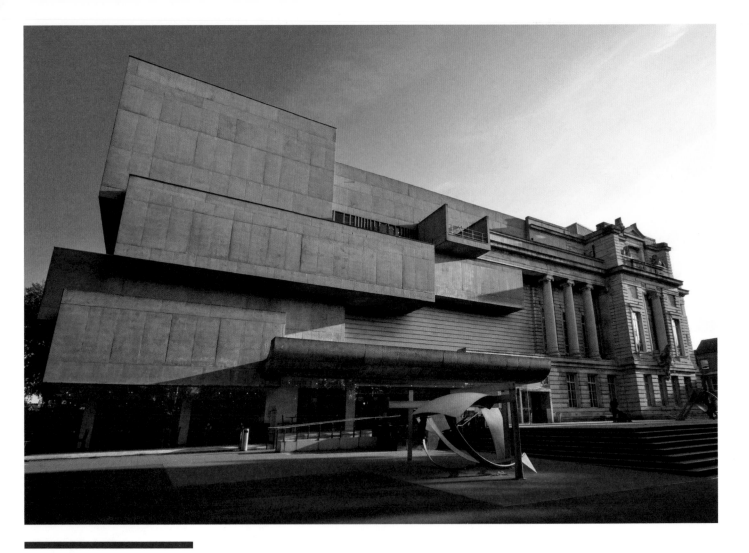

36

Ulster Museum Extension

Belfast

Northern Ireland

1964

Francis Pym

Museum/art gallery

A strange building for strange times. Only a few years after this bold extension of the former Belfast Museum (now Ulster Museum) opened its doors, Northern Ireland's simmering tensions erupted into seething, gruesome, violent civil conflict – it was dirty and messy and scarred a generation. This building was never featured on news reports of the time; we never saw the bucolic gardens that surrounded it or the art inside. This did not fit the official story. Francis Pym's faceless extension seems to be moving around when glimpsed through the trees, like some giant game of Jenga. A rare oasis of culture and sanity in a city that was falling apart, the museum survived that torrid era and prospers today. Two caveats: there is a sobering retelling of The Troubles inside; and despite its peaceful and civilised status, that 1964 extension does seem to be aggressively manhandling the 1929 original building it's soldered on to – maybe it was more of an emblem of those dark days than it realised?

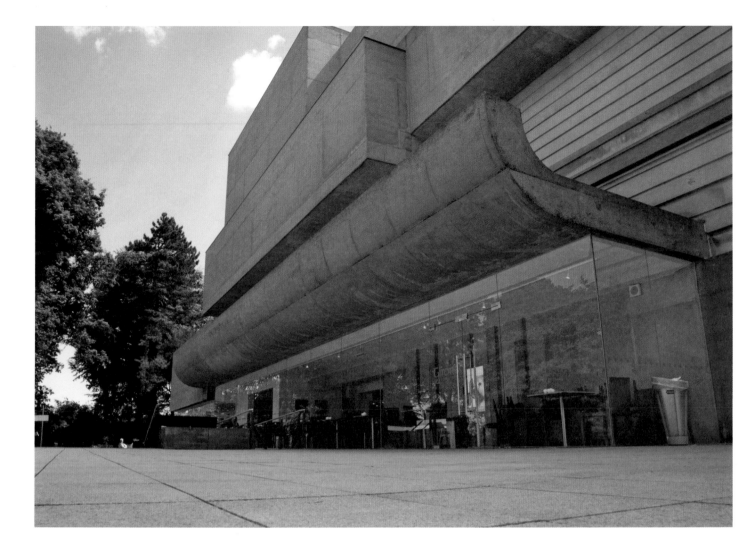

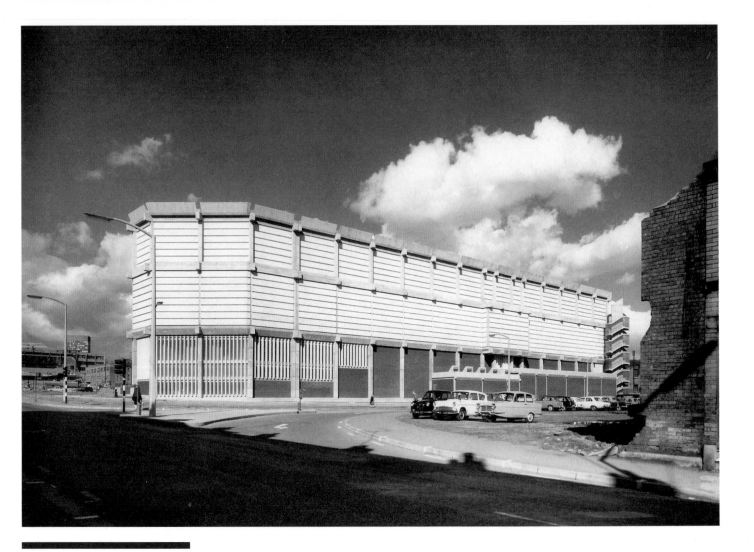

37

Moore Street Electricity Substation	Park Hill Estate
Sheffield	Sheffield
England	England
1968	1961
Jefferson Sheard	Jack Lynn and Ivor Smith
Electricity substation	Housing

**Moore Street Electricity
Substation, Sheffield, England.
Jefferson Sheard**

The modern world came to Yorkshire, northern England, in style, partly thanks to Sheffield's chief architect Lewis Womersley and then also because the Steel City's rock-hard socialist council was determined to create a modern industrial metropolis for the people. Once the impressive monuments like Moore Street Substation (a great ambiguous, abstracted hulk) and Park Hill (an ambitious snake of flats prowling across a hilltop above the train station) were completed, their physical presence began to define the entire city. The kitsch promo film Sheffield On The Move shouted about the city's new architecture, and the music of Pulp reflected a certain working-class aspiration that these buildings reflected. Not everything from those days remains: the surreal 'Hole in the Road' roundabout with its aquarium is just a memory; the grey, thrilling bazaar of the Castle Market couldn't make a case for itself in modern Sheffield either. But other brutalist offices and hotels remain in the People's Republic of South Yorkshire and both Park Hill and Moore Street are a reminder of some exciting times here.

141

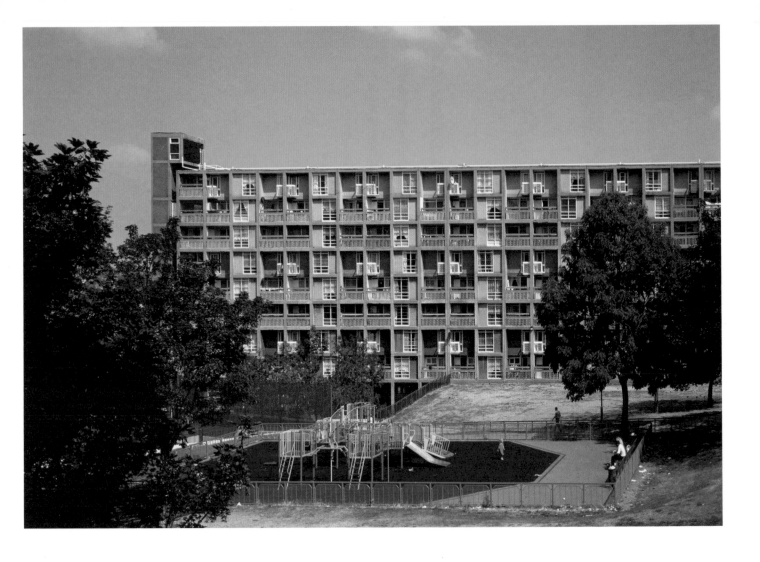

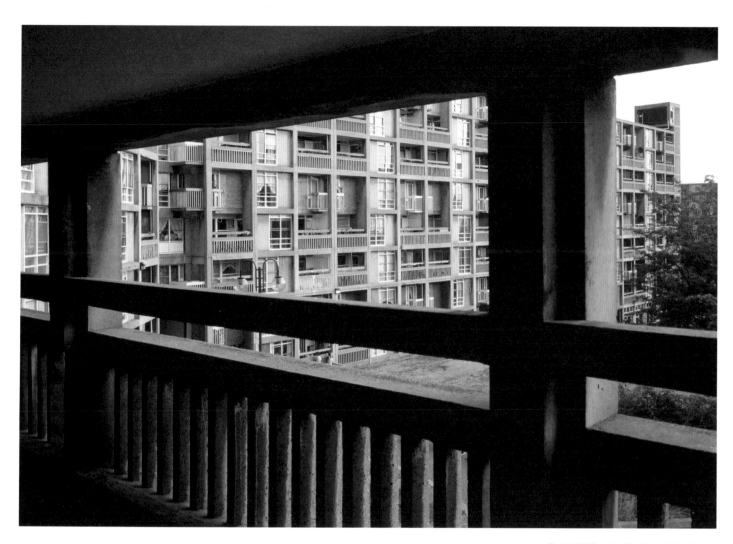

Park Hill Estate, Sheffield, England.
Jack Lynn and Ivor Smith

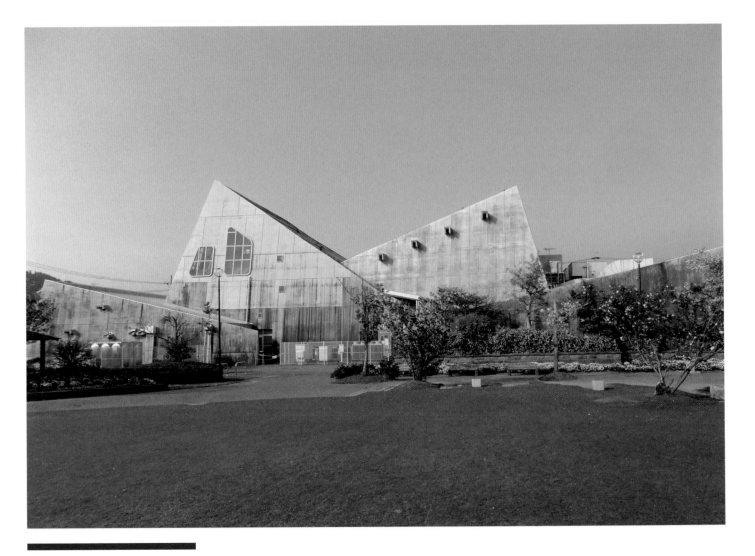

38

Nichinan Cultural Centre

Nichinan

Japan

1963

Kenzo Tange

Culture

Kenzo Tange was the wide-eyed wild man of Japanese mid-century design, bringing a muscular modernity to a country that wanted to forget the past, and yet was deeply rooted in a complex history. Whereas Tange's Hiroshima Peace Memorial of 1956 promised a clean, rectilinear, calm modernism, by the time Nichinan Cultural Centre appeared, he was going full throttle. This arts centre on the southern Japanese island of Kyushu is militaristic and bunker-like – confident, not apologetic. Tange kept on knocking out beasts: the Kurashiki City Hall in 1960 with its wide concrete facades and the Yoyogi National Gymnasium in Tokyo for the 1964 Olympics. By the time the Yamanashi Broadcasting Centre in Kofu went up in 1967, he was unstoppable. These offices for several media companies were bravura, bulky and unforgettable. It was no wonder that Tange was one of the minds picked to put on Expo 70 in Osaka and showcase Japan to the world. By that point Tange was moving away from brutalism, but he'd already left a potent legacy.

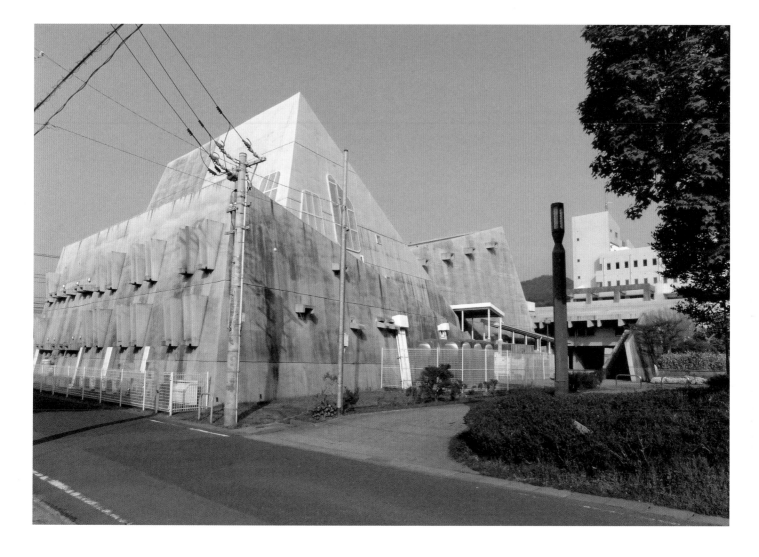

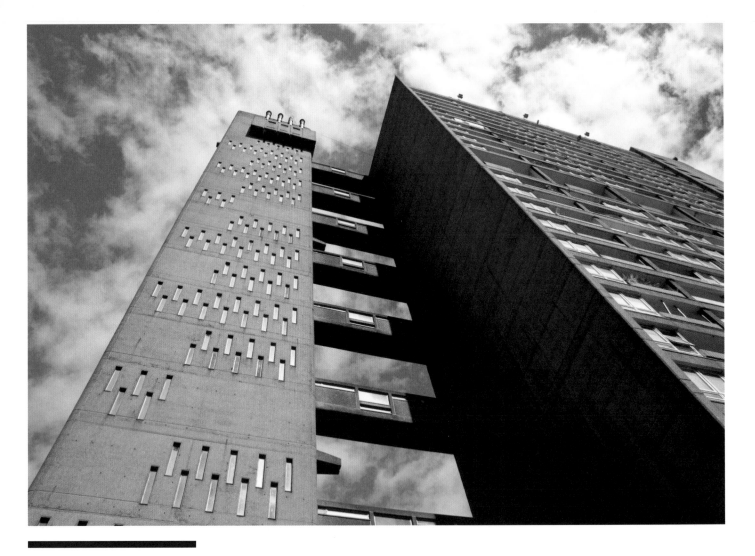

39

Balfron Tower	**Trellick Tower**
London	London
England	England
1965-67	1972
Ernö Goldfinger	Ernö Goldfinger
Housing	Housing

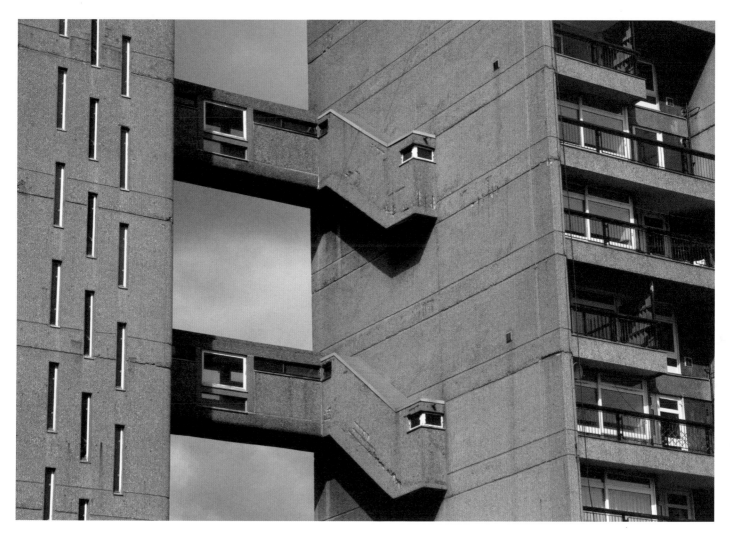

Balfron Tower, London, England.
Ernö Goldfinger

Balfron is a tough-as-old-boots block that glowers down at Poplar's circuit board of dual carriageways. It doesn't care about the hubbub below. Up in the air are flats with astounding views and huge rooms, a testament to the power of public housing in the post-war British welfare state. Its architect, Hungarian hat-wearer Ernö Goldfinger, sipped cocktails with the residents up in his bolthole while he lived here for a few weeks with his wife Ursula. This little ruse probably inspired JG Ballard's architect in High-Rise, Anthony Royal. In recent times, artists lived in the block and Shakespeare was performed in it. Its refurbishment apparently cost so much that many of Balfron's council tenants were out on their ear, while the inevitable gentrification is ushering in aesthetes with fatter wallets who dig concrete living and can buy their own flat. An odd ending to the tale. Goldfinger learned his lessons from the tenants at Balfron and a few years later he was at it again with the similar Trellick Tower in North Kensington. That building became another icon of London's brutalist tough-love aesthetic. It was high drama incarnate: poised over the screaming traffic of the new Westway motorway which snaked over the west London rooftops. Not only was it immediately visible from the cars driving out towards Heathrow and Oxford but also from the trains that ran right past too. It continues to be London's most visible brutalist landmark. Trellick experienced more social problems than Balfron yet its renaissance among the design cognoscenti began early, in the 1990s, and spurred the reappraisal of the brutalist style.

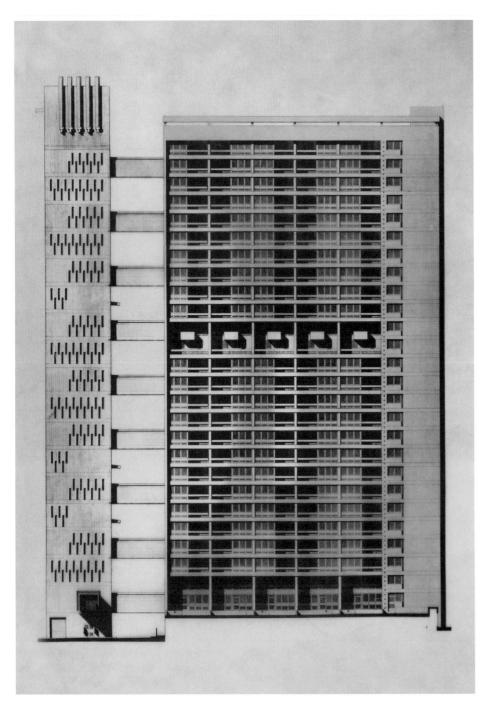

Above: Balfron Tower west elevation
drawing, 1965. Right: Balfron Tower,
London, England. Ernö Goldfinger

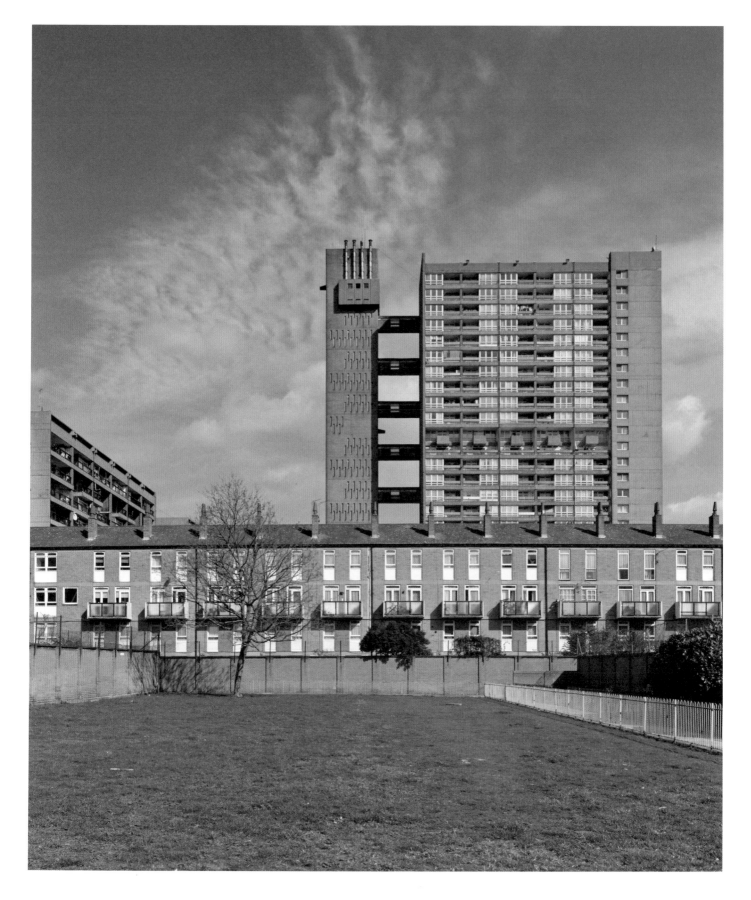

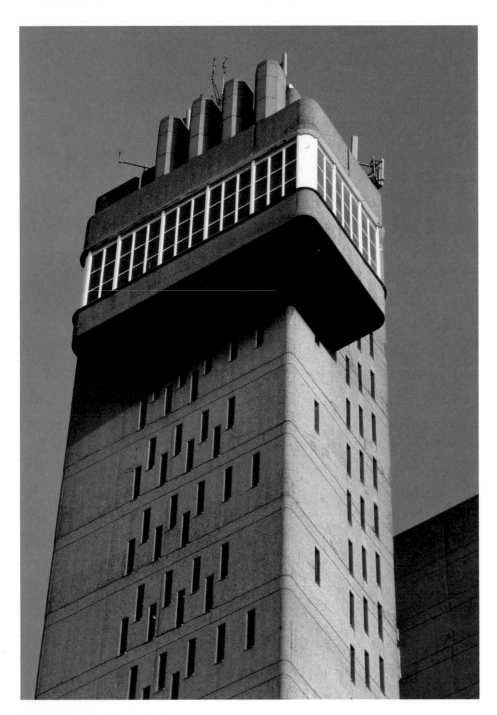

Trellick Tower, London, England.
Ernö Goldfinger

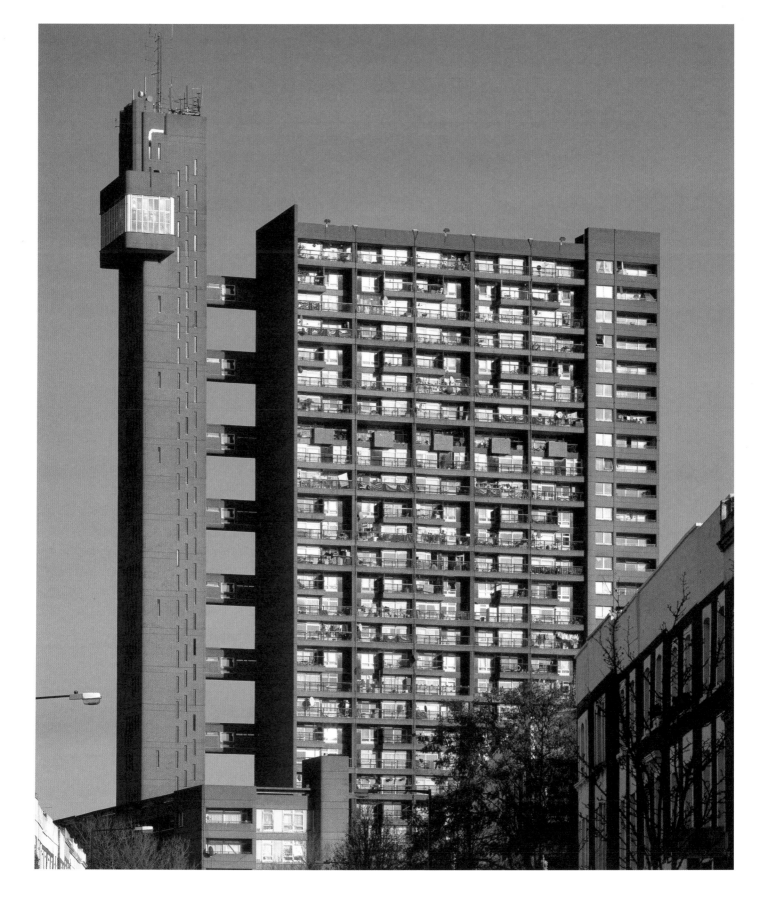

40

Palácio da Justiça

Lisbon

Portugal

1970

Januário Godinho and João Andresen

Courts/offices

There are some elements of this building which are eerily familiar, like a recycled storyline from a telenovela. Doesn't it make you think of Unité d'Habitation (p18)? The shape of the total ensemble evokes Corbusier's Marseille Maison du Fada, so do the pilotis it's piled up on. And yet, there are also decorative touches which announce themselves as being a bit off-kilter, a bit tropical – the repeated patterns of squares and circles aren't immediately familiar. They come from a hotter, more exotic kind of place – maybe even Portugal's former colony,

Brazil. Januário Godinho and João Andresen's collection of courts and offices certainly has a kind of stateliness associated with legal distractions. And because it sits sort of marooned away from other buildings competing for attention, its potency is increased somewhat. It's not the only brutalist work in Lisbon: there's also the 1969 Calouste Gulbenkian Museum from Alberto Pessoa, Pedro Cid and Ruy Athouguia and there's the Caixa Geral de Depósitos – which flirts with showy postmodernism above a firm brutalist base.

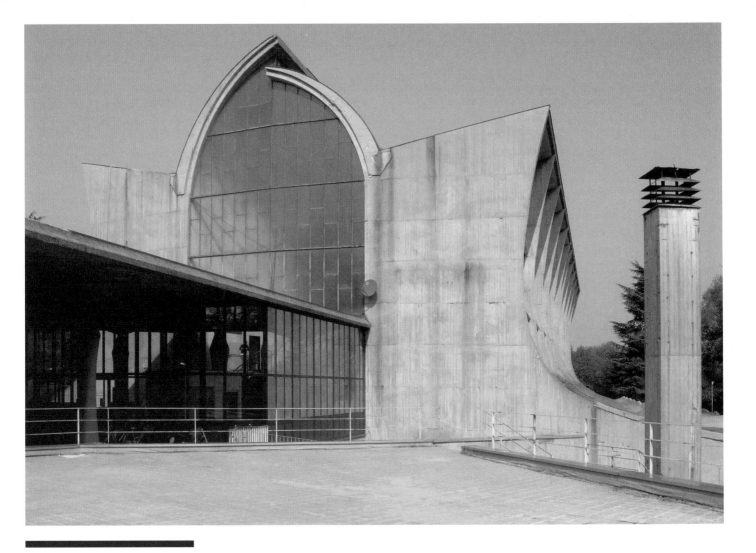

41

Busto Arsizio Technical College

Busto Arsizio

Italy

1964

Enrico Castiglioni and Carlo Fontana

Education

Busto Arsizio developed into an industrial city –
no doubt helped by its proximity to Milan, the
working, shopping, spending and preening capital
of Italy. Perhaps the influence of such Milanese
erections as the 1958 Torre Velasca by Gian Luigi
Banfi, Lodovico Barbiano di Belgiojoso, Enrico
Peressutti and Ernesto Nathan Rogers – a real
mix of medieval heft and modernist tub-thumping
– were in the minds of Enrico Castiglioni and
Carlo Fontana when they designed the city's new
technical college. Velasca was no-nonsense,

almost a single-finger salute on the skyline.
But then Milan doesn't obsess about its history
like Rome. Nearby, Malpensa Airport was being
expanded at exactly the same time that the college
was being dreamed up. There's something in the
college suggesting flight, movement at least, in
the curved shapes of the back-to-back pieces.
Each resembles a sofa or a piano maybe, but not
a sofa or a piano that wants to stay as still as
it should. The great side walls of unadorned,
shuttered concrete are an arresting addition too.

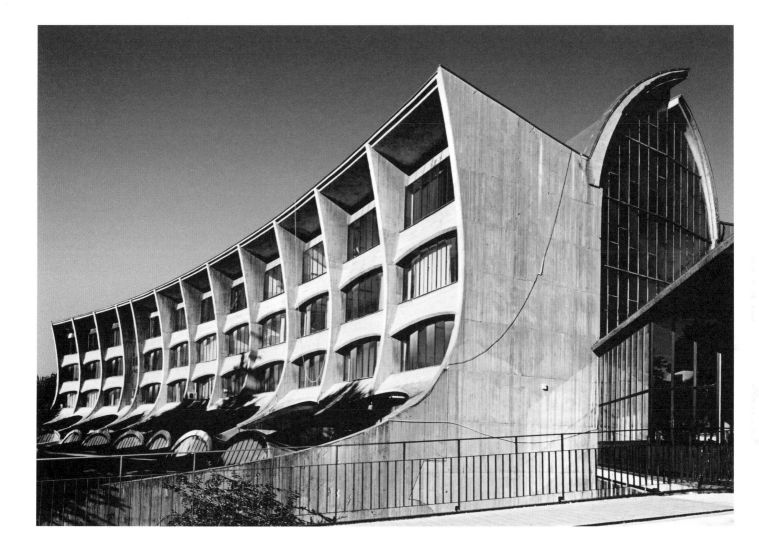

42

The bridges, tunnels, tollbooths and service areas that popped up next to the new motorways of the 1960s started as fat inky lines on a map. They defined a new, not altogether friendly liminal landscape that was inhuman in style and scope. This odd new world of flyovers and tarmac and amber glow and din was mined by Chris Petit in his road movie Radio On and in the documentaries of Patrick Keiller. In Birmingham things were more kitsch: a junction informally named after a plate of pasta was the scene for Cliff Richard's

bizarre musical Take Me High in which he takes to a hovercraft and races along the canal under the shadow of the the motorway. It also featured in the surreal BBC drama Gangsters. As with all these big bits of motorway the drama comes from all the precast concrete immodestly on show. It might be civil engineering rather than a building per se but the centipede-like flyover legs striding across the post-industrial wastelands and past Gravelly Hill's Armada pub beer garden are as hard to ignore as skyscrapers.

157

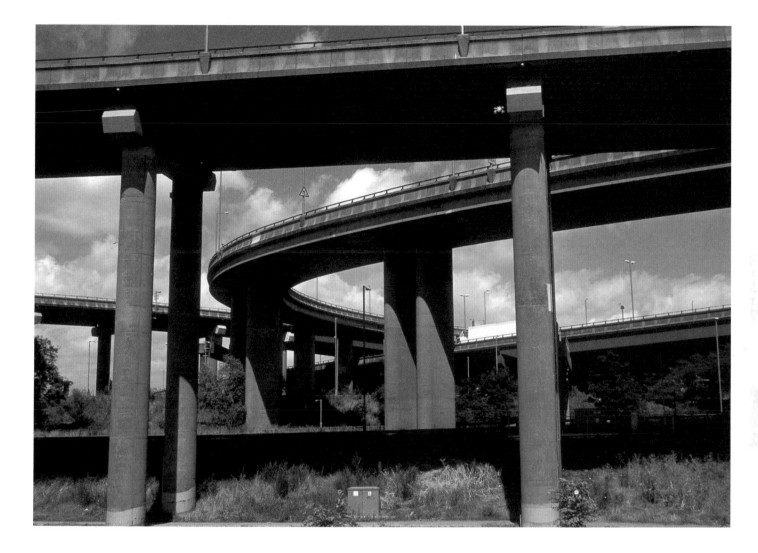

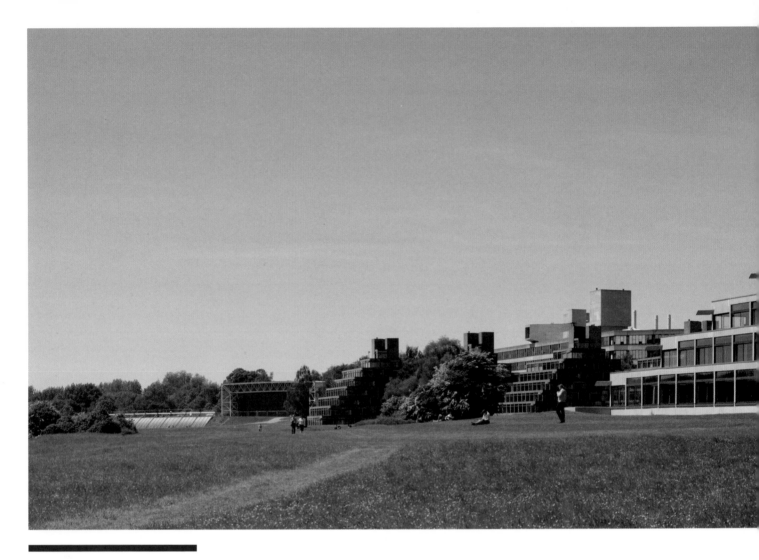

43

University of East Anglia

Norwich

England

1968

Denys Lasdun

Education

What is it about Mesopotamia and Mexico that so enthralled the post-war architects? They might not accept that they were influenced by the way that ancient civilisations laid down their stones in huge, frightening piles. But there is something in the way that ziggurats recur in brutalism; ziggurats potently press our buttons – apparently. Whether pointing to hell or the heavens, ziggurats are primal, affecting shapes. Denys Lasdun's student halls – Norfolk and Suffolk Terrace – bring powerful architecture to the sleepy Yare Valley and were the star attraction of

Norwich's new 1960s university, which is a fiesta of grey walkways and fun flights of steps. The halls are still used today, even though the bedrooms don't come with bathrooms – which is considered too 'retro' by some of today's students. However, one UEA undergrad defended Lasdun's aesthetic to British student newspaper The Tab by positing: "concrete looks totally badass" and adding: "Why do you need ensuite when you can piss in your sink?" Two sentiments that we can all surely agree with.

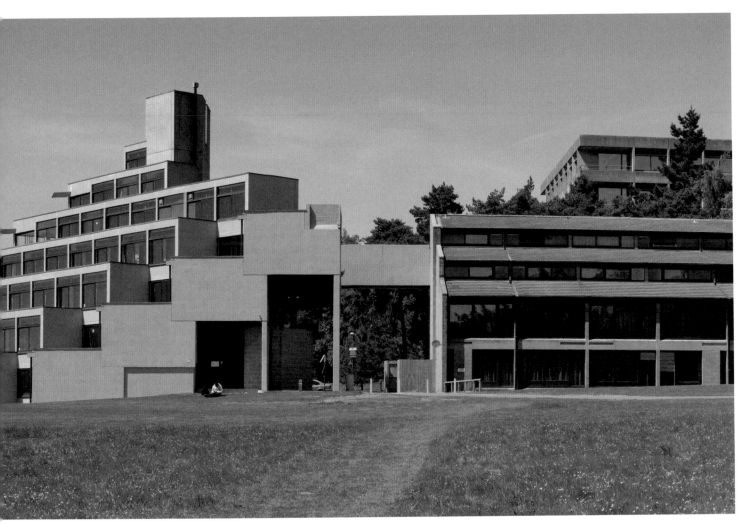

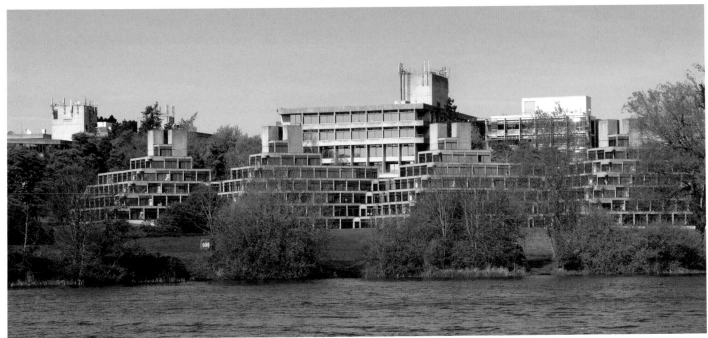

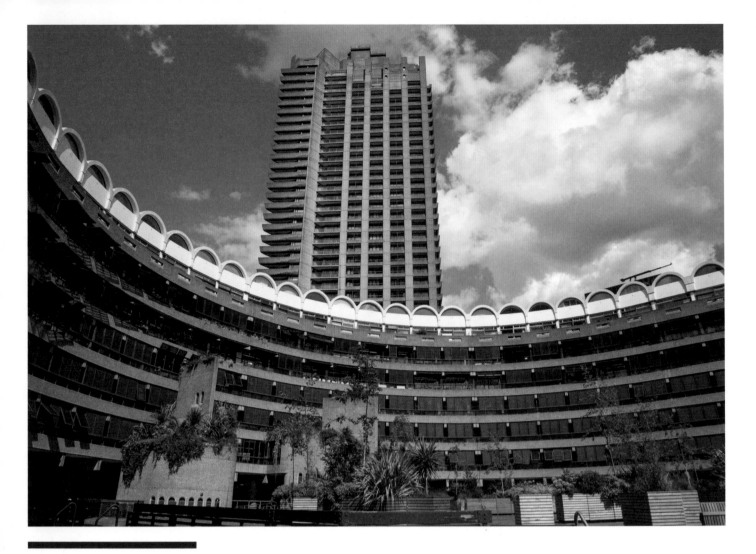

44

The Barbican

London

England

1965-82

Chamberlin, Powell & Bon

Housing/school/culture

Strange futures. These big spaces provoke thoughts of big visions: how big visions no longer float through architectural offices or planning departments. Eerily quiet highwalks, watergardens, wonderfully generous flats, a world-class arts centre: the real surprise about the Barbican is just how restrained and civilised such a bloody big project ended up being. There is gnashing concrete – especially on the trio of tower blocks, the most heart-stopping chess pieces on the board. But it's also a very sedate, middle-class sort of

modernism here. Which is why conservative Britain rather likes this super-sized site on former bomb-damaged land. Chamberlin, Powell & Bon did the design, after they graduated from the pleasing Golden Lane Estate, right up against the Barbican's northern border. Another interesting oddity is the stark Museum of London glued on to the opposite, southern side – and the elevated 'Pedways' for pedestrians feeding up to the Barbican and museum from London Wall. Every '60s city wanted its Pedway, from Leeds to Minneapolis.

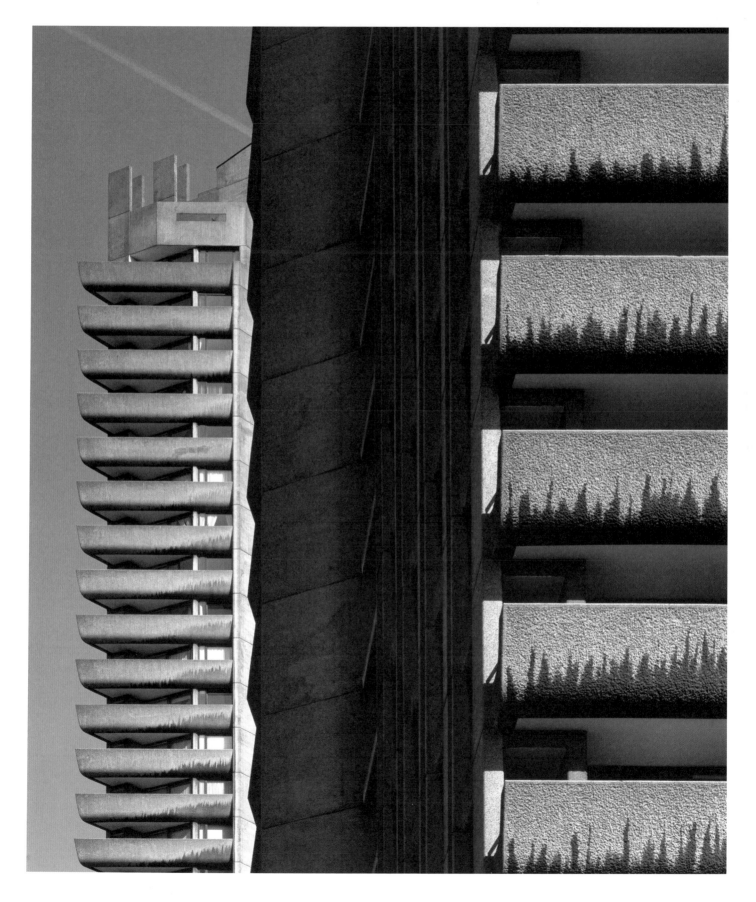

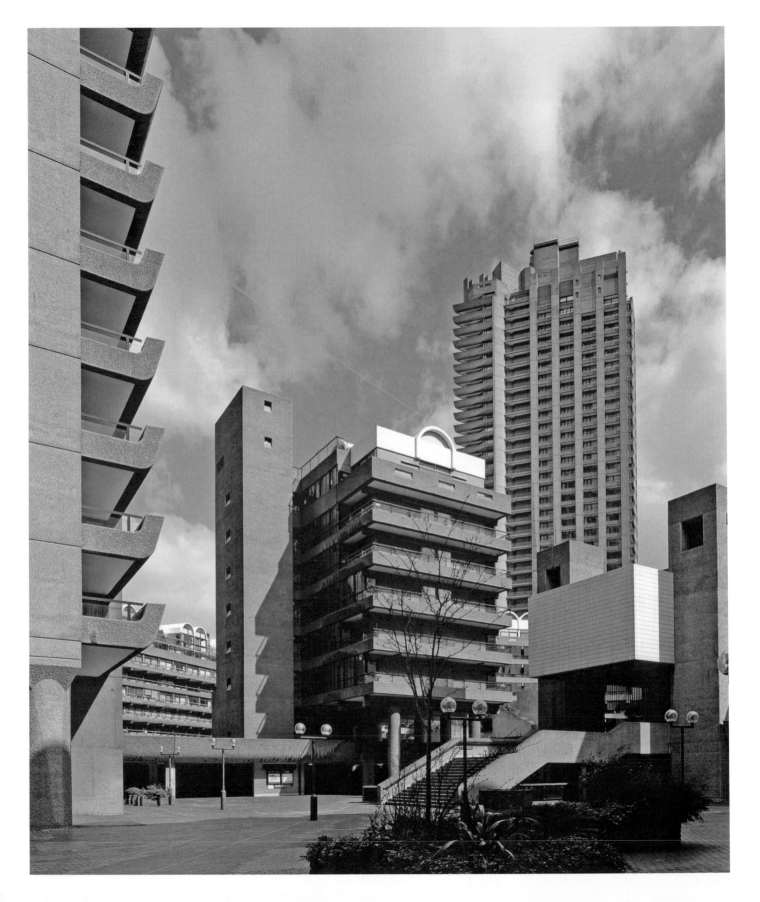

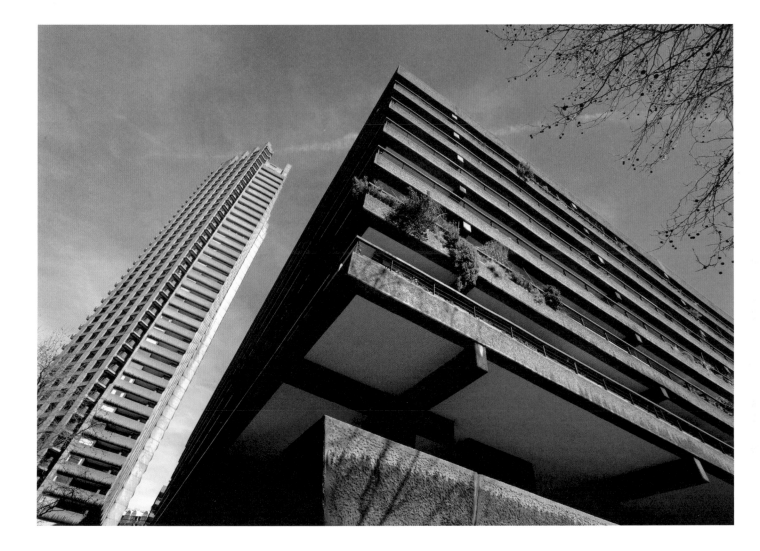

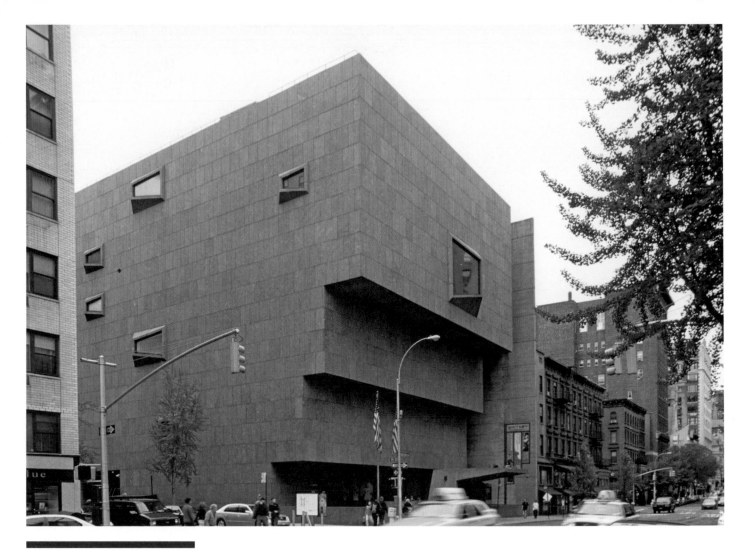

45

The Met Breuer

New York City

USA

1966

Marcel Breuer

Art gallery

Marcel Breuer's gallery on New York's Upper East Side looms. Maybe it wants to give you a tap on the shoulder. Its stepped shape puts one in mind of a puzzle piece from the computer game Tetris, fallen from the sky to land squarely on the corner of Madison Avenue and 75th Street, a block shy of Central Park. Despite all this, it's refined. It's clad for the most part in granite; gutsy extrusions and exposed concrete are minimised so as not to upset the delicate sensibilities of Manhattan's well-heeled gallery-goers.

The building put in a relatively modest 38 years of service as the Whitney, lay empty between 2014 and 2016, and has now been reborn as an offshoot of The Metropolitan Museum of Art, which itself is only six blocks north of here. The Met have tipped their hats to Breuer by dubbing their new toy The Met Breuer, a kind gesture which acknowledges the Hungarian's efforts in sculpting a gallery with extraordinarily large interior spaces and intriguing wonky windows which catch the eye of passers-by.

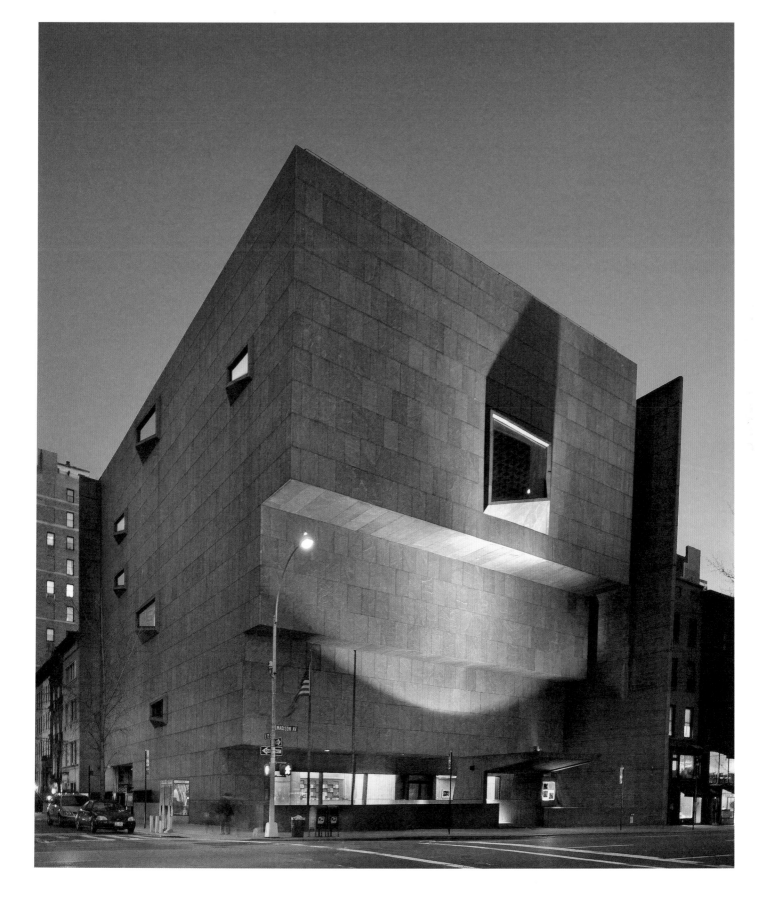

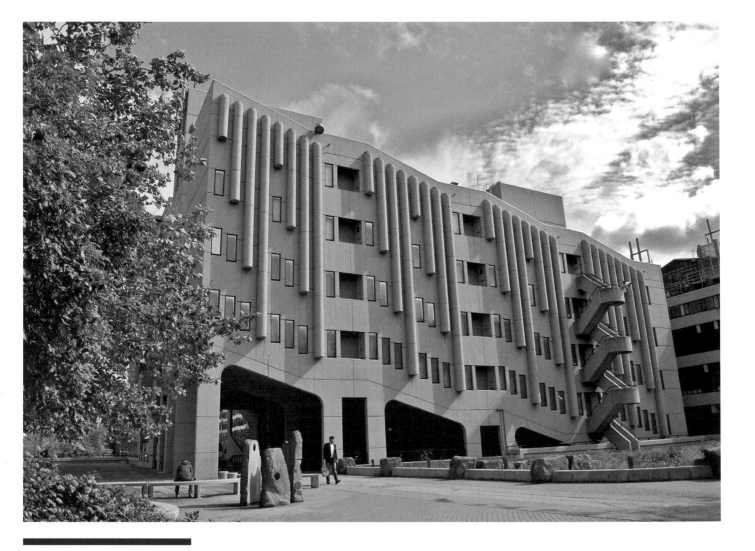

46

Leeds University

Leeds

England

1963-75

Chamberlin, Powell & Bon

Education

The giddy topography of Leeds north of the River Aire was the wellspring for the madcap ideas that swirled around in the 1960s. The full networks of underground and overground passageways were never realised, but at the city's university, the dreamers' schemes became a partial reality. Therein walkers are funnelled from the Edwardian campus into the Red Route corridor, which flies out into space as the hill drops away towards the city centre and river. The corridor can seem as interminable as the academic treatises students sleepily plough through in the comforting Edward Boyle Library. The Roger Stevens Lecture Theatre (pictured) is bold as brass, the masterplan by Chamberlin, Powell & Bon is a thrill ride of courts, right-angled blocks and walkways. The levels were colour-coded to contours, so the Red Route maintained the ground level of the red contour at the top of the hill. All levels in the city were to be renumbered too – from one at the river to seven where the Red Route hits land. Only the university followed through on this.

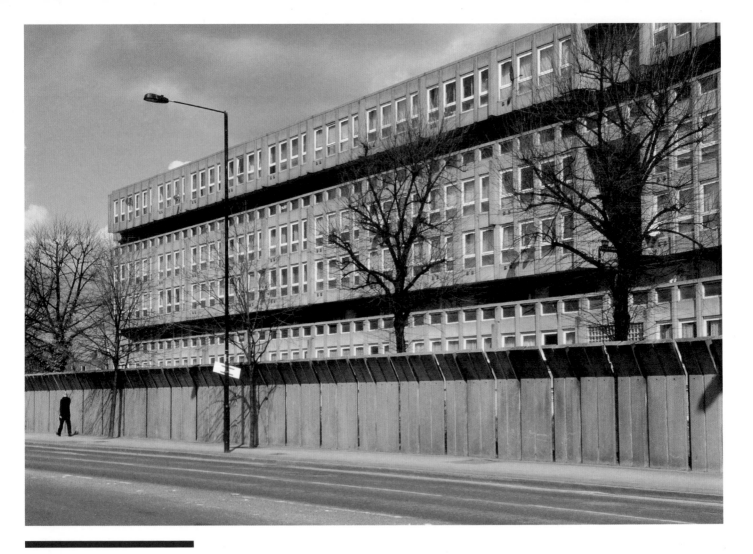

47

Robin Hood Gardens

London

England

1972

Alison and Peter Smithson

Housing

There's something strange in the air at Robin Hood Gardens in east London. One feels the heavy presence of the Smithsons: the lush central gardens are deserted. What's that rustling in the hedges though? A discarded copy of *The Economist* – Alison's ghost having a laugh? The couple's most critically accepted work was their HQ for *The Economist* in posher Piccadilly. The firebrand writer BS Johnson made a film for the BBC in 1970 called The Smithsons On Housing, about Robin Hood Gardens. Alison dressed like Barbarella and talked about "the poetry of the ordinary". But she and Peter were from the avant garde: they exhibited at This Is Tomorrow at the Whitechapel Gallery in 1956 with the likes of Victor Pasmore, Eduardo Paolozzi and Ernö Goldfinger. The pair were championed by beardy weirdy academic Reyner Banham and although their 1954 school at Hunstanton was dubbed 'new brutalism', that was due to its structural honesty rather than any raw concrete deployment. Robin Hood Gardens is starker, and who knows: haunted?

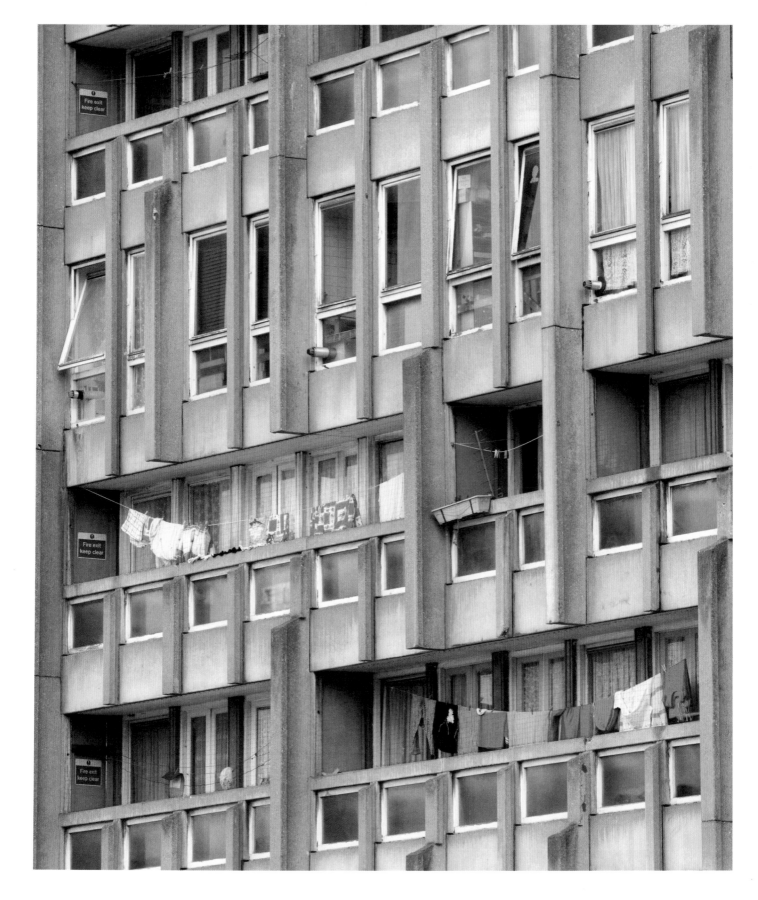

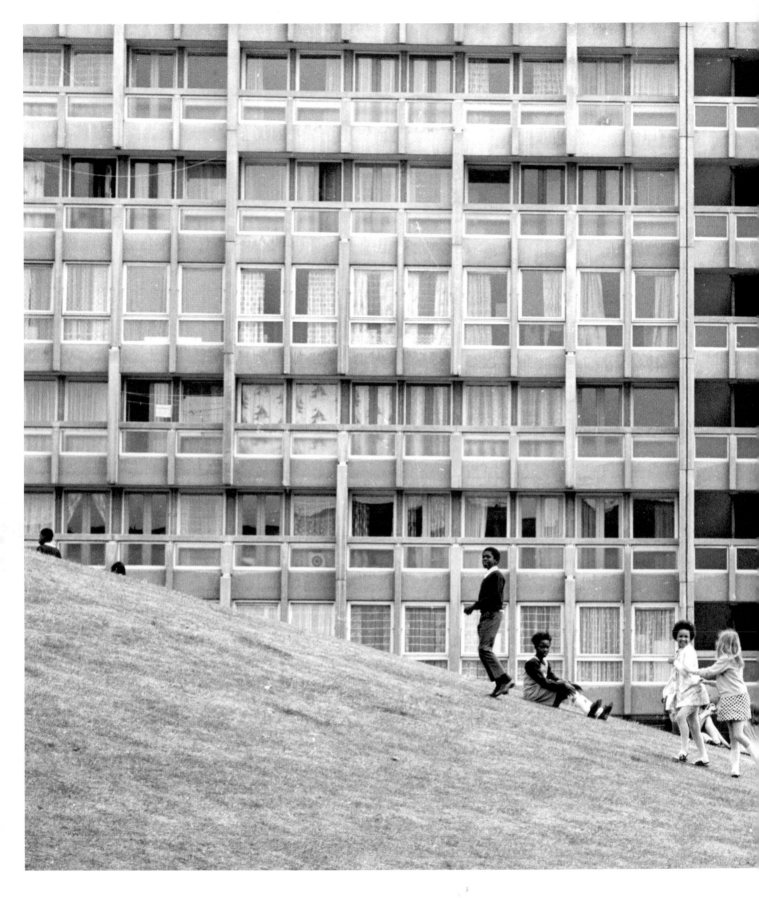

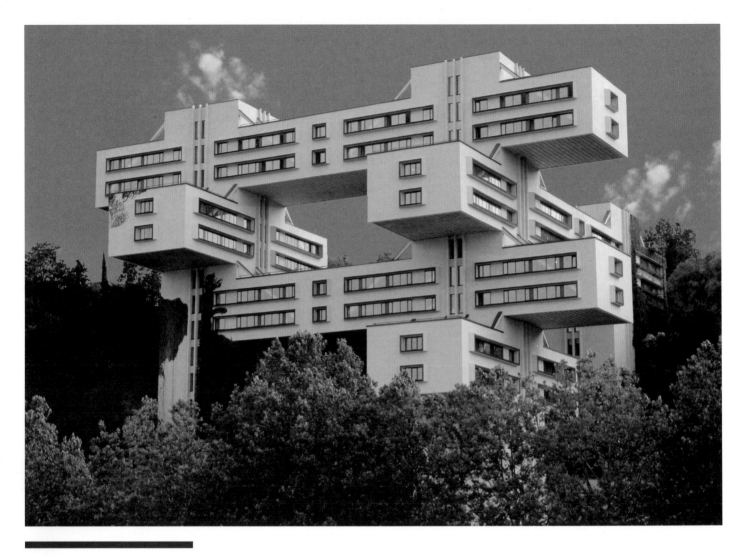

48

**Bank of Georgia (formerly
Ministry of Transport)**

Tbilisi

Georgia

1975

George Chakhava

Offices

Something seems a bit 'space station' about this office block for pen 'n' paper pushers in the former Soviet satellite state of Georgia. First it was transport ministry functionaries who sat at its desks, now it's the Bank of Georgia's multitudinous calculator-bashers. Perhaps the space station thing is unsurprising: the USSR was obsessed with interplanetary antics. So these kind of extruded cabins piled like huge bricks by local lad George Chakhava on a hillside outside Tbilisi fit in with that otherwordly aesthetic, the total belief in science and progress. It was a style which was weirdly applied to many hotels in former Soviet states too. Today's Georgia is determined to move in the exact opposite direction to its former masters in Moscow and commissions a ton of modern architecture – much of it not half bad. Though, as Jonathan Meades notes, one of its most prolific builders, Jürgen Mayer Hermann, does indeed turn to brutalism for inspiration in his many municipal Georgian buildings of the 2000s, like motorway service stations and border crossing points.

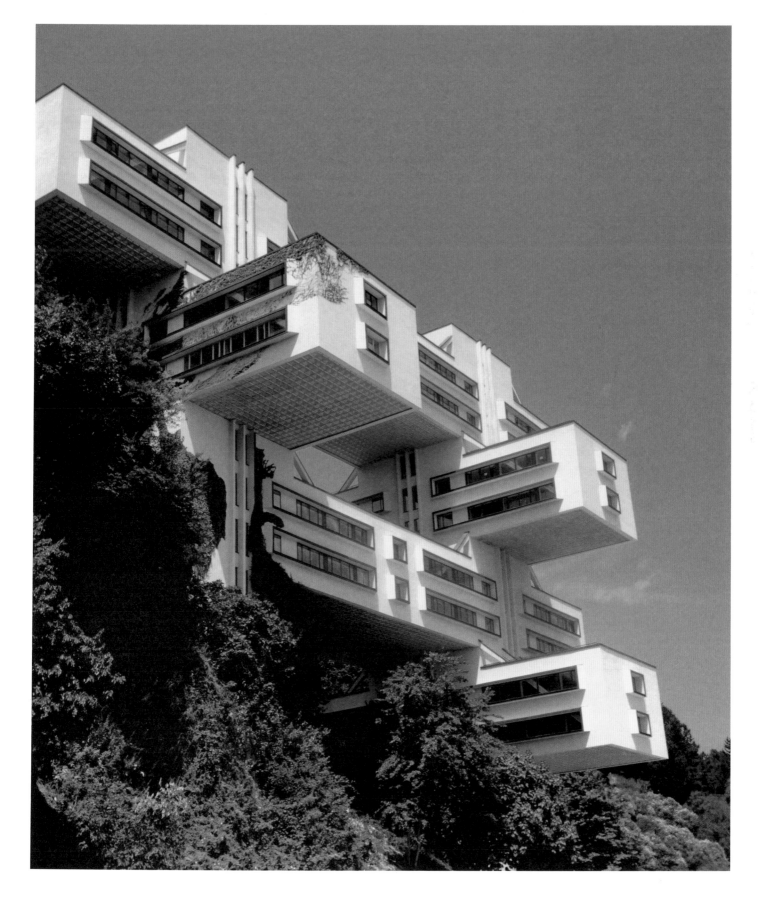

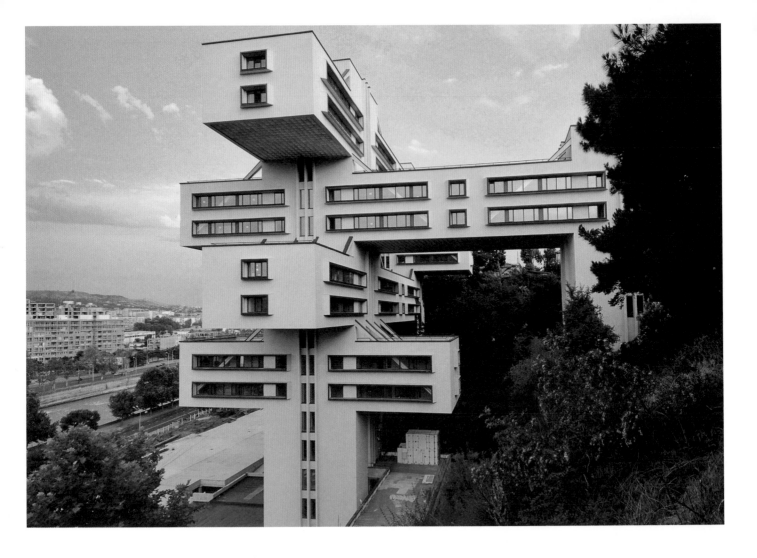

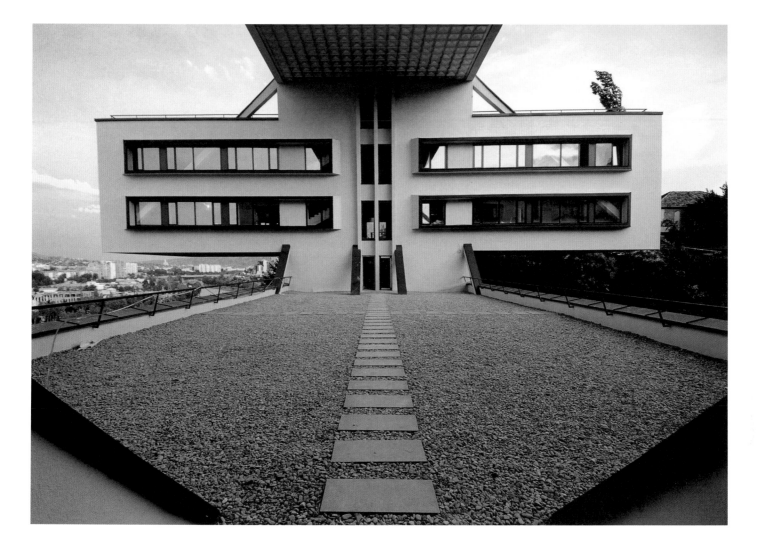

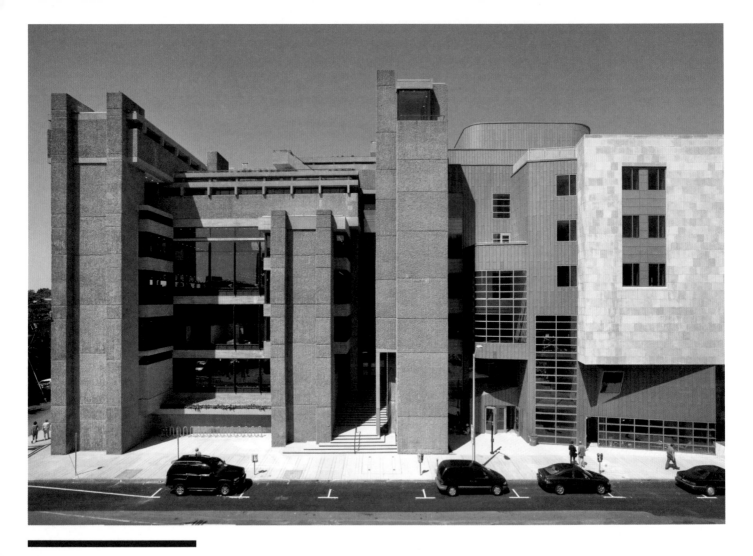

49

Yale Art & Architecture Building

New Haven

USA

1963

Paul Rudolph

Education

American architecture students were inculcated (whether they knew it or not) into brutalism by dint of often training in architecture schools which were, themselves, brutalist. Even today many survive – though this generation of architects has often said 'no' to the raw concrete they learned within. Paul Rudolph's Art & Architecture Building at Yale University is the perfect example of a brutalist architecture school – and is important for being an early deployment of American brutalism. Study areas, lecture theatres and a library are skilfully squeezed into this concrete chocolate box in New Haven. There are several murals, but the concrete itself is the real star . The building had a renaissance in the 2000s and is now more revered than ever. Gwathmey Siegel's refurbishment restored Rudolph's original intent (some duff alterations were made over the years), and importantly the striking tangerine colour scheme for carpets and seat covers is back – and it's determined to be as groovy as it must have been in swinging 1963. Siegel also bolted on a so-so extension.

50

Maria-Magdalena Church

Freiburg

Germany

2004

Susanne Gross

Church

Today, Freiburg is known as one of the greenest cities in the world. But it holds some concrete secrets too: two buildings that are more sure of themselves even than today's assertive eco movement. One is mid-century and rarely considered, located on Kaiser-Joseph-Straße, just south of the famous Martinstor gate. No one seems to know who built it. It is offices and shops and it hits you as you stroll down the street. The other is much more recent, a brilliant neo-brutalist oddity. We do know who built the Maria-Magdalena Church in the new district of Rieselfeld. It was Susanne Gross of KSG architects in Cologne. The austere church rears up out of a square like a lion. It's split in two – one half serving Catholics, one Protestants. This is remarkable enough. But the way the sharp lines of the church sing and shout as if midway through a hymn warms the cockles. So does seeing a multicultural congregation gathering outside on a Sunday morning. Brutalism, evidently, hasn't died. Its spirit is alive in Gross's concrete church in Freiburg. The start of a new chapter?

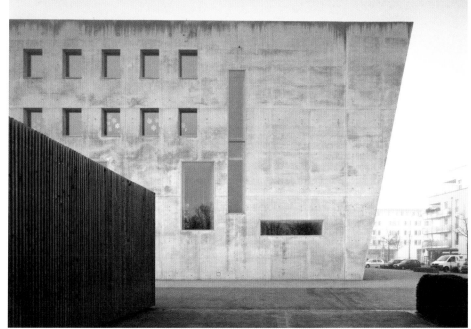

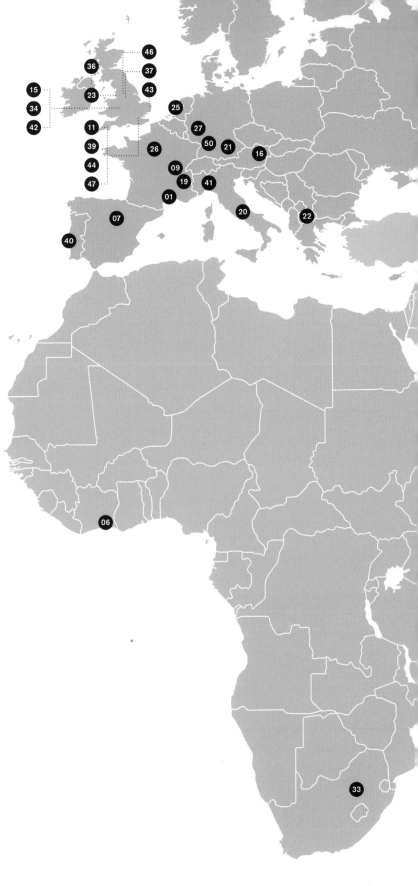

01 Unité d'Habitation, Marseille, France

06 La Pyramide, Abidjan, Ivory Coast

07 Torres Blancas, Madrid, Spain

08 Cultural Centre of The Philippines, Manila, The Philippines

09 Couvent Sainte-Marie de la Tourette, Eveux, France

11 Hayward Gallery, Queen Elizabeth Hall and National Theatre, London, England

15 Birmingham Central Library, Birmingham, England

16 Wotruba Church, Vienna, Austria

19 Flaine ski resort, Haute-Savoie, France

20 British Embassy, Rome, Italy

21 Munich Olympic Village and Park, Munich, Germany

22 Skopje Post Office, Skopje, Macedonia

23 Preston Bus Station, Preston, England

25 Aula at Delft University, Delft, The Netherlands

26 Centre Jean Hachette, Ivry-sur-Seine, Paris, France

27 Pilgrimage Church, Velbert-Neviges, Germany

31 Palace of Assembly, Chandigarh, India

33 Carlton Centre, Johannesburg, South Africa

34 Birmingham New Street Signal Box, Birmingham, England

36 Ulster Museum 1972 Extension, Belfast, Northern Ireland

37 Moore Street Electricity Substation and Park Hill Estate, Sheffield, England

38 Nichinan Cultural Centre, Nichinan, Japan

39 Balfron Tower and Trellick Tower, London, England

40 Palácio de Justiça, Lisbon, Portugal

41 Busto Arsizio Technical College, Busto Arsizio, Italy

42 Spaghetti Junction, Birmingham, England

43 University of East Anglia, Norwich, England

44 The Barbican, London, England

46 Leeds University, Leeds, England

47 Robin Hood Gardens, London, England

48 Bank of Georgia (formerly Ministry of Transport), Tbilisi, Georgia

50 Maria-Magdalena Church, Freiburg, Germany

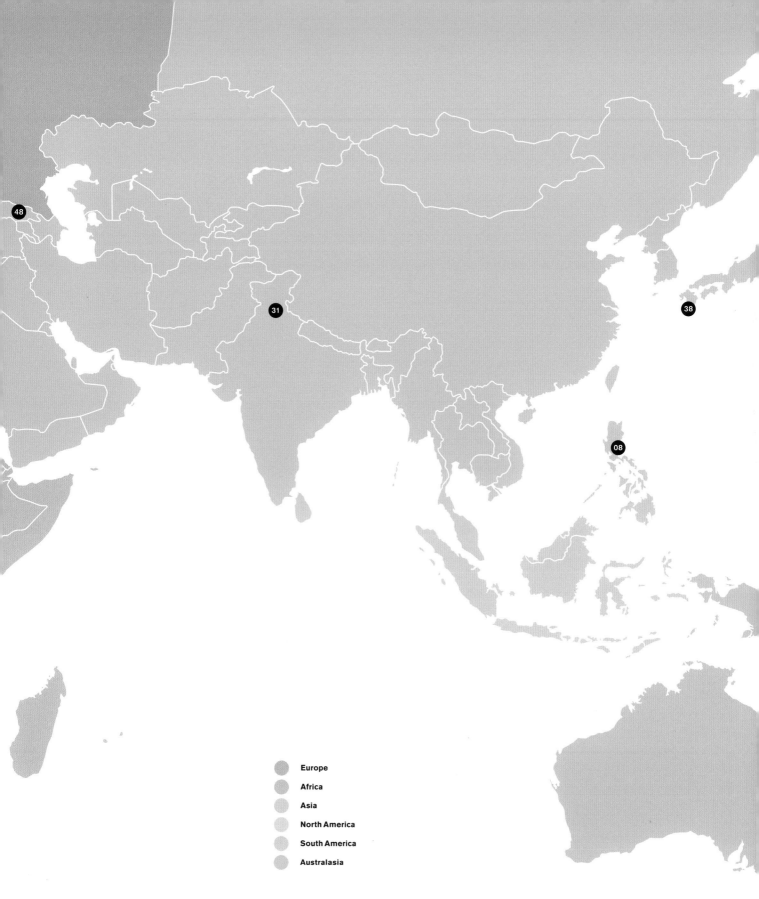

Europe

Africa

Asia

North America

South America

Australasia

Europe

Africa

Asia

North America

South America

Australasia

Photo credits

The publishers would particularly like to thank VIEW Pictures, the architecture and interiors photo-library, who have supported the picture research for this title. A further thanks to all photography contributors.

VIEW Alastair Philip Wiper 158; Andy Stagg 55, 59; Chicago Historical Society 80t; Collection Artedia 49, 166; David Borland 149; Dennis Gilbert 17, 142, 143, 163, 164; Ed Reeve 54; Edmund Sumner 15, 150, 151; Gerard Monnier /Artedia 18; Jacqueline Salmon/Artedia 48; James Morris 16; James Newton 58; Pascal Lemaitre/Artedia 86, 87; Richard Chivers 28, 29, 31; Richard Glover 22, 23, 24–25; Sue Barr 84.

AGE Fotostock/VIEW Bjanka Kadic 162; CSP_mlane 50; CSP_vichie81 52–53; Environmental Images 159; Gerhard Hagen/ Bildarchiv Monheim 40, 41; imagebroker.com 136; Nikhilesh Haval 51; Peter Erik Forsberg 99; Richard Bowden 160–161; russellkord. com 104; Sam D'Cruz 137; Stephen Rafferty/ Eye Ubiquitous 139; Therin-Weise /Arco Images; 119; VisionsofAmerica.com/ Joseph Sohm 105, 106–107; Wolf Winter 118.

Alamy allOver images 76, 77; Ball Miwako 79; Barnabas Calder 146; Brian Green 122; Chris Heller 12, 19, 20, 21; Chris Mattison 10; Colin Underhill 132; Craig Steven Thrasher 123; David Burton 161; Design Pics Inc 36–37; Ernst Wrba 75; F1online digitale Bildagentur GmbH 74; Francois-Olivier Dommergues 124, 125; Hemis 88–89; Ian Dagnall 120, 121; imageBROKER 46, 94, 95t, 96–97, 114, 115; Jason Lindsey 78; Keith Morris 102; LondonPhotos – Homer Sykes 171; Mechika 26; Midland Aerial Pictures 156–157; Paul Carstairs 165; Paul Lindsay 138; Paulo Fridman 27; Rob Crandall 131; Stephane Groleau 35b; Stephen Barnes/Public Transport 100–101; Stewart Bremner 133; travelRF 60–61, TravelStockCollection - Homer Sykes 170

Anna Armstrong 168, 169.

Anomalous_A 69.

Arcaid Alan Weintraub 82, 83, 85t, 85b; Richard Bryant 57; Richard Einzig 56; Andrew Haslam 103.

Art Institute of Chicago 80b, 81.

Bank of Georgia Archive 174, 175, 176, 177.

Ben Robson 38.

Canmore 90, 91t, 91b, 92, 93.

Cemal Emden 64, 65, 66.

Chihcheng Peng 127.

Christopher Lee 39.

Douglas Ensel 126.

Ed Lederman 167.

Edson Luis, via panoramio Creative Commons 144, 145.

Emporis 32, 33.

Federico Novaro 112, 113.

Garrie Maguire/Reframe-refocus blog 42, 43, 44, 45t, 45b.

Neil Poole 47.

Heinle, Wischer und Partner 95b.

Jefferson Sheard Architects 140, 141.

Jeffrey Pardoen 8.

Lloyds Banking Group Archive 67t, 67b.

Martin Feiersinger 154.

Naquib Hossain 116, 117.

Otto Magda Biernat 62, 63; Richard Barnes 178, 179; TY cole 180, 181t, 181b.

Palácio da Justiça. Lisboa, 1970 I Col. Estúdio Horácio Novais I FCG-Biblioteca de Arte: 152, 153.

Paul Bauer Endpapers, 11.

Reversed View blog, Shuko K Tamao 9.

Architectural Press Archive / RIBA Collections 71.

RIBA Collections 34, 35t, 148.

Richard Parminter 147.

Rob Low 72–73.

Roberto Conte info@robertoconte.net 155.

Rotterdam, Archives Broekbakema Architects (former 'Van den Broek and Bakema') 108, 109, 110t, 110b, 111.

Sandra Lousada 172–173

Sebastian Bravo 30.

Shawn Hoefler clevelandsky scrapers.com 68.

Steven P. Bley 128–129.

Ted & Jen 134–135 (City Concrete 2/08 (bo22) 70 (https://www.flickr.com/photos/10637778@ N00/2238067062)

Urban Splash 7.

www.bbmexplorer.com 130.

Yeowatzup/Flickr 98.

Yohan Zerdoun 182, 183t, 183b.

Every effort has been made to credit all copyright holders. The publishers will be glad to make good in future editions any omissions brought to their attention.

Further reading and watching

Books

Owen Hatherley – A Guide To The New Ruins
 Of Great Britain
Owen Hatherley – A New Kind of Bleak
Jonathan Meades – Museum Without Walls
Jonathan Glancey – Modern World Architecture
Ian Nairn – Nairn's London
John Grindrod – Concretopia
JG Ballard – High Rise
JG Ballard – Concrete Island
Douglas Hickman – Birmingham
Alan Clawley – John Madin
Catherine O'Flynn – The News Where You Are
Lynsey Hanley – Estates
Adrian Jones & Chris Matthews –
 Towns In Britain, Jones The Planner
Keith Collie, Jeremy Till, David Levitt –
 Park Hill Sheffield
Elain Harwood – Space, Hope and Brutalism
Elain Harwood – England's Listed Buildings

Magazines and pamphlets

Clog magazine – Brutalism issue, Feb 2013
The Manchester Modernist magazine, various
Brutalist Speculations And Flights of Fancy,
 Site Gallery publication, 2011
Concrete Quarterly, Various

Film

Radio On (Chris Petit)
Get Carter (Mike Hodges)
The Passenger (Michelangelo Antonioni)
Take Me High (David Askey)
Telly Savalas Looks At Birmingham (Harold Baim)
Utopia London (Tom Cordell)

TV

Six Men – John Madin (1965)
Gangsters (BBC's Play for Today, 1975)
Bunkers, Brutalism, Bloodymindedness –
Concrete Poetry (2014)
Remember the Future (1995)
The Shock of the New – Episode 4,
 Trouble in Utopia (1980)
Dreamspaces (2003-04)

Online

f*ckyeahbrutalism.tumblr.com
skyscrapercity.com
dezeen.com/tag/brutalism
municipaldreams.wordpress.com
lovelondoncouncilhousing.com
dirtymodernscoundrel.blogspot.com
instagram.com/brutal_architecture
twitter.com/thisbrutalhouse
paradisecircus.com

Acknowledgements

Thanks must go to my amazing commissioning editor Zena Alkayat, Glenn Howard for the design and Laura Nicolson for picture research. Thanks too to Andrea Klettner, Giovanna Dunmall, Elizabeth Hopkirk, Barnabas Calder, Catherine O'Flynn, Hugh Pearman, Ross Brown, John Grindrod, Jonathan Meades, Catherine Croft, Elain Harwood, Michael Abrahamson, Helen Pidd, Alan Clawley, Berwyn Kinsey, Jon Bounds, Alexandra Lange, Natalie Olah, David Adjaye, Katharine Grice, Andrew Garford Moore, Angus Montgomery, Beatrice Cooke, Anne Heaton and Niky Rathbone. High fives to Rebecca Armstrong, Hugh Montgomery, Sophie Lam, Louisa Saunders and Will Dean for trusting me to write pieces about ugly buildings and flyovers for The Independent. Michael Beanland showed me Sheffield's brutalism, Carole Beanland and John Beanland encouraged me, and I couldn't have done any of this without Nicola Trup.